A Writer's Guide to Police Organization
and
Crime Investigation and Detection

David Cole was born in Gloucestershire in 1938. He
served for thirty-five years in the army and police,
attaining the rank of detective chief superintendent.
He spent two years teaching at the Police Staff
College in Hampshire, commanded an urban
territorial division for four years and was the senior
detective of a large criminal investigation department
for the last ten years of his service. He has
investigated all types of serious crime including
espionage, IRA terrorism, homicide, armed robbery
and rape. His inquiry into the activities of a KGB spy
was described as 'masterly and remarkably diligent'
by a senior government law officer at an Old Bailey
trial and he was awarded the Queen's Police Medal
for Distinguished Service in 1985. Now retired he
enjoys writing and the pursuits of a born
countryman.

D0231628

By the same author

The Detective and the Doctor:
A Murder Casebook (with P.R. Acland)

Contents

Contents

Acknowledgements

I gratefully acknowledge the assistance given to me by my friend Dr Peter Acland, consultant pathologist to the Home Office, who answered many questions; the chief constable of West Mercia Constabulary in allowing me to check facts with former colleagues; and the librarian of the Police Staff College for assistance with research.

I am also indebted to the editor of the *Police Journal*, the Association of Chief Police Officers and Butterworths (publishers) for permission to use previously published material.

Crown copyright is reproduced with the permission of the Controller of HMSO.

Introduction

A constable is a citizen, locally appointed, but having
authority under the Crown, for the protection of life
and property, the prevention and detection of crime,
and the prosecution of offenders against the Peace.
As quoted in the *Constable's Training Manual* (1958)

Police officers are recruited from all walks of life, entrusted with
considerable powers and mandated with the burden of
maintaining a just and stable society. In a democratic society the
police service can only succeed in its objectives with the
co-operation of the majority of the population, and if it performs
within acceptable limitations laid down by parliament and the
judiciary.

Today law enforcers face an uphill task – organized, serious
crime is increasing, much of it related to the huge financial
benefits accruing from drug trafficking. They must also operate,
in many areas, in an atmosphere of unfamiliar hostility and
violence. The need to balance personal liberty against the
common good is a feature of our history, and it is surely a
reflection of continuing relative equilibrium that police officers
can still keep the peace without recourse to the general use of
firearms.

This book concentrates on the field of criminal investigation,
and is directed primarily towards those who wish to write
authentically about the work of detectives. It provides necessary
background to the formation and organization of forces, as well
as the detailed procedures that ensure police accountability. It is
also written for anyone who wishes to acquire a good working
knowledge of detection procedures or those who actually aspire
to become detectives.

There is nothing mystical about the investigation of crime.
Modern criminals may appear more devious and sophisticated,
their adversaries increasingly dependent on science and

technology, but the basic principles remain constant. The detective's challenge lies in unravelling the vagaries of the criminal mind, and he succeeds by watching, listening and probing – leaving no stone unturned in a methodical quest for a solution.

No matter how complicated the issue, the fundamental approach crucially relies upon the investigator's capacity to unearth information. Successful prosecution often depends upon the skill required to convert information to hard, acceptable evidence. In that regard, the modern detective has a distinct advantage over his predecessors because of the many technological advances of recent times.

Misconceptions abound in fictional writing about detective work; mostly they stem from devotion to a cult of personality; this often fails to recognize that a wide-ranging criminal investigation relies upon many disparate elements in a team and strict adherence to legal codes of conduct. The modern senior detective is, generally speaking, only a co-ordinator of effort and enforcer of rules, although his experience allows him to stimulate progress by personal inspiration and intuition. Crime fiction will surely become more credible if authors appreciate the progress achieved by a better regulated, informed and educated police service.

I have included many methods and procedures in a series of case studies. Some are loosely based on actual events, but all have been expanded in some way for the purposes of illustration, and none should therefore be regarded as a factual account of any particular incident. It should also be noted that several highlight what it is possible to achieve *in theory* – in the real world of financial stringency not all crimes receive such concentrated attention and commitment of expensive ancillary services.

Women make an equal contribution to the investigation of all types of crime and, therefore, unless the text makes it otherwise apparent, the use of masculine pronouns should be applied to both genders.

Note: The reader should appreciate that the book concentrates on investigative procedures and the legal system pertaining to England and Wales. Policing Scotland, although organized along similar lines, is subject to a different legal constitution, and any study of the Royal Ulster Constabulary must be regarded as a separate issue.

1 A Brief History of Law Enforcement and the Development of the 'Modern' Police

The hesitant progress of the 'new police' system throughout England and Wales during the decade after the formation of London's Metropolitan force in 1829 was born from necessity after long periods of unprecedented social instability. For more than three-quarters of a century libertarians had resisted proposals for a professional service to replace an already corrupt and discredited system. Many more years would pass before there was universal acceptance of the benefits to be derived from the new order.

The practice of voluntary policing had evolved over a millennium, during which principles of individual liberty and freedom of association were won in the face of tyranny and oppression. It was not therefore surprising that some vigorously resisted the change towards a disciplined, trained service. Apprehension about political interference or centralized control superseded concerns about escalating crime and mob rule.

Two continuous themes run through the history of law enforcement: the duty of individual citizens to bear responsibility for their personal conduct and a collective duty to maintain a well-ordered society. These general principles, ignored or neglected at various times throughout the centuries, remain the enduring feature of our national ethic on which the concept of policing by consent is based.

The foundations of the English legal system were laid by Alfred the Great in the ninth century, when he began the process of uniting a country previously divided by invasion and predatory warfare. His book of laws contained a bald edict that nurtured and developed the common law:

What ye will that other men should not do to you, that do
ye not to other men. By bearing this in mind a Judge can
do justice to all men ...

This encouragement towards responsible citizenship predeter-
mined the need for a form of enforcement that would provide
common protection against criminal elements. In the plebeian,
rural and scattered society of the tenth century collective
responsibility was maintained by close-knit family networks –
an early form of consensual policing that obviated the need for
dictatorial methods of enforcement.

Law-breakers were dealt with by local courts, which were
supervised by a royal appointee known as the shire reeve,
whose diverse administrative duties included the maintenance
of the king's peace. These rudimentary provisions served a
tribal, static population, even though their practical effect-
iveness was, in all probability, minimal. Compliance with the
established order was typically secured by punishing the group,
rather than individual miscreants. This system undoubtedly
ensured that most offences never reached official notice, but
were instead settled privately.

This ancient order of English society was rudely shattered by
the Norman invasion in 1066 and many subsequent years of
oppression and misery. All free men were required to give a
sworn pledge to uphold the law and deliver offenders to the
barbaric courts of barons and sheriffs. A further mandate
required suspicions about criminal behaviour to be reported to a
panel of twelve worthy citizens. This attempt to transform the
population into a nation of informers has assumed considerable
historical significance; not only was it the precursor of the jury
system, it also served to foster in the national psyche an abiding
distaste for common informers and a reluctance to accept
sanctions that relied upon suspicion rather than positive proof.

Stubborn resistance towards such tyranny eventually secured
progress towards a fairer system of justice, one that enshrined
principles of freedom and introduced further administrative
measures designed to regulate society better. It was a system
based on the feudal manor, the affairs of which were
supervised by courts-leet that elected officers annually to
perform civic office – among them being the constable. Official
recognition in a statute of 1252 placed the law enforcer alongside
the mayor and bailiff in social status although his title had
survived a chequered history over the centuries – originally the
Roman *comes stabuli*, count or officer of the stable. It later

denoted the custodian of Saxon castles before evolving as the dogsbody of the sheriff.

The constable's duties and responsibilities increased at a time of considerable population growth and significant movement from rural to urban settlements. In 1285, the statute of Winchester implemented preventive, rather than purely punitive, measures in the larger towns and in addition to his normal tasks of presenting offenders and reports about crimes to the court, the constable now found himself organizing the night-watch and hue-and-cry parties. These time-consuming duties proved burdensome to elected officers, who invariably came from the merchant class. This was soon reflected in the quality of service they provided. A general reluctance to commit time and energy to their voluntary civic duties often meant that enforcement was neglected. Inevitably law-breaking and injustice became rife, which in turn led to public disillusionment and the virtual collapse of any form of order.

In 1361 efforts were made to provide further support for law enforcement. The constable lost his pre-eminence and became subordinate to newly appointed justices of the peace. These were the successors of the king's knights, who had travelled the realm maintaining order. The new appointees by contrast were charged with judicial and administrative duties within a defined area. They were also able to exercise influence over the appointment of constables and supervise their performance. This ensured a more stable and equable system of law enforcement, tailored to the needs of a particular place.

During the centuries of conquest, acquisition and internal warfare that marked the medieval age, the ruling classes were more intent on furthering their own causes than safeguarding the welfare of the lower orders. Justice for ordinary people was overshadowed by economic and social considerations. During the first six decades of the 17th century when parliament was preoccupied with its struggle for supremacy over the monarchy, the only authority interested in regulating local affairs was the ecclesiastical parish. This ineffective form of civil management created an environment that encouraged crime, corruption and public disobedience on an unprecedented scale, and the only remedy offered was a barbaric form of oppression.

The government's apparent indifference to this rapidly deteriorating situation was reflected by the disenchantment of those elected to civic office. Senior officials would delegate thankless tasks to unsuitable, and often degenerate, deputies. Once germinated, these seeds of corruption soon flowered in

the ranks of those holding judicial office, and eventually society was plunging towards chaos.

The perverse system relied upon rewarding those who brought alleged offenders before the courts. Corrupt 'trading' justices gradually replaced those reluctant to continue in a voluntary capacity and exploited a system that offered rewards for successful prosecutions. Unscrupulous informers took full advantage of the situation and their unreliable evidence led to miscarriages of justice on a massive scale. Active criminals, who were able to pay their way out of trouble, evaded the courts, and continued their activities unhindered. A prosperous criminal underclass was gaining strength in most heavily populated areas – and at a time when discipline was urgently required: the onset of the Industrial Revolution.

The early years of the eighteenth century saw a hitherto agrarian society gravitate rapidly towards large centres of population to service mines, foundries and factories. There was no co-ordinated planning or infrastructure to cope with mass migration and a spiralling birth rate. Drainage, sanitation and highways were virtually non-existent. Exploitation of the workforce created appalling slum conditions and an industrial and social morass. In these particular areas the absence of effective policing created untold opportunities for theft, robbery and violence, and as citizens sought to blot out hardship by resorting to debauchery and alcohol, complete anarchy became a real threat.

Government tried to stem the tide by reverting to a savagery reminiscent of the Middle Ages: capital punishment for petty crimes, regardless of the sex or age of the offender; barbarous physical punishment; disproportionate terms of imprisonment in disgraceful penal institutions or transportation to the far reaches of the world. In many instances penalties were inflicted on the basis of dubious or corrupt testimony, presented by unscrupulous constables whose incentives were financial rewards given for successful prosecutions.

Fortunately a few visionaries perceived a better way. The brothers Henry and John Fielding, successive Bow Street magistrates, restored some respectability to the administration of justice in central London. They rejected the substantial monetary advantages of the trading justices and introduced radical measures to rid the streets of criminals.

Popular mythology credits Henry with establishing the Bow Street Runners as the first professional police service in 1750, when in truth they were a motley collection of parish constables

to whom he granted extended terms of tenure in order to provide continuity in criminal inquiries. Their inducement was still the substantial sums of 'blood money' paid on results, but by having constables under control for longer periods, Fielding was able to insist on higher standards.

Within their limited jurisdiction, the Fieldings were able to show that improvements in policing were possible. Their most significant achievement was to stimulate a political debate about rapidly deteriorating social conditions, which encouraged vice and lawlessness. By drawing attention to the inadequacies of traditional policing, they were also able to concentrate the minds of other influential thinkers on the need for change.

Another magistrate, Patrick Colquhoun, supported the Fieldings' campaign for a professional police service to replace the voluntary system. He presented detailed and persuasive proposals for a national police force under the direct control of the home secretary. Unfortunately, any idea that sought to extend centralized authority or organized force always met with overwhelming resistance from influential libertarians. A Bill that sought to introduce such measures to London was heavily defeated in parliament in 1785, and the debate rumbled on throughout the remainder of the century. While the libertarians concerned themselves with intellectual arguments, most of their fellow citizens were obliged to abandon any hope of freedom from crime.

Eventually when criminal activity started to damage the commercial or financial interests of entrepreneurs and industrialists philosophical arguments were swept aside. A handful of ruthless villains controlled London's underworld and were able to escape punishment by manipulating the system. Thieves' kitchens infested the capital, but it was the Port of London that was particularly targeted by criminals. The docks were cluttered with every kind of merchandise needed to supply an expanding industrial economy, and rich pickings were to be had.

The reformers received a far more enthusiastic reception from those whose pockets were being hit than from the libertarians. Colquhoun's plans for a uniform preventive force were accepted by the port authority, and in 1800 the Thames River Police was created. The success of round-the-clock patrols was quickly demonstrated and persuaded larger towns like Bristol, Liverpool and Manchester to pre-empt government action and follow suit. In rural areas the gentry, tired of the attentions of local poachers and thieves driven from towns by police activity,

took the law into their own hands and employed gamekeepers to protect their estates. In other parts of the country armed vigilantes replaced, or supplemented, the inadequate traditional methods of enforcement. Yet still government vacillated.

It was the aftermath of the Napoleonic Wars that, in the end, galvanized parliament into action. Thousands of servicemen and camp followers were demobilized without financial, welfare or housing support. Many inflicted themselves on an already beleaguered society as beggars, rogues, vagabonds and vagrants. Parliament hastily introduced emergency legislation, specifying numerous new criminal offences, without giving any thought to its enforcement. An already inadequate system was completely incapable of dealing with the added burden, and this situation allowed Robert Peel to introduce a Metropolitan Police Bill in 1829. This time it passed into law with hardly a whimper of opposition. At long last the control of policing the capital passed from parochial and judicial authority to that of the home secretary. But anyone who believed it would be an easy matter to extend the principle to the country as a whole underestimated those who remained adamantly opposed to any further infringements on personal liberty.

The first joint commissioners of the Metropolitan Police, Rowan and Mayne, were well aware of the sensitivity of their task and the need for sympathetic planning if the force was to succeed. Their strategy was deliberately unprovocative: a large group of ordinary citizens would be trained in the skills of preventing crime and protecting life and property with the use of minimum force. The initial instructions outlining this philosophy for the 'new police' established a model that is still largely adhered to.

Careful planning and sensible implementation, however, did little to allay the hostility and derision that greeted the first patrols. Dressed in distinctive blue uniforms and armed with only staves and reinforced hats, they were the butt of ridicule and violence and represented easy prey for a vindictive press. There were also many internal problems in the early years; satisfactory recruits were difficult to find and the necessity for harsh discipline led to many abandoning the service prematurely. It was only by a process of firm yet fair determination that the force was able to gradually demonstrate its worth by creating increasing stability in hitherto turbulent areas of the community. When law-abiding people in other parts of the country witnessed its success and clamoured for similar protection, civic leaders were forced to recognize the compelling

arguments in favour of reform.

Some larger towns established effective policing measures on their own initiative, but many others were not prepared to provide the necessary financial resources without government assistance. It was soon appreciated that, left to their own devices, large tracts of the country would continue to rely on the historic voluntary system, unless legally required to introduce the new measures. The only solution that could be agreed was at best a compromise: all self-governing boroughs were obliged to establish a police force by an 1835 Act of Parliament. Nothing was demanded of rural areas or towns that had not been granted independent charters; many of these had since grown into sprawling industrial ghettoes with acute social problems.

A further problem was the diverse interpretations given to the new legislation. Some boroughs organized a highly efficient service while many relied on the existing, ineffective watchmen. The result was entirely predictable: a migration of criminals from well-policed areas to places where they could extend their activities without fear of reprisal.

In 1839 further legislation empowered magistrates to appoint professional constables in the shires. There was no compulsion to do so, and the provision was largely ignored. Another thirty years passed before all local authorities were required to provide policing services. This was at a time of general local government reform, and long-held fears of centralized, authoritarian control of the population were assuaged by placing the onus for law and order on the new provincial authorities.

The length of time it had taken to achieve universal policing, and the fragmented nature of the service, meant that constabularies were completely uncoordinated. From their inception rationalization was urgently needed. This process, which began during the last quarter of the nineteenth century, has never achieved complete standardization. The same arguments have been used time and again to avoid creating an ideal prototype: loss of local influence and interference from the centre.

Many difficulties arose because of different forms of police administration. In the ancient boroughs watch committees, consisting entirely of elected councillors, were given full regulatory powers over their forces, including rights to appoint, promote and discipline. Their equivalents at county level, standing joint committees, comprising councillors and magistrates, had no such overall authority. Their duties were limited to providing the resources necessary to maintain a constabulary,

and the chief constable, appointed by the Home Office, regulated the affairs of his force. The dichotomy militated against any common conditions of service or working practices.

In 1857 there were 237 constabularies in England and Wales, offering widely different terms of employment. For the next ninety years, cities and boroughs allowed them to combine police duties with other functions. Policemen became multi-skilled: firemen, ambulance attendants, inspectors of animal health and weights and measures. County constabularies were in the grip of the landed gentry, a class that prevailed in the magistracy and county councils and which sought to influence chief constables. Both types of governing body stoutly resisted any proposals that threatened the status quo, and in some well-publicized instances tried to exert pressure on a chief constable's prerogative over operational policing policy. Political dogma, in other words, frequently threatened the impartiality of law enforcement.

While the managerial echelons engaged in power struggles the circumstances of constables and junior supervisors were largely ignored. Until working conditions began to improve in the early years of the twentieth century the preventive policing system entailed continuous foot patrols in all weathers; officers were required to perform two lengthy periods of duty during daylight with an alternated twelve-hour night shift. There was no entitlement to regular rest days, tied accommodation was invariably spartan and remuneration at the lowest level men could be persuaded to accept. These primitive conditions took a heavy physical toll and illness replaced most other causes of premature retirement.

Political and operational difficulties threatened to undermine the clearly demonstrated advantages of organized policing; patrols were proving effective in reducing crime and maintaining order on the streets, while newly formed detective branches began to deal effectively with the identification and prosecution of offenders. But if progress was to be sustained performance and procedures needed to be standardized further. At last this process was set in motion by government intervention: the payment of an annual exchequer grant was made dependent on satisfactory periodic inspection. Legislation was also enacted to merge many smaller constabularies into larger units, thereby increasing efficiency and facilitating uniformity in wage settlements and conditions of service.

These developments allowed the police service to enter the twentieth century with added confidence. An enfranchized and

better-educated population began to demand improved social services; successive governments were thus forced to create a plethora of regulatory legislation that only the police could enforce. The advent of motor vehicles created further problems; more regulation was necessary and the police again bore the brunt. The enforcement of traffic laws started to affect relationships between police and public. Whereas previous sanctions had been exerted against clearly recognizable miscreants, police officers were now obliged to censure otherwise ordinary and respectable people. This partition of purpose, between largely supportive and preventive agency on the one hand and regulatory body on the other, is one that has never been satisfactorily resolved. It is instead tolerated mainly because the police use considerable discretion and continually strive to foster good relations with the community they serve.

The demands placed upon the service by emergency regulations enacted during the First World War aggravated difficulties. Intense dissatisfaction festered within the ranks as financial rewards for onerous wartime duties fell way behind those of industrial workers, often reducing the circumstances of many police families to poverty levels. Police chiefs proved largely indifferent to the problem and the workforce was denied union representation to pursue genuine grievances. But when large numbers of Metropolitan officers withdrew their labour in 1918, and publicly received the sympathy of national unions, the response was immediate. The government, facing a difficult postwar period, acknowledged the need for an impartial police service to help re-establish a stable society, and sought to discourage union barons from believing that open support for the police cause would give them a valuable ally during times of industrial unrest.

Seeking to defuse a potentially dangerous alliance as quickly as possible, the authorities awarded the Metropolitan police a substantial pay rise. This did nothing to improve morale elsewhere, but it brought a period of grace during which a solution could be engineered. The urgency of the situation was highlighted by police strikes in other areas, after which all those who withdrew their labour were summarily dismissed. These unfortunate events drew public attention to the plight of a service, still organized along Victorian lines, whose members were subject to intolerable demands.

A committee of inquiry, chaired by Lord Desborough, recognized the need for radical change if many problems were to be overcome. Greater direction and influence by the Home

Office was an obvious answer. The committee shied away from implementing the logical arguments in favour of a national police service and relied instead on the traditional supposition that society would reject any further centralization of law enforcement. Inevitably its final recommendations were a compromise between the two positions: it laid to rest the notion that society could be relied upon to police itself; recognized that a well-regulated professional policing structure was essential to the maintenance of order; and established a management partnership in an attempt to satisfy both sides of the debate. The result was a Police Council representing Home Office, police authorities and all ranks of the service. Its mandate was to advise the home secretary, through a newly created Police Department, about all administrative and procedural requirements. A representative Police Federation was created for all ranks below superintendent, although trade union status and a right to strike were denied. An element of centralization was at last achieved by a stipulation that the secretary of state must be empowered to issue regulations, to be universally applied, concerning pay, discipline and conditions of service. The proposals were enshrined in the Police Act, 1919. This landmark in the history of policing laid the foundations for a professional, organized and well-regulated body on which formal structures could be built.

The value of the new measures was soon demonstrated. During the 1926 General Strike a unified response from a well-trained, disciplined and mobile service reacted to a volatile situation with great sensitivity and without the need of military assistance. The British bobby finally established his place in the community, earning a degree of public esteem and good will that would have once been impossible. Unfortunately the harmony was relatively short-lived.

The Second World War, another watershed, exacted a heavy toll on all constabularies. Military service reduced the number of regular officers available and their places were taken by special constables and war reserves. Salaries for those who remained again fell below the national average, which meant that many enlisted men failed to rejoin at the end of hostilities. Recruiting sufficient replacements proved impossible and many forces became seriously undermanned; the Metropolitan Police's strength dwindled to such an extent that it was employing 1,000 fewer officers than it had at the turn of the century.

A nationally depleted force struggled to cope with mounting problems: the black market, ever more crime, traffic congestion

and public disorder – all presented seemingly insurmountable challenges. An increasingly transient population and more mobile criminal underclass confirmed glaring deficiencies in the collection and collation of criminal intelligence. As the tempo of everyday life gathered pace, aided by the start of a technological revolution, the police began to lose ground and, in the process, morale. Another hike in wages and more mergers of smaller forces did little to reverse the trend. 125 Constabularies were still too numerous, localized and disparate to deal with problems that were increasingly national in scope.

Moreover public confidence was undermined by a series of crises that forced the government to act. In 1956 a chief constable was disciplined for maladministration, another was imprisoned for fraud, and corruption among senior ranks was alleged. The following year a disagreement flared up between the watch committee and chief constable in Nottingham about operational autonomy. In 1959 the home secretary answered a motion of censure in parliament concerning a minor traffic incident that turned into an action for assault between a motorist and constable. These matters focused attention on differing levels of accountability between the Metropolitan and provincial forces.

The mounting crisis of confidence coincided with large numbers of disenchanted officers resigning prematurely. The causes of discontent were manifold: ostracism of families, unsociable hours, rigid working practices and a harsh disciplinary code that appeared to be out of touch with the *mores* of contemporary society. There was also an ever increasing risk of violence and little support from ineffective leadership against unfair criticism. The previous attractions of a police career, security of tenure and early pensionable retirement, were no longer sufficient inducements when the general workforce was also being granted similar, if not exactly comparable, benefits. It was also a fact that by 1960 better-paid employment was available in the commercial and industrial sector.

These complex problems had not blown up overnight; for many years the needs of the police had been conveniently ignored. Now, in the absence of an obvious remedy, the government wheeled out that familiar stand-by of the British constitution in times of crisis. A royal commission, chaired by Sir Henry Willink QC, was charged with the task of examining the entire concept of policing a modern society. Its members immediately appreciated the need to halt the premature retirement of experienced officers. Therefore, before addressing

the main issues, they awarded pay increases that almost doubled senior constables' salaries.

When the commission presented its final report in 1962, the most cogently argued views were contained in a dissenting minority document submitted by an academic member, Dr A.L. Goodhart. He put forward an almost undeniable case for a national police force, controlled from the centre. The majority of his colleagues went to the brink of agreeing with many of his assertions, but finally advanced tamer proposals based on the existing arrangements. Once again the reason given for side-stepping radical change was the need to maintain traditional interaction between police and local communities. In the light of subsequent events this hoary old chestnut came to seem disingenuous.

Many substantial reforms recommended by Willink were incorporated into the 1964 Police Act. The constitutional obligations of police administrators were clearly defined. Significant changes affected the powers previously enjoyed by watch committees: all police authorities would in future comprise a mixture of magistrates and elected councillors. Chief constables were given complete control over their personnel. The home secretary became answerable to parliament for policing issues throughout England and Wales, as well as being given sweeping powers of organization and administration. Within a short space of time the mandate to organize saw a reduction in the number of constabularies from 117 to forty-nine and local government reorganization in 1974 reduced the number further to forty-three.

The rapid and compulsory mergers flew in the face of precious beliefs in parochial accountability that had been so recently advanced. They also created tremendous upheaval at great financial cost and at the expense of morale. In the light of the Willink Commission's insistence on retaining local links between those who control the police and the operatives themselves, the logic behind the creation of many of the new constabularies was difficult to discern. While working constables would undoubtedly maintain the link, the executives who controlled them operated at appreciable distances from the majority of the public they serve. Justification on grounds of economy of scale and standardizing the use of resources would have been more acceptable reasons had not several small forces with establishments of less than a thousand personnel been excluded from the proposals. In the eyes of many the attempt to rationalize was a political fudge that would inevitably necessitate future changes,

perhaps in the form of new regional forces.

The casual observer may be excused for concluding that the progress of policing during the twentieth century has been a catalogue of disasters, punctuated by feeble rescue missions and always accompanied by whining about pay. The true picture is, however, far more complex. The intractable, uncooperative stances taken by intellectuals and politicians, and a lack of visionary leadership, contributed to many early problems. These reactions were only to be expected when disciplined enforcement threatened to curtail the activities of a population that had been largely left to do as it pleased for so long. Once the inevitability of change was plain for everyone to see, a more open and unselfish approach, particularly by those in authority, would have helped eradicate suspicion and advance the cause of democratic policing. Sadly there are still many who hold jaundiced views and see attempts to undermine confidence in the police as the best way to destabilize society.

The question of pay is another matter. It is an unpalatable fact that for more than 150 years, those responsible for remuneration took advantage of a group of workers denied the right of industrial action, and rewarded them with salaries that constantly lagged behind those who had the muscle to force employers towards negotiated agreements. This short-sighted policy created most of the crises – crises that might well have been averted if the incentives had been available to attract and retain high-calibre personnel.

Although many believe that the role of policing needs to evolve further, recent events indicate that the requirements of a sophisticated law enforcement agency have at last been recognized. High levels of unemployment have directed quality recruits towards the service; adequate pay levels and a more liberal regime bode well for keeping them. There are also encouraging signs of a more efficient use of resources and greater co-ordination of effort, particularly in the battle against crime.

It is a surprising feature of police history that throughout its difficult birth and adolescence the service has maintained a consistent excellence in operational development. While those in authority have been engaged in high-flown philosophical battles, officers on the beat have largely succeeded in maintaining the peace. The methods they employ are admired and copied throughout the free world, and the balance they strike between personal liberty and the common good still commands the respect and admiration of the majority of people they seek to serve.

2 Organization – Structure – Control

Responsibility for the effectiveness of the police service is shared by three parties: the home secretary, police authorities and chief constables.

The home secretary has a special responsibility as the police authority for the Metropolitan force in London, but also exercises considerable influence in national policing affairs. His primary mandates are the internal security of the nation and maintenance of law and order. While he delegates the operational aspects of these functions almost exclusively to the police, they must nonetheless work within strictly controlled parameters that monitor structure and performance.

The Home Office Police Department is directed by a deputy under-secretary of state and staffed by civil servants, many with technical and scientific backgrounds. The department is divided into divisions, each responsible for a particular aspect of policing; their work embraces research, formulation of policy, and advice and collation of information for parliamentary purposes. One division deals exclusively with matters relating to the home secretary's responsibility for the Metropolitan Police. The others focus on such issues as establishments, pay, allowances, police regulations, training, discipline, police powers, regional crime squads, anti-terrorism, road traffic policing, public order and firearms legislation. The department also supervises ancillary agencies that provide assistance to the police, including the forensic science service, communications, scientific research, technical development and the Police National Computer Organization.

Advice emanates from the department in the form of Home Office circulars, which are generally issued only after exhaustive consultation between interested parties. While these documents do not in themselves have the force of law, they carry sufficient

authority to ensure compliance by those to whom they are directed.

Adherence to a national policy is further guaranteed by the system of funding individual constabularies. An annual grant from the exchequer, conditional upon a certificate of efficiency issued by Her Majesty's Inspectorate of Constabulary (HMI), provides slightly more than half of the budget; the remainder is funded by the relevant local authority.

The inspectorate is an important link in the chain of control. H.M. chief inspector of constabulary is the principal adviser to the home secretary, responsible for reporting annually on the national policing situation in a document laid before parliament. He is assisted by a number of subordinates who oversee critical areas of law enforcement and administration. Regional HMIs also have a powerful and influential voice in the formulation of policy. Usually retired chief constables with extensive experience, they are in a position to provide chief constables with authoritative advice and guidance.

Financial support from government is not limited to the annual fiscal grant. The Home Office effectively controls the many operational and administrative functions necessary to co-ordinate the national policing effort. The Common Police Service Fund, to which all forces are obliged to contribute, finances a range of support services. These included the National Police Staff College, recruit training centres, police computer organization, specialist crime squads and research establishments.

The amount of influence exerted by the Home Office, which acts on behalf of central government, is reflected in the progressive development and responsibilities of police authorities. The potential for interference in local operational matters has been gradually eroded over the years by statutory changes to their constitution and a clearly defined mandate. This is not to say that their role in affairs should be dismissed as insignificant; rather that there has been a shift of emphasis.

The Police and Magistrates' Courts Act, 1994, introduced smaller authorities throughout England and Wales, and substantially changed their constitution. Each comprises local councillors, magistrates and a number of independent citizens appointed by the membership. The chairman is selected by his peers, but requires the approval of the home secretary. The broad terms of reference are to provide strategic management for the force and act as a voice for the view of the community it serves. Within this framework the principal tasks are to:

maintain an efficient and effective force; establish, in consultation with the chief constable, local policing requirements that reflect community views; monitor the performance of the force; and set a budget for a financial year that will meet both local and government objectives. Each year the home secretary announces a number of key objectives and these are refined to meet local needs. Continual quality and performance audits, monitored by the police authority and HMI, are conducted by the force, and in large measure support the annual grant of a satisfactory performance certificate.

The success of a police authority depends on its ability to assess and act upon the views of the constituency it represents, and insist that the force remains sensitive to those views. It thereby serves to justify the historic axiom that the British police function with the consent of the people.

The chief constable is the third party in the management triumvirate. He is appointed by the police authority from a short list of applicants approved by the home secretary. Applicants must have served in another force in a senior rank at some time in their career, and must be graduates of the Staff College Leadership Development Programme (SLDP).

A chief constable is guaranteed freedom from any political influence in exercising his operational function, and is responsible for the financial management of his force within the limitations of the allocated budget. His statutory right to appoint, promote and discipline members of his force is also unchallengeable, and he may not be removed from office without the approval of the home secretary. However, his duties and responsibilities are closely defined in the Police Act, 1964. The Home Office and police authorities hold legal powers which may be used to call chief officers to account for any questionable action or decision in the conduct of their forces' affairs.

(Arrangements for policing London differ from provincial areas. The commissioner of the Metropolitan Police is appointed by the Sovereign and is accountable to the home secretary in his role of police authority. Until 1995 the force was not subject to annual examination by the inspectorate, but relied upon internal departmental scrutiny. It is now inspected on the same basis as any provincial constabulary.

The Court of Common Council is the authority for the City of London police and appoints its commissioner. The force is administered and financed in the normal manner.)

Organization

There are forty-three autonomous police forces in England and Wales. A chief officer is expected to determine operational policy for his area, after consultation with the community, and after taking into account the competing demands made upon resources at his disposal.

The size of individual constabularies varies considerably and there are four types:

1. The Metropolitan Police (MPD) operates within the Greater London area and performs several unique functions, such as national security and the physical protection of important public figures, visiting dignitaries and public buildings.

2. The small business and commercial area in the centre of London is policed by its own city force, which owes its continued existence to history and tradition.

3. Metropolitan county forces, which were created following local government reform in 1974, police the conurbations and were brought into being by amalgamating a number of independent constabularies. One example is the West Midlands Police Force, now covering an area previously policed by individual constabularies responsible for Birmingham, West Midlands, Coventry and parts of Staffordshire, Warwickshire and Worcestershire. Other such forces are Greater Manchester, Merseyside, Northumbria, South and West Yorkshire. The police and support staff in each of these areas number several thousand.

4. All the remaining constabularies cover one or more shires and provide the best example of diversity in the size of police forces. Thames Valley, an amalgamation of several counties, has an establishment in excess of 5,000, whereas Wiltshire, untouched by reform, continues to police its traditional administrative territory with a strength of 1,500 personnel.

It is impossible, given the complexity of law enforcement in contemporary society, for any one constabulary, with the possible exception of the Metropolitan Police, to operate effectively in isolation. National services have therefore been created to provide cohesion and consistency in areas such as

organized crime, public order and national security. During the early years of development, some of these undertakings were carried out by the Metropolitan Police, but as problems have increased in scale separate national organizations to which all forces contribute have been created. Those that operate in the field of criminal investigation are:

1. Regional crime squads.
2. National Intelligence Unit.
3. National Identification Bureau.
4. Forensic Science Service.
5. Police National Computer (PNC).

Regional crime squads (RCS), whose headquarters are located in London, operate under the direction of the national co-ordinator. The country is divided into areas, in each of which are several branch offices staffed by experienced, specialist detectives seconded from local forces. The areas are commanded by a regional co-ordinator with the rank of detective chief superintendent. Because so much serious criminal activity is now linked to the importation, manufacture and distribution of illegal drugs, a number of officers who specialize in narcotics are also attached to each region.

RCS operate against major, organized criminal activity and 'target' criminals, both identified by intelligence supplied by the National Criminal Intelligence Service. They have a highly sophisticated surveillance capability and the advantage of freedom of movement throughout the British Isles. Many enquiries undertaken by the squads take years to reach fruition, often requiring officers to work undercover for long periods and sometimes in situations of considerable personal danger.

The National Criminal Intelligence Service (NCIS) is a recent innovation, established to co-ordinate information about the most serious crimes and offenders. The first crumbs of information usually come from local sources; these are then expanded upon and refined by field intelligence officers who pass it for assessment to their force's intelligence bureau. If the information identifies substantial criminal involvement over a widespread area it is forwarded for further monitoring by NCIS officers working within regional units. All data are computerized to facilitate co-ordination and evaluation, before decisions are taken at the highest level to deploy financial and manpower resources to high-profile operations. These commitments are undertaken only against those actively engaged in

criminal enterprises that have the potential to threaten the stability of society. Because of the proven connection between narcotics and crime, the unit has close operational links with HM Customs and Excise.

The popular myth, held particularly by radicals, that intelligence is commonly gathered by telephone tapping is completely inaccurate. The facility does exist, but may only be used on the personal authorization of the home secretary and will only be granted for matters which affect the stability or security of the nation. Only a small number of approvals are given in any year and the information obtained may only be used for intelligence purposes, never as evidence in court.

The central bureau of the International Police Organization (Interpol) operates from the London headquarters of NCIS and co-ordinates information and enquiries between British forces and foreign law-enforcement agencies. It is not a pro-active department, but a recording and intelligence channel for investigations concerning criminality on an international scale. Any requests for reciprocal enquiries between home forces and those abroad must be processed through the department.

National Identification Service (NIS). Originally known as the Criminal Record Office, this unit maintains the national definitive record of criminals. Descriptions and fingerprints of everyone arrested for a recordable offence, together with particulars of the offence, are forwarded for comparison with records already held. Details of any subsequent court conviction are also notified, making it possible at any time to connect an individual with his criminal record. The system is frequently used to pinpoint those who seek to change or conceal their identity or unidentified deceased persons. The classified system of finger impressions enables computerized searches to be made for comparisons between fingerprints found at scenes of crime and those of convicted criminals.

Forensic Science Service. Laboratories are situated at strategic locations and each serves several constabularies. Since the Second World War remarkable progress has been made in the many disciplines of forensic science and the quality of examination and analysis produced in evidence to the criminal courts is internationally acclaimed. The service now has agency status and supplies its expertise and products on a commercial basis.

Police National Computer (PNC). During its twenty years' existence PNC has revolutionized the retrieval of information by operational police officers. It is possible to check the credentials

of any person or their motor vehicle within seconds of their being apprehended. Radio contact between officers on the streets and controllers at the large police stations allows for consultation of PNC by means of directly linked terminals, and provides almost immediate clarification of information.

Information contained within the system is personal, confidential and therefore highly sensitive. Strict security measures exist to protect source material, which is constantly updated by police control rooms, NIB and the Driver and Vehicle Licensing Centre (DVLC). Continual verification of the accuracy of the database is necessary, as obsolete records may lead to wrongful arrests or illegal seizure of property.

PNC contains a number of indices. Vehicle Index stores the registration mark and description of all registered motor vehicles in England, Wales and Scotland. Sub-indices list those that have been reported stolen or suspected of being engaged in criminal activity. Details of engine and chassis numbers are also available, and may be cross-matched to registration marks and descriptions to identify those which may have been altered or cannibalized.

Other sections of PNC store names and particulars of all persons convicted of crime or disqualified from driving motor vehicles, wanted criminals, missing persons, escaped prisoners, parolees and absentees from the armed services.

One problem that PNC has been unable to resolve is the cross-matching of property reported stolen with that recovered from thieves. The huge volume of such property in circulation at any one time and the inadequacy of descriptions supplied by victims make this an almost impossible task. The PNC property index is therefore limited to items of high value, like antiques and works of art. Identification of the majority of remaining items depends largely on local and regional indices, which often lack precise information, too. Consequently, collections of recovered property are increasingly advertised in the media or publicly exhibited in the hope that owners may recognize their possessions.

The importance of PNC cannot be over-emphasized. It allows instant communication between forces and provides a broadcast facility whereby urgent information may be simultaneously circulated to every constabulary in the country. A search and analysis function makes it possible to refine raw information into data that can be used to advance operational investigations. The database will provide possible matches to any personal description for which it is programmed to search and can supply

specific information relating to motor vehicles. The system's usefulness depends entirely on the quality of information upon which a search is based. For example, if a car involved in crime is described only by its marque and colour, the output is likely to be a list of several thousand registered owners of identical vehicles. If, however, further enquiries produce a witness who is able to supply part of the registration mark, the computer may be able to reduce the list to several hundred. It is then a matter for the officer in charge to decide if the crime is serious enough to warrant expenditure on a costly elimination exercise to find the suspect vehicle.

Investigators often discuss the evidence and information in particular cases with PNC managers, who can give advice on searches most likely to be productive. For example, if the detective has sightings of a vehicle involved in crime that he can link to similar offences in other areas the search parameters can be restricted to the known and adjoining geographical areas by using the post-code system. In the case of a partially described vehicle the number of targets will be limited to a more manageable number.

Force Structure

The duty of a chief constable effectively to organize and deploy his resources for the needs of his area inevitably produces variety in the structure of forces. However, the majority conform to a basic framework of command responsibilities, and only the Metropolitan Police (MPD) should be considered as a special case because of its unique size, scale of operation and particular national accountability.

New Scotland Yard (NSY) and the telephone number, Whitehall 1212, are synonymous throughout the world with the best traditions of policing. The original headquarters was named after a street running along the rear of small offices in Whitehall Place, and it was given preference over the proper address by officers who worked in the building. The name stuck and has since been transferred to successive locations as the organization grew and larger premises became necessary.

Since its inception the 'Met' has enjoyed distinct advantages over provincial constabularies. It has reaped the benefits of consistently policing the same geographical area, with only minor additions as Greater London has expanded. The home secretary, as the authority responsible, has provided a

continuity that has left the force free from the power struggles suffered elsewhere. These stabilizing factors have allowed the MPD to mature and develop an identity, tradition and skill. It soon established itself as the focal point of policing – an organization to which all other forces looked for advice and assistance.

Half-a-million urbanized acres and over 7 million people require the policing services of 28,000 officers and 11,000 support staff. The strength represents almost a quarter of the total police establishment in England and Wales. In former times centralized operational and administrative functions accounted for several thousand officers within the New Scotland Yard complex, but these numbers have been considerably reduced by civilianization and redeployment programmes. The headquarters function is now limited to the strategic planning and resource responsibilities of the commissioner and his deputy, and two departments, each headed by an assistant commissioner.

The Inspection and Review Department monitors performance, investigates allegations of police malpractice and has overall responsibility for research, planning, analysis and public relations.

The Specialist Operations Department co-ordinates a national response to organized international crime and supplies specialist detectives for serious offences committed on territorial divisions within the MPD. Senior officers are temporarily seconded to Commonwealth, and occasionally foreign, police agencies to conduct difficult inquiries needing expert detective experience. Several sub-branches have been established to deal with the particular problems of policing London. These include the Flying Squad, Criminal Intelligence Section, Company Fraud Branch (operated jointly with the City of London force), Counterfeit Currency, Stolen Vehicles and Extradition squads.

Special Branch was originally established to co-ordinate operations against the Fenian movement in 1884. During the early years of the twentieth century it gradually became responsible for collating all police intelligence material linked to national security. Its efforts are directed against all subversive groups and it works closely alongside the Anti-terrorist Squad and government security services. Since October 1992 the work of gathering intelligence about the IRA has, somewhat controversially, been transferred to MI5, since when several spectacularly successful operations have been mounted against terrorism on the United Kingdom mainland.

The threat of terrorism and other extremist activity necessitates the protection of high-risk individuals and property – work that is a significant drain on resources. Royalty Protection, Royal Palaces and Diplomatic Protection branches are sensitive areas of policing, calling for particularly well trained officers. The capital is the focal point for national ceremonial occasions as well as public demonstrations, both of which demand considerable management expertise in tactical deployment of manpower.

The territorial command structure of the MPD reflects the greater burden of responsibility imposed on supervisory officers compared to their provincial counterparts. The force is divided into five areas, each under the command of an assistant commissioner. They are assisted by officers holding ranks unique to the MPD – deputy assistant commissioners (DAC) and commanders. The areas are further divided into territorial divisions led by superintendents – many of these have more police and civilian staff than some provincial forces. The divisional units are the direct link with the community and operate the primary functions of policing, supported by specialist departments when necessary.

Police Strategy

Ideally ground-level policing in any constabulary should concentrate on a system of uniformed preventive patrols around the clock. Unfortunately the demand for police services no longer allows this situation to prevail consistently; forces are obliged to adopt a more reactive approach that does not always satisfy the public demand for community policing. Because police commitments are rescheduled regularly and priorities vary continually it is difficult to describe a typical divisional structure.

Effective policing attempts to reduce three essential causes of disruption to public tranquillity: criminal activity, disturbance of the peace and misuse of motor vehicles. None of these aims is achievable without an intimate knowledge of the given territory and the people who live within it. In the past the continuous presence of a constable patrolling fixed beats provided security for residents and largely maintained equanimity. More recently increased mobility and developing technology have triggered changes to such traditional methods, none of which appear to have satisfied public opinion. In an attempt to regain that

confidence tried and tested methods of community policing are being re-established, forging closer links between police officers and members of the public. However, in order successfully to combat escalating crime, public order and traffic problems, it is essential that community constables are supported by specialist departments.

Responsibility in contemporary policing is divided in terms of geography and personnel. Police ranks have always denoted function – inspecting and superintending – and their mandate has been allied to a set area: division, sub-division or section. Front-line supervisors of a group of officers, for example, are nominated sergeants. There are, of course, variations to the basic structure. In urban areas inspectors supervise groups of sergeants and constables on a shift system, while their rural peers will often command sections of officers as required throughout the 24-hour period. An intermediate rank of chief inspector is created as deputy to a superintendent or to assume responsibility for specialist sections of a force.

Provincial police forces are led by chief constables, supported by an assistant chief constable (designated officer) who deputizes during absence and has specific responsibility for disciplinary matters. The number of additional assistant chief constables depends on the size of the force. A small rural constabulary will have one or two who define administrative and operational management policy. Larger constabularies may designate as many as seven, each overseeing a section of the organization: crime, traffic, personnel, support services, administration, operations, inspectorate.

Territorial divisions are common to all constabularies, but the level of command varies according to a variety of factors: acreage, population, crime rates or particular community problems. At street level there are innumerable variations to policing patterns. The normal daily period of duty is eight hours on a rotating shift system. A team will be divided into foot and motorized patrols, each designated a specific geographical area. In an emergency, support is provided by fast-response vehicles, some carrying firearms. Specialist assistance is available from traffic patrols, public order squads or detectives. Each division maintains its own intelligence system co-ordinated by a collator, who compiles intelligence packages to assist in planning local initiatives. He also acts as a filter for information relating to criminals whose activities extend to other areas and who may be of interest to the central intelligence bureau. While all officers are expected to contribute regularly to the collator's indices,

most such work is carried out by full-time field intelligence officers.

Standard shift patterns can differ in rural areas or city suburbs, in that chosen constables are allocated a district to patrol on a discretionary basis. Variously known as rural-beat, residential or community constables, these officers are at the forefront in establishing relationships with the public.

Spontaneous and unforeseen occurrences call for continual re-evaluation of policy and deployment. Day-to-day commitments are influenced by several factors: commission of major crime, serious accidents, natural disasters, community problems and public disorder.

The public expectation of police commitment is often at odds with a senior officer's perception of priorities – a dichotomy that is rarely easily solved. Ordinarily people are personally unaffected by crime and disturbance, but are more concerned with minor nuisances that affect the smooth running of their lives. To the police manager these may appear to be trifles compared with escalating crime, traffic congestion and riotous behaviour. While he will try to balance all demands, this difference in perception almost always has the deepest effect upon the constables, who are at the receiving end of every victim's frustrations. One moment he is treated as uniformed social worker, the next called upon to suppress criminal or anti-social behaviour. It is not an enviable task at a time when authority is openly challenged and police action continually subjected to media and public examination.

The office of constable, a citizen granted unique powers under the Crown, demands virtues not expected of an ordinary person. These expectations are cogently expressed in two public statements from different periods; they both emphasize the need for versatility in performing daily duties:

There is no comparison between what is expected of a policeman today and the policeman of old. Our predecessors were invariably big, illiterate men, from whom little was expected. Nowadays a policeman must be as brave as a lion, as patient as Job, as wise as Solomon, as cunning as a fox, have the manners of Chesterfield, the optimism of Mark Tapley, must be learned in criminal law and local bye-laws, must be of strong moral character, able to resist all temptations, be prepared to act as doctor, be a support to the weak and infirm, a terror to evil doers, a

friend and counsellor to all classes of the community and a walking encyclopedia.
(*Committee on the Police Service: Minutes of Evidence, Cmd 874, 1920*)

The purpose of the Police Service is to uphold the law fairly and firmly: to prevent crime; to pursue and bring to justice those who break the law; to keep the Queen's Peace; to protect, help and reassure the community; to be seen to do all this with integrity, common sense and sound judgment.

... we must be compassionate, courteous and patient, acting without fear and favour or prejudice to the rights of others. We need to be professional, calm and restrained in the face of violence and apply only that force which is necessary to accomplish our lawful duty.

We must strive to reduce the fears of the public and, so far as we can, to reflect their priorities in the action we take. We must respond to well-founded criticism with a willingness to change.
(*Association of Chief Police Officers: Statement of Common Purpose, 1990*)

In rising to these challenges a constable must accept that he alone bears the responsibility for unwarranted use of his extensive powers – a position unparalleled among subordinates in any other profession.

3 Recruitment – Training – Promotion

The deliberate policy of recruiting 'ordinary' men to the police service during its formative years determined that it became, and has largely remained, a calling of the working class. For many years this strategy impeded the development of a cadre of high-calibre junior leaders on which a sound management structure could be established. Instead it became accepted practice to appoint chief officers from other professions.

The social and educational standards of the rank and file fostered attitudes which became entrenched in a police culture, and still remain a stumbling block to radical change. Contrary to the original intention that the police would be a democratic force reflecting society's norms, it quickly developed along quasi-militaristic lines, with rigid working practices, strict disciplinary controls, and a system of reward based solely upon a set rank structure. This was hardly surprising given most chief constables were retired military officers with no formal police training, who often held office for decades and were more intent on maintaining their social position than kickstarting progress.

The reputation and effectiveness of the police service was traditionally perceived to depend on the core value of experience at constable level. This engendered the view that any aspirant to higher rank must begin his career working a traditional beat before being qualified for better things. Given the harsh realities of service at ground level it was inevitable that the police initially failed to attract educated, ambitious men of vision.

The abysmal lack of leadership and poor quality of policing were generally appreciated by the early years of this century, but decades passed before much was done to alter the situation. Meanwhile constables became public figures of fun and detectives, even those emanating from New Scotland Yard,

were depicted as bunglers, who, in the eyes of contemporary crime writers, needed assistance from intellectual civilians to solve complicated crimes. Poor organization, coupled with insufficient resources, explain why the service had come to such a pretty pass. Moreover, the absence of traditional values in a newly formed service meant that more emphasis was placed on establishing a position in society than on insisting on quality in its workforce and a sound hierarchy.

It is ironic that although national security ranks alongside defence and economic stability as the three most important governmental responsibilities, the former was consistently neglected while higher academic and intellectual achievers were actively directed towards military and civil service. Only in the past fifty years have steps been taken to redress the balance.

Lord Trenchard became commissioner of the Metropolitan Police in 1932 and was concerned by the lack of effective leadership. In response he established the Hendon Police College to train future leaders, originally intending that the entrants would be directly recruited into junior management positions as sub-inspectors. Resolute hostility met his plans to create an officer class, and he was forced eventually to limit his direct entry to between six and twelve recruits each year. The remaining students were selected from within the ranks of the Metropolitan Police, and eventually provincial officers were allowed to compete for places. The timing was fortuitous in that during the Depression many graduates and other high-quality recruits turned to the police service as a career. In all 197 students undertook the two-year course and to a large extent spearheaded police leadership in the years after the Second World War. From this pool of excellence many chief constables were appointed.

The Hendon experiment, abandoned shortly after the outbreak of war, was never reintroduced and in the post-war period egalitarian attitudes prevailed. Its graduates, while making an immeasurable contribution to police management, were never accepted as true policemen by the rank and file, and as they retired it was soon appreciated that few equally qualified men existed to replace them. Once again the force found itself in a leadership crisis.

The Police College, now the National Police Staff College, was established in 1948 to provide vocational and academic training for selected officers from all constabularies. Although the college provided a few short-duration courses for senior officers, its efforts were mainly directed towards sergeants who were

regarded as suitable material for promotion to inspector. Thereafter the vast majority of its graduates received little formal training, no matter what rank they eventually achieved. The situation today is very different: in the last thirty years a nationally co-ordinated system of training has been established for all from the raw recruit, through the various specialist departments, to the highest echelons.

Recruitment

Many restrictions formerly placed upon police recruitment have now disappeared. No height, age or gender qualification applies and there exists a genuine desire to recruit from all ethnic groups, although the results among the black community are disappointing and the situation is not aided by allegations of internal racism, however unfounded the majority of these may be. Educational standards are tested by an entrance examination, but formal qualifications are not required; of greater interest is the applicant's vocational aptitude and attitudes towards the enforcement of law in a diverse and complex society. The only absolute disqualification to enrolment is the possession of a criminal record (although youthful peccadilloes may be overlooked), or a poor medical history. At a time of high unemployment the police service always benefits from the pool of high-quality recruits in the labour market and competition for vacancies is extremely keen. In these circumstances, the aspirant who offers educational qualifications alone is at a disadvantage against a similar competitor with managerial or professional skills, voluntary service in the community or experience in the armed services.

The old processes of recruitment, consisting of educational examination, medical check-up and formal interview, have been almost universally replaced. Today a peer group of experienced constables evaluate the applicants' performance through an extensive series of exercises and make recommendations as to their suitability for appointment. This practice has proved effective in reducing the high drop-out rate of police recruits during early years of service.

Training

Today's police recruit reaps the reward of recent enlightened

and imaginative developments in communication skills and instruction. Gone are the days when endless definitions of statutory offences were learnt by rote. Instead a hands-on practical approach, combined with emphasis on the social skills of policing, has turned out constables far better equipped to communicate with people today. Previous basic training courses, with a military flavour, trained recruits only in rudimentary skills before letting them loose on an unsuspecting public. Their successors spend the best part of a year undergoing formal instruction and practical patrol work under the supervision of an experienced mentor. Only after two years' satisfactory assessment and self-appraisal will the aspirant be permanently accepted as a constable. At any time the probationer may be summarily dismissed if he fails to reach or maintain the standards.

A long period of assessment is necessary to confirm that the recruit has the necessary aptitude to spend the rest of his working life in a sometimes unpopular and often unpleasant job. Most successful entrants remain constables through their careers, performing tasks that the majority of their peers would avoid: controlling drunks, handling dead bodies, dealing with the gore of road accidents, defending innocents from deviants, sorting out family squabbles and, on occasion, having the physical strength and courage to resist violence. It is a popular misconception that the police service attracts people whose psychological profile is far removed from the norm. In fact police recruits are drawn from a variety of backgrounds and very few have idealistic reasons for joining; security of employment and retirement benefits are still the main attractions. Those who seek to change that ethos would do well to reflect on the likely consequences of discouraging a minority who volunteer to perform society's dirty work.

Having successfully completed the probationary period a fully fledged constable will perform the primary-line function of routine patrol and response to incidents, until selected either for specialist work or promotion to higher rank. All specialist arms of the service and supervisory functions are intended to support patrol constables, who are the first line of contact with the general public.

Individual expertise will always be required in any constabulary. Rural forces with relatively low crime rates have less need of specialist crime or public-order squads than inner city areas, whereas a rural force bisected by a busy motorway will have greater need of traffic specialists, vehicle examiners

and response drivers. To equip the specialist or supervisor for his role, police training beyond basic levels is roughly divided into two concepts: skill and command.

Skill training, often conducted on a regional basis, embraces the diversity of specialisms required of a modern police service: high-speed mobile patrol driving; empathy between man and dog or man and horse; co-ordination and the precision of effort required by riot squads; the inquisitive, analytical approach of the detective. All specialist training has been developed to a level of excellence seldom matched in other areas of public or private enterprise. But it is in one particular area that police training has been forced to provide a higher degree of control and accountability than any other: the use of firearms.

The image of the unarmed British bobby is one that the majority of police and public would wish to retain. Unfortunately this is difficult to sustain as the criminal use of firearms is on the increase in most parts of the United Kingdom. The manner in which police react to the problem is designed to maintain public confidence in forces of law and order while not detracting from the popular belief in the existence of an unarmed civilian force. To this end the issue of firearms is a strictly controlled responsibility vested in a small cadre of highly trained officers under written rules of engagement. Past experiences have taught the police service that in an open democracy, nothing it does escapes scrutiny, particularly if the liberty, safety or life of a citizen is involved. Because individual police officers are responsible by law for their own actions, the rules governing the use of firearms recognize that particular vulnerability and seek to safeguard against tragic accidents. Decisions to issue arms are normally vested in the highest authority, the only exception being immediate response to an emergency situation by an armed vehicle's crew. Firearms are only resorted to when all other means of resolving the situation have been considered and when a risk remains of death or very serious injury.

Authorized firearms officers are selected from volunteers only after rigorous psychological and physical testing. This is followed by intensive training at a regional firearms training centre. The officers' fitness to remain 'authorized shots' is reassessed annually and depends on maintenance of mental attitude, physical fitness as well as satisfactory performance with various types of weapon in realistically simulated scenarios.

Firearms incidents occur infrequently in most areas and thus

firearms officers perform their normal duties on a stand-by basis. Where greater demand exists a designated squad is committed to respond, and it is becoming common practice to equip fast-response cars, manned by qualified personnel, with a secure arsenal to provide a response to emergencies. If the rise in the criminal use of firearms continues the number of mobile arsenals will inevitably increase and the command level of authorization will need to be reassessed.

An organized and detailed action plan is called for if it is anticipated that weapons will be discharged in a threatening situation. After every such occasion a thorough investigation is carried out, whether to advance the prosecution case or to justify the use of weapons by the police.

Command Training

> The cherished principle that leaders of the British police service should be found from within its own ranks was another honest attempt to present the image of a fair, egalitarian force. Unfortunately the quality of recruit attracted to the service meant that the proposition could not be fully accepted as a matter of practice until after the Second World War. Until then, there had been much comment about the dearth of educationally qualified police officers without much effort to remedy the situation: in the popular imagination it was a service which had little interest in attracting brains.
>
> (*Taverne Report*, page 25, 1967)

At a time when many of the 'Trenchard scheme' chief constables were approaching retirement, it was appreciated that radical measures would be necessary if the principle of internal promotion to the highest rank was to be retained. These included enhanced promotion prospects for younger officers, encouragement for transfers of experienced senior officers between forces and positive action to improve the educational profile of the service. Nothing could be achieved without some compromise between traditional principles and the need for a system to encourage the better educated, particularly graduates, to consider policing as a worthwhile career. Graduate entry schemes offering rapid promotion, scholarship awards and serving officers studying in their own time – all have contributed to an immense improvement: the police service can

now boast a complement of more than 7,000 graduates compared to 200 in 1970.

Self-sufficiency at command level has been sustained by a progressive system of training at the National Police Staff College. A national director of police training is primarily responsible for pushing forward developments that will attract suitable applicants from all forces in England and Wales. After a rigorous and extended selection process a candidate can now graduate from the Accelerated Promotion Course and achieve the rank of inspector after five years' service. Further selective command courses allow the most able to progress rapidly through intermediate ranks and achieve the highest levels at an early stage of service while they still have much to offer. It is now mandatory that all aspirants to the ranks of assistant, deputy and chief constable should have progressed through the Senior Leadership Development Programme, and it is a further significant feature that over 40 per cent of all members of these executive ranks hold university degrees.

General Promotion

Most intermediate supervisory ranks are still attained via the traditional channels of experience, examination and internal selection. The ordeal of extensive written examination has recently been superseded by objective testing and practical assessment for both sergeants and inspectors. Ordinary candidates from these ranks achieve promotion through a process of continual assessment: do they have the ability to assume responsibility for the higher operational functions of superintending?

The Detective Officer

To be a detective, romantically portrayed in books and television as the elite of the police service, is the ambition of many new entrants. Not every recruit is temperamentally suited to crime investigation, and even those who are finally selected quickly realize that the popular image bears little resemblance to reality. The cut and thrust of the fifty-minute episode loses its lustre in the mind-crushing routine of mundane crime inquiries, endless paperwork and continual contact with society's misfits. The only consolation for the embryo detective will be the occasional

expression of gratitude from a victim who has sought help, a word of encouragement from a senior officer and the anticipation of headier times once a long period of training and apprenticeship has been served.

The detective's main function is to provide specialist support to uniform patrol officers, who are, generally speaking, the first to react to calls for assistance. For this reason it has always been assumed that detectives must be recruited from the uniformed ranks, in order to be instinctively aware of the kind of support required by their colleagues. Such a system provides ample opportunity for supervisors to assess the potential of applicants before sending them on an expensive selection and training programme.

Potential candidates for the Criminal Investigation Department (CID) initially identify themselves by traits of personality and effectiveness of performance. They must be self-confident and assured; have an inquisitive nature and imagination; display determination to the point of obstinacy; possess intelligence and energy to match the wiliest adversary. The selection process begins with probationary training, during which the recruit is seconded to a detective department. Those who are earmarked as likely candidates will eventually be attached to the department for an extended period as aide to an experienced detective. This is a useful period of assessment on both sides. Many aspirants who have dreamed of becoming detectives become disenchanted, while others are rejected without any stigma if regarded as unsuitable.

A trained detective must always retain enthusiasm for the job in hand, develop good powers of observation and expression, possess the ability to communicate at all levels with enough self-confidence to reassure those he seeks to assist and assert authority over those he pursues. He must perform these tasks in plain clothes, without the psychological protection provided by a uniform, and will be judged by his powers of detailed analysis, rather than how effective he is in physical confrontation. Further desirable attributes are above-average intelligence, a good memory and specialized knowledge of the criminal law. Above all he must be able to work as an individual, with honesty and integrity, while at any given time be prepared to act as part of a team on major operations.

When accepted into the CID a detective does not necessarily expect to serve within the department for the rest of his working life. Many will do so, but interchange of experience between police departments is now replacing the former system of career

specialization. It is common practice for detectives, on being promoted, to transfer to other duties, returning to their specialism when they have had the opportunity to pass on their particular skills, while at the same time absorbing other aspects of the police role.

Training

Dedicated training courses of up to three months' duration are attended by junior detectives at regional detective training schools. The standardized syllabus is comprehensive and instruction is given in both law and procedure. At the conclusion of the initial course an officer will be well versed in the detail of the criminal lexicon, the factors essential in proving individual cases, procedures involved in the collection of evidence and the processes required in dealing with crime suspects. He will be conversant with the complete mechanics of a criminal investigation, from the time an offence is reported to its final disposal at court.

Throughout his time in the department a detective will attend a variety of courses designed to update his general investigative abilities or provide further training in one of the many support specialisms. Supervisory ranks can avail themselves of senior and advanced training. The summit of detective training is at command level, when the most senior detectives and assistant chief constables learn the necessary skills for controlling the vast machinery of major crime investigation, which may cover the resources of several constabularies.

CID Structure

The responsibility for criminal investigation in most police areas is split between operational divisional commanders and a support group at constabulary headquarters. The rationale behind this practice is that the bulk of offences are committed by local criminals, and therefore more effectively controlled by detectives who have intimate knowledge of the area and good local sources of information. Serious and serial crime, more likely to be committed by travelling criminals, require the additional skills of centrally based specialist units. Additionally, the most serious incidents require the sagacity of a dedicated team, led by the most experienced detectives available to the force.

Each area of the Metropolitan Police is staffed by a detective department capable of dealing with the majority of crime committed within its boundaries. Problems that affect more than one area or the force as a whole receive the additional support of appropriate units from the specialist operations department.

Some larger urban forces designate an assistant chief constable as the head of all crime-fighting functions, but in the majority of constabularies those duties are undertaken by a detective superintendent, whose designation is 'Head of the Criminal Investigation Department'.

Hierarchy within the detective department is identical to other branches of the service, although the rank title is normally prefixed by 'Detective'.

The Head of CID is answerable for the investigative strategy adopted towards all crime committed within the force area; he is responsible, in particular, for mobilizing support groups and co-ordinating the most complex inquiries, such as murder, organized robbery, serial rape and large-scale frauds. He also originates policy and tactical plans for combating emerging crime issues. To enable him to carry out these various functions he is supported by several groups of detectives and civilian staff. These sub-units specialize in particular fields, including fraud, robbery, drugs, fingerprints, photography, anti-terrorism, SOCO – scientific aids – scientific support, criminal intelligence, special branch, child protection and domestic violence. The size of each unit is dictated by available workload and varies considerably between forces.

The senior detective officer of each division is either a superintendent or chief inspector, depending upon the size of the workforce and the annual crime load. The post entails divided loyalties. His first duty is to enforce the crime strategy of the local commander, but he is also required to monitor the overall policies emanating from headquarters, to which he must also justify his tactical use of resources.

Divisions are organized on the basis of topography and density of population, but the basic detective grouping will be split into two or more operational units at sub-divisional police stations. Each will consist of a number of constables and sergeants, the complete group being supervised by a detective inspector. The severity of a crime dictates the level at which it will be investigated: junior detectives are expected to cut their teeth on mundane thefts, burglaries and assaults, but will be called upon to assist their seniors in cases of robbery, rape, homicide and other more serious issues.

In cases requiring an intensive, co-ordinated approach, a team will be employed and use made of whatever specialist units are required. The supervising officer's function is to ensure that each inquiry is carried out in a logical, sequential manner and that it is curtailed when further progress is unlikely.

Ancillary Support

Detectives should never be reluctant to welcome advice and assistance from experts in any field of knowledge to further their quest for solutions. Basic patterns of criminality are often stereotyped, but many are so unusual that even the most experienced detective frequently grapples with a set of circumstances that he has never encountered before. Because of these variations, and the ingenuity of the brightest criminals it is impossible for the service to provide for all eventualities within its own organization.

The Forensic Science Service is an example of such assistance, and although it employs scientists of diverse disciplines, it too is sometimes presented with situations which it lacks the facilities to explore. In such a case the detective and scientist will seek help from other public or private institutions. It may be that a deposit left within a skidmark requires analysis by a tyre manufacturer to suggest a type or make; or an explosive substance, never before encountered, requires the highly sophisticated equipment of a government research establishment to determine its composition.

It is from medical science that a detective most frequently seeks assistance. At a junior level he will ask a police surgeon to examine assault victims and describe injuries. These doctors are usually general practitioners who receive an annual retainer in exchange for their availability and are paid on a case-by-case basis. They receive only limited additional training in clinical matters, but more importantly are instructed on the collection and preparation of evidence prior to trial.

The evidence of forensic physicians is often crucial in cases of sexual assault, an area recognized as one of the most difficult in medicine. Police surgeons will be asked to corroborate penetration in offences of rape and unlawful sexual intercourse, or provide opinions on the likely truth of allegations in the absence of physical evidence. They may also be expected to compare injuries sustained by a victim with other available evidence to test the fidelity of a victim's or witness's recollections.

Specialist branches of the medical profession are called upon to give advice in difficult cases; most commonly those involving death, when the services of a Home Office-appointed pathologist are necessary. These highly qualified practitioners have specialized in forensic matters for some years. Generally they are employed in hospital pathology departments, but increasingly dedicated pathologists are establishing private services devoted entirely to criminal work, both for prosecution and defence.

The fundamental question the pathologist will be asked to determine at the scene of a death is whether the incident came about by accident, suicide or homicide. In some cases the answer is all too obvious, even to the lay observer; but in others, where debris, blood and any number of other diversions can easily lead to misinterpretation, only an expert can be expected to provide an authoritative opinion. An example would be the discovery of an elderly female's body on the floor of a living room. A head wound and pool of blood obviously give rise to some suspicion, which is further justified by additional blood marks on walls and furniture. Although there is no sign of forced entry and nothing appears to be missing, the first police officer to arrive, and a police surgeon called to certify death, will be reluctant to speculate about a cause without further advice. An examination of the body *in situ* and subsequent autopsy establish that the woman met a natural death, caused by massive brain haemorrhage. The external injuries and gore were only the effects of violent movement when she was *in extremis*. On occasions a pathologist will need to confer with other experts to establish a cause or unravel a perplexing set of circumstances. A number of knife wounds to the heart may sensibly force the conclusion of almost instantaneous death, but the body may lie some distance from where the attack took place. A cardiac surgeon experienced in the effects of stab injuries to the heart will be a better person to judge their incapacitating effects than a practitioner who only examines the dead.

Case Study: A Firearms Incident

In the early hours of the morning a shrill scream awakens some residents in a quiet suburban street. Shouts and loud banging follow from the direction of an elderly couple's house. It is common knowledge that their daughter and infant grandchild have recently returned to live with them and gossip has it that the young mother lives in fear of violence from the psychologically disturbed father of the child.

Within seconds the young woman flees the house to an adjoining property, blood pouring from her head on to a flimsy nightdress.

Hysterically she blurts out a story of being disturbed by breaking glass and finding her former boyfriend in the entrance hall with a knife in one hand and a gun in the other. He stated his intention of taking the child to his parents and as she tried to prevent him climbing the stairs he slashed her across the face with the knife. His path was then obstructed by her father, who received a stab wound in the chest from which, she believes, he must be dead. Before leaving she saw the assailant leap over her father's prostrate form and run towards the baby's room. Threats to kill her mother, at that time standing in a bedroom doorway, rang in the young girl's ears as she ran to safety.

Any doubts about the authenticity of the intruder's weaponry are quickly dispelled when a young patrol constable arrives and parks his car some distance from the house. He has been dispatched in response to a '999' call and has been told to exercise caution as a suspect may be armed. Any doubts he may have are quashed when a shot rings out as he opens the car door and hears the ominous swish as a bullet passes overhead and thuds into a nearby wall. Putting the engine block between himself and the house, he peeps over the bonnet and sees two figures outlined in a lighted window: a female secured around the neck by the arm of a less distinct figure standing behind. He is unable to hear what the man is shouting but he is in no need of exact words to interpret them as threats.

The constable is fortunate that he belongs to a constabulary that operates a 24-hour system of armed response vehicles. His radio call for assistance is quickly answered as ambulances and senior police officers are also directed to the area.

When the mobile armoury arrives the two-man crew make a brief reconnaissance of the situation and assess the risk of further serious injury as being extremely high. On their own initiative they break open the weapon safe and arm themselves, a decision that will be ratified later by an assistant chief constable. The firearms officers on the ground must, at this stage, adopt a policy of containment and avoid an aggressive response at all costs. At any time during the operation it is the armed officer's personal decision as to when he pulls the trigger, but rules of engagement have been constantly drilled into him throughout training. Weapons may only be discharged when there are grounds to believe that the officer's life, or that of any other person, is in immediate danger, or that the commission of a serious crime is threatened. This may mean not only a threat of murder, but offences such as rape, robbery, grievous bodily harm, explosions or arson, when there is no other safe means of apprehending an attacker.

The two constables arm themselves well out of sight of the suspect and approach the house from different directions to enable them to cover each side of the property. As they do so a local police inspector with a

loud-hailer creeps along a wall shielding him from the premises in an effort to establish contact with someone in the house. His efforts are rewarded only by further threats, so he quickly withdraws. His assessment of the suspect's unpredictability is confirmed when the latter brandishes an authentic looking service-type revolver and points it at the temple of his victim.

The initial information stimulated immediate and well-ordered activity in other reaches of the force. The assistant chief constable answered the telephone call at his home some forty miles away and confirmed the authority to deploy arms. After a briefing about the current situation and an assurance that a firearms incident controller has already been alerted, he gives instructions for the mobilization of a tactical firearms unit. From the beginning of the operation every decision and action will be recorded on a computerized running-log and all voice communication taped.

The firearms unit is available for duty on a call-out rota, its members being on trust not to consume alcohol for twenty-four hours before a period of stand-by commences. Throughout operations they are supervised by similarly trained senior officers. Every live firearms situation is carried out under the direction of a firearms incident controller, who holds the rank of superintendent or chief inspector. He will have successfully completed courses of instruction in strategy and tactics. As he may be a stranger to the area in which an incident occurs, he will need to establish a close rapport with the ground commander whose ultimate decision it will be to storm the premises. To this end, a tactical plan is devised for approval by the assistant chief constable before any move is made towards rapid intervention that might jeopardize the safety of police officers or innocent civilians.

During the time it takes to marshal the special forces there is intense but unobtrusive activity around the house. A doctor and ambulance worker attend to the injured woman and she is taken to hospital accompanied by a female officer. As her condition allows, she will be debriefed for every trifle of information she can provide about the assailant and layout of the house. Other officers rouse residents in close proximity and evacuate them to safer premises. The police inspector with the loud-hailer is replaced by an experienced negotiator who attempts to make contact with the house by telephone. If necessary, surveillance experts are on hand to install new lines of communication between the police control point and the premises.

Because there is already clear evidence of crime and a suspicion that someone lies mortally wounded inside the house, a senior detective begins to assemble a team of investigators and scientific personnel to conduct a criminal inquiry. It will also be his immediate priority to confirm the identity of the suspect and update the negotiator and

controller with as much information about him as possible.

Within an hour the negotiator has established voice contact but is given little reassurance that matters will not escalate towards further tragedy. He uses all his powers of persuasion to calm the situation while not offering any promises or inducements that he knows he will be unable to keep. In the early stages he tries to gain confidence and rewards continued conversation with supplies of food, drink and cigarettes. He is now aware that the man has a history of unpredictable violence and has recently been released from a hospital. Arrangements are set in motion for his psychiatrist to attend and provide advice on how he should be approached.

Several hours pass by. Firearms officers are strategically deployed to contain the man within the house. He is persuaded to report on the condition of the elderly man and confirms that he is still alive. It is also established that no harm has befallen the infant or his grandmother. For this information the gunman is rewarded with more comforts – the priority is now to provide medical attention for the injured father, and the negotiator is advised by psychologists on the best way to appeal to the man's conscience. Eventually he sees reason and allows unarmed volunteers, closely covered by concealed armed personnel, to enter the house and recover the victim. With that immediate problem resolved the operation enters a new phase. Providing no harm is likely to befall the innocent parties in the house, the ensuing period could last for some considerable time and there will be no pressure to bring it to a precipitate end. It does not matter what scale of disruption is caused to ordinary life; the key benchmark of success is the avoidance of further violence, including the need to use police fire-power.

At regular intervals police personnel are relieved in order to maintain the state of alertness; no one can survive without sleep indefinitely and tiredness does dull the senses. For a hostage-taker, it is the realization of these irreducible facts that often causes apprehension and increased instability. It is a time that tests his resolve to carry out threats or submit to inevitable slumber with the certainty of capture. For the same reasons, it is the most testing time for the negotiator and his patient colleagues. Unfortunately, in this case, such considerations would never be at issue.

The man's mental condition rapidly deteriorates and the negotiator is the first to be aware of the situation. Marksmen surrounding the house are warned by the ground commander that the hostages appear to be in increasing danger. They are all conversant with the tactical plan that has been approved by the assistant chief constable and there is an air of tension among all those engaged in the operation – adrenalin levels are at high pitch.

While urgent consideration is given to put the plans into effect the

front door of the house bursts open and an elderly female clutching a child rushes along the garden path. As she does so, the gunman is seen silhouetted in the doorway: he aims his revolver at the retreating female, but before he can pull the trigger a single shot rings out from behind a low wall on the opposite side of the road. He falls to the ground and is rapidly surrounded by policemen who secure his weapon and summon medical assistance. Equally quickly, the hostages are enveloped by helpers and their ordeal is over. For the police officers involved in the operation – particularly the individual who fired his weapon – it has only just begun.

The discharge of firearms by the British police is always subjected to stringent examination. Where death or injury is involved, or there are other allegations such as racism, recklessness or criminality, the chief constable is obliged to refer the matter to the Police Complaints Authority (PCA). When the death of a member of the public is involved, responsibility for the investigation will be removed from the host constabulary as a matter of course and deputed to an assistant chief constable from another force. He will conduct his inquiry under the direction of a member of the PCA who is required to issue a certificate of satisfaction stating that all necessary avenues have been pursued. The investigation report is then considered by the director of public prosecutions to decide whether criminal charges should be laid against any police officer. It is a stressful process for all concerned and usually takes many months to complete.

A PCA inquiry, which is concerned only with police accountability, obviously takes some time to set in motion. If the gunman survives he will inevitably face serious criminal charges: if he does not, the matter will just as thoroughly be examined by a coroner. In either event immediate action is required at the end of the siege to collect all available evidence before it is destroyed, contaminated or forgotten. These processes are overseen by a detective superintendent of the local force.

The first task of identifying the police marksman responsible for felling the gunman is simple when only one shot is fired. It is considerably more complicated when a number of weapons have been used simultaneously and repeatedly fired.

Police marksmen are trained to aim at the torso; they do not seek merely to disable an aggressor, and if the bullet accurately finds its mark not many targets survive. Throughout training and practical exercises it is drilled into marksmen that they are only justified in opening fire if they believe it is the only course of action to prevent serious harm befalling someone, either by way of direct injury or during the commission of a serious crime. He must also be satisfied that the person he needs to immobilize is so dangerous that he cannot be safely restrained without the use of a firearm. He can be reassured that he will

be protected by law if he acts with just cause: 'A person may use such force as is reasonable in the circumstances in the prevention of crime, or in the effecting and assisting in the lawful arrest of offenders or suspected offenders or of persons unlawfully at large.' (Section 3, Criminal Law Act, 1967).

However, no amount of training or guarantees of legal support can prepare the individual officer for the emotional distress that follows the ultimate act of taking life, particularly after the tension that accompanies a prolonged siege. The unfortunate officer who pulls the trigger will have adrenalin coursing through his veins at the time; but in most cases it will not be long before he suffers symptoms associated with post-traumatic stress disorder. These may take a considerable time to abate. But before he can receive counselling or other professional help he must subject himself to thorough examination and debriefing.

His weapon will be seized and sealed. Later a forensic science laboratory specializing in firearms will examine it, along with the slug from the bullet and the shell casing. The condition of the weapon is first assessed and its mechanical functions tested. Trigger sensitivity is measured to rule out any suggestion of accidental firing, and only then is the weapon test-fired. Striation marks on test shells, together with features of the firing pin and ejector mechanism, will be compared with those on the original projectile. Confirmation of matching characteristics by microscopic examination and photography provides positive identification of the weapon used.

Swabs impregnated with a chemical preservative are taken from the officer's hair, face and hands as soon as possible after the encounter, and his clothing is packaged and sealed. These exhibits are tested for firearm residue and provide a further match to the type of propellant in the discharged shell. Additional corroboration will be obtained from identical samples on the victim's clothing and skin surrounding the entry wound.

A thorough examination of the house will entail a full video and photographic record prior to a search for physical evidence and fingerprints. Damage to the building or its artefacts, recovery of blood, footprints, human tissue, discarded clothing and household items will all be plotted for comparison with witnesses' statements and allow the investigators to draw conclusions about the accuracy of their recollections, as well as providing corroborative evidence against the assailant. Assessments of scientific data are useful in enabling detectives to measure the accuracy of a witness's memory of events, particularly when it may have been distorted by panic and fear.

The innocent victims within the house will be subjected to a similarly detailed examination. Clothing, which may prove contact with the assailant, is removed; a medical inspection might identify injuries or

forceful handling. Surgeons treating the injured father will adduce evidence of the nature and effect of the knife wound. Indeed examination of such wounds may not only assist in identifying the type of weapon used, but also show the nature of assault. The width of incision may reveal the size and shape of blade, confirm whether it was inflicted by stabbing or slashing, and in the event of a precise wound, whether the weapon was single- or double-edged, a stiletto or flat-bladed shape. Probes into the wound determine the depth and cuts to hands and arms indicate that the victim tried to defend himself. All lacerations help to establish the relative positions of the parties involved in an altercation.

Numerous additional samples – of clothing, footwear, blood, hair, finger-nail scrapings, saliva – are taken to aid comparison. The analysis is time-consuming and carries on throughout the investigation as detectives question and record statements from anyone who knows about, or has been involved in, the incident.

If the eventual decision is that criminal charges are inappropriate, internal disciplinary proceedings must be considered, separately, not only against the marksman, but also anyone concerned with the police operation. Although this is also the prerogative of the PCA, the deputy chief constable of a force may pre-empt its decision by laying charges if he is in possession of sufficient evidence to do so. If proceedings are not instituted by the force but the PCA believes there is a case to answer, it has the power to insist on a hearing. In that event the accused officer will appear before a tribunal comprising two members nominated by the PCA and chaired by the officer's own chief constable or one from another force. When a guilty verdict would inevitably lead to serious consequences, such as dismissal or reduction in rank, the accused is entitled to legal representation. In less grave cases he may be accompanied simply by a fellow officer, there to speak on his behalf. Unless the punishment is minor, a system of appeal to the home secretary is available to any officer if he feels the verdict or the sentence is unjust.

In straightforward cases, where disciplinary or criminal charges do not apply, the events surrounding the gunman's death will be publicly examined by a coroner's court, whose only duty is to establish where, when and how the fatality occurred: it is specifically prohibited from apportioning blame. Verdicts available to an inquest are restricted to: unlawful killing, accident, suicide, natural causes, industrial disease, drug dependency and, where the evidence is insufficient to arrive at a conclusion, an open verdict.

4 Crime Investigation – General Policy

In general terms crime is either committed in confrontation or stealth. Official statistics, published annually, confirm the obvious – the police have far more chance of success against criminals who offend in the presence of victim or witness than they do with those who wait for an opportunity to strike against unguarded property. It is also a fact of life that serious crime stands a greater chance of detection than minor matters of routine or nuisance value.

These obvious truths underlie the principal management processes of a criminal investigation department: identification of suspects, and the allocation of resources to achieve that end. Victims of crime must often grapple with emotional traumas and anticipate that if they take the trouble to report the matter to the police their problems will receive urgent attention, irrespective of the severity of the offence. Unfortunately the restrictions placed upon the police by legal procedures and the sheer volume of crime make such expectations unrealistic.

More than five million crimes are reported each year, an estimated quarter of those actually committed. The rest, for a variety of reasons, are never brought to official notice. As crime detection is only one function of the police, such a huge case-load simply cannot be handled by the number of officers available. In recent years new legislation and changes in administration have radically shifted the manner in which criminal investigation is carried out. Initiatives are undertaken to identify and eradicate the causes of crime; significant resources are committed to preventing crime by encouraging the public to safeguard themselves and their property; ever more emphasis is given to management policies by supervisory detectives, so that crimes and criminals may be targeted to optimize the possibility of success.

The days when all crime was referred to a detective department have long since passed. Even in the most densely populated inner-city areas where crime is at its worst, most reported offences will be 'screened out' by supervisors who see little chance of detection. Most of the remainder, mainly those that can be quickly resolved will be allocated to uniformed patrol officers, and only that proportion requiring active investigation is referred to the detective branch.

Senior crime managers assess the seriousness of an offence and whether it is likely to be solved before allocating the crime for investigation. Certain types of offences will always receive some attention, irrespective of the chances of success: treason, murder, manslaughter, rape, kidnapping, incest, buggery, gross indecency, explosions, defilement of young girls under thirteen, firearms offences, death by reckless driving, hi-jacks and hostage situations. Investigations are obligatory if the security of the state or public order is placed at risk; or when interference with the course of justice is alleged; and in cases involving serious fraud.

Before resources are committed to the investigation of more minor offences the criteria that need to be closely examined all relate to the chances of detection. Has the likely perpetrator been identified? Has that person been seen at or near the scene of the crime when it was committed? Is there a witness who can provide a good enough description of the offender to limit an inquiry to a small group of suspects? Has anyone obtained the registration number and description of a vehicle used in the commission of the offence? Without positive information the crime is destined for the filing cabinet in the drawer marked 'undetected' – a drawer that will only be reopened if firm evidence is obtained later.

This screening process inevitably dismays many victims of crime and the police service is always hard-pressed to justify its policy. Opinion surveys repeatedly show that the general public have vastly different priorities from those perceived by police management on their behalf. Nuisances such as litter, vandalism, unruly behaviour, petty pilfering and damage all feature high on the general public's list. Only a small number of people are directly affected by serious crime, but many more live surrounded by unacceptable standards of social behaviour. The police service, in isolation, cannot provide a remedy.

Public opinion can influence police priorities when causes are supported by structured pressure groups. Contemporary attitudes to marital and child abuse, homosexuality, rape and

racially motivated crimes are all examples that have stimulated enlightened reactions from the police. They have also had a significant influence on police culture, which is now shifting gradually towards becoming a more caring service.

Detective Case-load Management

A government committee that examined criminal investigation procedures in the 1930s recommended that a detective should not be burdened by more than 250 cases a year. That theoretical maximum was in fact never possible, and a detective working today in a busy urban environment would laugh at such a figure.

A detective constable's case-load is allocated by the inspector in charge of the detective section; thereafter it is closely supervised by a sergeant responsible for a small group of officers. Some investigations will be undertaken by a single officer, while others may involve a group or complete section.

A detective section comprises a group of individuals, each with particular strengths or weaknesses. The art of allocation is to identify the case most appropriate to an individual's capabilities: some are good interviewers, able to extract the fine detail from witnesses; others have the interrogator's gifts, best suited to dealing with difficult prisoners; a few can deal most sympathetically with juveniles; and others will be committed to the cut and thrust of team work on the streets.

Whatever particular skills an individual possesses it is important that the case allocation be kept within reasonable bounds. No detective can be expected to concentrate on too many issues at once and a continual 'weeding' policy must be adopted to ensure that all cases receiving attention are heading in a meaningful direction. It is an understandable human reaction among young detectives, faced with a distressed victim, to pursue matters beyond reasonable expectations. The job of the supervisor is to channel those efforts towards other more productive areas without dampening enthusiasm or commitment.

The many difficulties and obstructions placed in detectives' paths can weaken their commitment to active investigation. The bane of every detective's life is paperwork, linked as it is to bureaucratic rules and regulations. At any time, moreover, he is likely to be side-tracked from an investigation to assist a uniformed colleague in an interrogation or form part of a team

investigating a major incident. It is a further depressing feature of the system that most detectives are occupied with pushing cases through the courts rather than with investigating new crimes.

Case Management

The sheer volume of crime in a busy detective section often requires a diversity of effort to ensure that cases, from the time of arrest to the appearance of an offender before a court, progress quickly. Once the investigating officer has identified and apprehended a culprit the matter is often transferred to other sub-sections so that he may move on to his next case. The arresting detective will invariably interview the suspect, formulate the appropriate charge and negotiate continued detention or release on bail with uniformed supervisors responsible for the custody of prisoners. Thereafter follow-up enquiries will be conducted by other officers experienced in the collection and collation of witness statements, scientific and expert evidence and the presentation of evidence to the Crown Prosecution Service.

Investigative Processes

Every detective is trained to approach an investigation systematically, and the principle is the same for both minor and serious crimes. The system revolves exclusively around processes of identification: the victim, the nature of the crime and the perpetrator. The victim is usually self-evident, the scene may occasionally be obscure; but it is the identity of the offender that demands the detective's skill and tenacity. Although the basic strategy remains constant, the diversity of criminal behaviour ensures that every case is different; the tactics employed are therefore adapted to suit individual circumstances.

Theft

A person is guilty of theft if he dishonestly appropriates property belonging to another with the intention of permanently depriving the other of it.

Section 1 (1) Theft Act, 1968

Theft, being the most common reported offence, occupies a large proportion of a junior detective's time. The crime may range from petty pilfering by juveniles, isolated instances of shop-lifting, organized thieving expeditions by gangs of practised criminals or the wholesale taking of lorry-loads of high-value goods. Unless immediately discovered and readily detected the majority of minor offences will receive little attention. A great deal of effort is expended on the more serious cases.

The theft of motor vehicles, with its prospect of good money for those who get away with it, represents a major problem. The law provides special penalties for joy-riders who temporarily take vehicles and abandon them after they have served their purpose. Although these lesser offences often cause much damage and inconvenience there is often little investigative work which can be usefully carried out, other than record the vehicle registration mark on the Police National Computer and wait for it to be found abandoned. It is only when a stolen vehicle can be linked to the commission of a separate crime like ram-raiding commercial premises, or it is involved in causing physical injuries to a third party that the matter receives greater attention.

So varied are the means employed by professional car thieves to disguise or alter the identity of stolen vehicles that all police forces have been obliged in recent years to create a stolen vehicle squad staffed by specialist detectives. Their expertise is also used in connection with more serious unrelated crimes as they are able to identify vehicle marques from the minimal detail provided by witnesses, such as the shape of light clusters, position of body pillars, location of interior door and window handles.

Whatever the nature of the theft a detective will set about his task in the same methodical manner he would adopt for any other crime.

Case Study: Theft

A lorry carrying a container loaded with a thousand television sets is left overnight in an insecure lorry park within a mile of a north–south motorway. The driver secured the vehicle and set the alarm before taking his rest period at a nearby hostel. At 7 a.m. next morning he discovers that his vehicle is missing and reports the matter to the police.

The duty operator at the police station records particulars, verifies the vehicle registration mark and enters this, along with a description of the

vehicle and its load, into the Police National Computer (PNC). Details are circulated over the radio network to all patrols in the area and a police officer is dispatched to the scene. The high value of the load predetermines the involvement of the CID and a detective will link up with the uniformed officer. The detective's primary task is to confirm that a theft has actually taken place – it is by no means unusual for lorry drivers to be involved in conspiracies to divert their loads into criminal hands. Fraudulent hauliers may also dispose of goods placed in their charge, either for direct financial reward from the receiver or to make falsified insurance claims. He will, therefore, closely question the driver and verify his movements since taking charge of the cargo, before committing his witness statement to paper. Eventually he will need to produce all records relating to the load and journey to prove that the television sets actually existed. Discreet enquiries will also be made about the financial credibility and character of the driver's employers, before a representative of the firm is also asked to provide witness evidence of the theft.

All witness statements recorded by the police bear the following caption, which the maker must read and sign before finalizing the written record:

> *This statement (consisting of X pages each signed by me) is true to the best of my knowledge and belief and I make it knowing that, if it is tendered in evidence, I shall be liable to prosecution if I have wilfully stated in it anything which I know to be false or do not believe to be true.*

Immediate enquiries are made in the vicinity of the lorry park to identify possible witnesses. Lorry parks are not usually guarded round the clock, but there may be visits from mobile security patrols that can sometimes assist in narrowing down the actual time of a theft. Local residents are another source of possible information and those within a reasonable area will be visited: it is surprising how often detectives receive vital information from people who answer a call of nature during the night and glance through a window on scenes of villainy. It is equally surprising how few people report these occurrences until their memory is stimulated by an inquisitive police officer.

Given the present circumstances it is unlikely that a scenes-of-crime officer will be called to the lorry park; the chances of discovering useful evidence on the tarmacadam surface are slim, and the detective responsible for the case is capable of searching for his own clues. He may find property accidentally dropped by the thieves or parts from the stolen vehicle, left as a result of damage caused during its removal.

The driver turns out to be an honest man, the credentials of his

employers are beyond reproach and no one connected with the lorry park or nearby residents can offer assistance. The uniformed officer goes about his other duties, leaving the detective with little option but to wait for the lorry to be recovered – by which time its high-value load will almost certainly be missing.

During the waiting period the only avenues open to the case officer are through police channels; he may, for example, establish that the theft is one of a series of incidents committed by a similar modus operandi. Detailed lists of the stolen property will be widely circulated in the hope that some of it may come into police possession from thieves or receivers arrested for other offences. Local informants will be approached to keep an ear to the ground for whispers from the underworld. Efforts will also be made to establish how the lorry thieves were aware of the trans-shipment of this particular high-value freight, although in the experience of all detectives this is very often futile because of the sophisticated and secretive nature of the intelligence network operated by professional thieves.

Within a few days the lorry is found by school children trespassing in a derelict warehouse on the outskirts of an industrial town some fifty miles from the lorry park. The rear tailgate has been forced open and empty cardboard boxes litter the interior of the vehicle and surrounding area. The fact that the television sets have been removed from their containers leads to the prediction that they are intended for the second-hand market by thieves who have opted for a quicker, yet smaller, return on their villainy than may have been the case if they had an outlet for brand-name goods in mint condition. These circumstances will give the case officer some grounds for optimism and will certainly influence his future strategy. He will travel to the new location and seek the co-operation of local officers.

Considerable time and energy must have been spent transferring the sets from their packaging to a fresh means of transport. Such bustling activity gives a greater chance of finding trace evidence left by the thieves. The investigator will therefore concentrate his efforts along three main avenues of enquiry: first, he will try to find out how the lorry reached the warehouse and when it arrived; second, he will require a full forensic examination of the lorry and surrounding area; and third, he will be anxious to probe local intelligence for information about the possible disposal of the stolen goods.

Confirmation of the route taken by the lorry will not depend merely on the chance of someone seeing or hearing it on its journey; more reliable evidence may be obtained from the tachograph fitted to the vehicle. Analysis of information contained on tachograph discs, compulsorily fitted to all heavy goods vehicles, can identify directional manoeuvres that can in turn be correlated to maps and street plans.

Such detailed analysis is a rapidly expanding discipline among vehicle examination specialists.

Forensic scene examination is carried out by civilian scenes-of-crime officers, called SOCOs in police jargon. They are trained at a national centre near Durham in identifying, collecting and packaging material evidence at all types of crime scene and from victims. Because of the high cost of modern scientific analytical techniques all police forces are obliged to adopt a strict screening regime to ensure that only those exhibits which have the potential to advance an investigation are forwarded to regional forensic science laboratories.

On arrival the SOCO is always briefed on the circumstances of a crime by the investigating officer before photographing the scene as a permanent record. In some serious cases a complete video film is taken of the examination. The rule of thumb adopted by all SOCOs at a crime scene is that no one can pass through any given area without leaving trace elements of his presence and he will systematically go about his task with this in the forefront of his mind.

Impressions of footwear may be visible on the floor surrounding the lorry, in the bed of the trailer or on the cardboard boxes. Those invisible to the naked eye may be enhanced by the use of zinc powder or specialized lighting equipment. Fingerprints, accepted by the courts as the most specific means of identification, can be discovered by a variety of techniques. The SOCO will initially dust the areas of the lorry with which the thieves have come into contact: doors, tailgate, seat, mirrors, dashboard, keys and leading edges of the bodywork. All loose documentation and empty containers will be removed to a fingerprint laboratory for examination by other more suitable techniques. It is now possible to recover finger marks from many different surfaces using a variety of chemical and photographic processes.

Careful examination is made of the point of forced entry to the trailer for indications of the type of instrument used. Under the microscope, plaster impressions of indentations caused by jemmies, screwdrivers and the like can reveal unique characteristics that may later be matched to equipment found in the possession of suspects. Similarly, the ends of wires severed to by-pass ignition or alarm systems during a vehicle theft may be matched with a set of wire-cutters or pliers.

Adhesive tape is used on seats, door frames and other areas of likely contact to attract hairs and fibres that can be classified and matched against a suspect or his clothing. And, finally, when all other examinations have been completed the complete scene will be examined again in the lorry driver's presence in the hope of identifying anything foreign to the vehicle since he secured it. Criminals have a tendency to leave behind clues to their identity, and it is by no means unknown for names and addresses to be discovered in letters or diaries dropped

carelessly from pockets. More usual are hand-written instructions and maps; items of clothing and buttons; and flesh or blood from injuries sustained in carrying out the crime.

The documentation of the examination and seizure of exhibits will probably take the SOCO as long as the inspection itself. Each item removed from the scene is individually packaged and labelled with its own reference number before being numerically listed on an exhibits record sheet. The item will retain the same reference until the case is disposed of by a court and each time it is handed on, for whatever purpose, its passage is carefully recorded to maintain its continuity: any gap in the record renders it worthless as an evidential exhibit. A prosecutor's file of evidence must contain documentation proving transfers of exhibits from the possession of one individual to another and in cases where continuity is in dispute the matter must be affirmed verbally in the witness box.

During the time it takes to examine and assess the exhibits recovered by the SOCO a detective sergeant attached to the regional crime squad is approached by a small-time criminal who wishes to impart information in return for payment and a favour. As is often the case a cat-and-mouse game develops. The initial approach is along the lines of inside knowledge about a valuable 'lorry-load of gear' that would be imparted in return for an unrealistic sum of money. In the absence of concrete detail the detective shows only mild interest, but promises a further meeting if the informant has any more to tell: he knows that if there is any credibility in the story the natural avarice of the petty criminal will ensure his return. In the mean time there are formal procedures with which the detective must comply if he wishes to pursue the delicate relationship between informant and 'handler'.

Informants volunteer their services for a variety of reasons, among which are: financial reward; anticipation of a lighter sentence from a court if he is in trouble; or simply as a return favour for sympathy and understanding shown to a victim of a previous crime. Many professional informants are dangerous people, concerned merely with their own selfish interests and always despised by the criminal fraternity. It is always necessary to check the background and criminal record of those who seek to betray the trust of associates, and all stages of the process are carefully supervised.

The approval of a senior officer must be secured before a detective is allowed to enter negotiations with an informant and a register is maintained of all such individuals, which lists all meetings and transactions in comprehensive detail. Although the anonymity of informers is jealously protected, it is essential that the handler is safeguarded from accusations of impropriety; to this end his negotiations are closely monitored by a nominated supervisor.

The detective sergeant does not have long to wait for the next approach: a meeting is arranged at a local pub and the informant is more forthcoming. He is due to appear in court within a few weeks and, because of an appalling criminal record, faces the prospect of a substantial prison term. Like most people who live a life of crime the proceeds of his misdeeds have been frittered away and he needs money to support his wife and children while he is inside. He also wishes to exchange information for another reason: he thinks that if he provides valuable intelligence, his handler may be in a position to have a word in the judge's ear and earn him more lenient treatment. Time is short and in desperation he is prepared to bear his soul for these considerations.

Over a couple of drinks the story unfolds: the criminal knows the identity of the gang who stole the lorry and disposed of the television sets. There are only a few left and he can get hold of one for £100 to prove the truth of his story. But he then reveals that he knows where the thieves intend to strike next: a much bigger job intended to provide them with the wherewithal to finance entry into the far more profitable activity of drug importation and distribution. An armoured vehicle transporting a huge amount of cash between banks is to be hijacked, and the informant has been asked to drive one of the getaway cars.

Close questioning confirms to the detective's satisfaction that the story has some credence, and the two men part company after arranging a further meeting. The detective sergeant is aware of the dangers inherent in the informant's direct involvement and will discuss it in depth with his controller before taking action. Informants are a legitimate and important feature of crime investigation, but may not be used to organize crime in order to entrap other criminals. They should play only a peripheral role, except on rare occasions when involvement is necessary to secure arrests to prevent serious injury or damage to property. The controller will need to be satisfied that these conditions have been met before he seeks approval from the head of the CID to employ the services of a 'participating informant'.

The detective superintendent needs to be assured that the gang's background and the authenticity of their plans have been thoroughly researched before allowing the operation to continue. Undercover officers may undertake surveillance and discussions with the cash-in-transit company will certainly be needed. The handler is provided with cash to buy a television set from the thieves. A check on the serial number shows that this part of the information, at least, is correct. When all possible enquiries have been made, a major stumbling-block remains: the degree of involvement of the informant in the intended crime. Everything he has told his handler has checked out: the security firm have confirmed the accuracy of the thieves' knowledge of their undertaking; and the gang consists of dangerous criminals who

need to be taken out of circulation. There is insufficient evidence to arrest them beforehand for conspiracy to commit a robbery, or for possession of weapons or equipment intended for use in carrying out the crime. The dilemma can only be solved by the informant bargaining his way out of his intended involvement and into a job of lesser importance. If he distances himself completely it will probably arouse suspicion and the crime may not go ahead; in the process he may place himself at considerable personal risk. He pleads with his associates, arguing that he is simply not in their league and is already in quite enough trouble. He persuades them to allow him to steal one of the getaway cars and store it safely until it is required. This negotiation satisfies the detective superintendent, who gives the go-ahead for the police operation. He reckons that having one of the gang's cars available may prove advantageous – an electronic tracking device will be fitted while it is in the informant's custody – and should they evade the police net after the robbery their movements will be monitored.

The detailed planning, preparations for the issue of firearms and 24-hour surveillance of the robbers involves tactical experts and several units of the regional crime squad. On the day of the attack all officers will operate under a tactical plan, approved by an assistant chief constable and supervised by a firearms incident commander and ground controller. At a given signal, just as the robbers move to waylay the target vehicle, the waiting tactical units execute an ambush and secure arrests. Immediately afterwards searches carried out at locations identified during surveillance lead to the recovery of a wealth of incriminating evidence, including some of the stolen television sets.

The informant will be well rewarded for his efforts. In addition to payment from the police for information about the robbery he will be entitled to any reward offered by the lorry's insurers. The money will be handed over by his controller in the presence of a senior police officer to avoid future allegations of corrupt practice. His request for lenience when he appears in court will also be carefully considered. His past and future usefulness as an informant will be balanced against the ethics of giving preferential treatment to a persistent offender. If such assistance is approved, it will be delivered to the court in the form of a written assessment. In some cases the handler may give evidence personally on his behalf, but this is frequently avoided to protect the informant's identity.

The scope for allegations of impropriety in the relationships between detectives and informers is enormous. The codes of conduct are designed to protect detectives from temptation or false accusations, while at the same time allowing the use of a legitimate investigative tool. Because of new regulations that impose a duty on a prosecutor to disclose all details of a police inquiry to the defence prior to trial, it is becoming

increasingly difficult to protect the identity of those who volunteer information. Sometimes it is necessary for charges to be withdrawn rather than expose an informant.

Burglary

A person is guilty of burglary if:

1. he enters any building or part of a building as a trespasser with intent to steal anything in the building or part of the building in question; or inflict on any person therein any grievous bodily harm, or rape any woman therein; or do unlawful damage to the building or anything therein *or*,
2. having entered any building or part of a building as a trespasser he steals or attempts to steal anything in the building or part of it; or inflicts or attempts to inflict on any person therein any grievous bodily harm.

Theft Act, 1968, Section 9

Aggravated burglary is committed when a person carries out the offence of burglary as defined above and at the time has with him a firearm or imitation firearm; any weapon of offence or any explosive.

Theft Act, 1968, Section 10

The Theft Act, 1968 was intended to simplify the law relating to burglary, which had previously set the level of punishment against the type of building entered and the time of day the offence was committed. Nevertheless the many explanatory sub-clauses of present law, combined with a host of key judicial decisions, make burglary one of the most complicated offences to prove. It is a good example of the depth of knowledge required by investigators: faced with a set of circumstances, they have to decide in an instant whether a crime has been committed and an arrest is therefore justified.

As with other all-embracing legal definitions the degree of gravity in burglary varies considerably: from nuisance-value offences committed by juveniles in factories, sheds and shops to highly organized criminal enterprises involving property of every description and value. In recent years respect for the sanctity of private property has declined and the offence of dwelling-house burglary has proliferated. It is a most distressing

crime for the victim and contemporary detectives will need to rise to their most demanding challenge if the trend is to be reversed. The signs are not encouraging; in many urban areas burglary is endemic and detection levels are abysmally low. This has more to do with insufficient police resources than any deficiency in expertise. The situation will only be improved by instilling in property owners the importance of crime prevention of course, and, by catching more offenders.

Offences of burglary are investigated using the same systematic methods, whatever the importance of the property attacked or value of property stolen. Only a small proportion of reported offences can be properly investigated and most of those that are eventually detected have normally been committed by someone with local connections or knowledge of the victim or premises. The main obstacle to better detection rates is the mobility of the modern criminal. Able to plunder remote areas using stolen or hired vehicles, he can then dispose of his ill-gotten gains in the relative anonymity of big cities. These offences are generally only detected via fingerprint or forensic trace evidence, 'inside' information, careless disposal of property, chance encounters with inquisitive police officers or being disturbed and apprehended at the scene of the crime.

Crime intelligence is not the prerogative of the informant: the police recording system provides all officers access to a wealth of data on criminals and their methods. All arrests are documented in great detail and include the prisoner's fingerprints and photographs as well as a comprehensive description of physical features, marks, scars, tattoos, abnormalities and deformities. Of equal importance is the means by which criminals commit a crime: they are creatures of habit and the *modus operandi* index in a force intelligence bureau is constantly searched for comparisons between the methods employed by previously convicted criminals and freshly reported offences. The descriptive index is used in exactly the same way to compare witnesses' descriptions of suspects with those of known offenders. Computerization of these records has hastened the process and led to greater effectiveness.

Case Study: Burglary

A house in the centre of a terrace is temporarily unoccupied when the elderly female resident is admitted to hospital. All doors and windows are secured and the keys are in the care of a relative who visits the property occasionally to check its security. The house contains some

moderately valuable antiques, the usual domestic furnishings and a life-time collection of personal effects.

On an early weekday afternoon the key-holder opens the front door to find a scene of wanton disruption; contents of drawers and cupboards litter the floors and several items of furniture are missing. It is obvious the dwelling has been burgled, and, passing quickly to the rear room, he sees that a small transom kitchen window is wedged open, as is the rear door. The first-floor rooms present an equally chaotic picture and when the visitor reaches for the telephone he discovers that the wire has been severed. In the back garden he finds the back-door key and he is able to trace the passage of shoe marks across flower borders towards the common passageway connecting all houses in the terrace.

A detective dispatched to the scene already has a heavy case-load, but approaches this particular task with no preconceived idea that it is a routine occurrence destined for the record book and little else; if there is a chance of detection there is every possibility that it is one of a series which will relieve either his or a colleague's workload. He takes a tentative look around the premises and closely questions the shocked key-holder. When were the premises last known to be in order? Does he know of anyone showing an interest in the house? Did he see anything suspicious when he approached the premises? Does he know anyone who may have committed the crime? How long has the house been empty? Has the occupant spoken about unusual or unwelcome visitors prior to her admission to hospital? Most importantly, he wants to know what is missing.

The circumstances call for the assistance of a scenes-of-crime officer (SOCO), and while he and the detective survey the premises the occupier's relative is set the task of trying to remember adequate descriptions of the missing property.

Upon closer examination the SOCO judges that the scene of this particular crime is not as straightforward as it first appeared. A superficial jemmy mark on the exterior window-frame appears not to have penetrated the woodwork sufficiently to spring the catch. There are no marks in the dust of the outside sill to suggest anyone climbed on it to gain entry through the transom, the only possible point of entry in an otherwise solid window. In any event the transom is so narrow that only a small child could have gained access. The window is situated immediately above the kitchen sink, which the burglar would have had to negotiate before dropping to the floor. Remarkably pot plants on the window sill and kitchen utensils on the draining board have not been disturbed in any way. Although adult-sized shoe marks can be discerned on the shiny kitchen floor near the rear door, there are no similar marks or scuffs in the area around the supposed point of entry. Further close examination confirms the SOCO's suspicion that the kitchen window has been prepared to mislead an observer.

Sometimes burglaries are simulated by occupants for the purpose of bogus insurance claims, but the detective's initial impressions make him feel this would be unlikely. Before exploring that possibility he will look for alternative explanations. The back-door key had been left on a table and was therefore accessible to an intruder once inside the house. Debris scattered on the rear patio and the shoe impressions confirm that property was removed through the doorway. The puzzle of initial access remains, but only for a short time; dusty smears on the wooden cover in a bedroom ceiling, leading to the roof space, and a scuff mark on the wall below are tell-tale signs. The SOCO scrambles through the opening to discover a loft common to all houses in the terrace. The area is covered with fibre-glass insulation but there is no evidence to suggest which of the other loft covers was lifted to provide a route to the attached premises. All occupants of the terrace will now be regarded as suspects until they are eliminated.

The SOCO is left to continue his search for clues while the detective sets about making enquiries in the vicinity. All surfaces and items that the thief may have touched will be dusted for finger impressions. An electrostatic lifting-device will be used on the floors to reproduce shoe marks; plaster-casts will be made of those that were visible in the flower beds. Adhesive tape is used on the areas around the loft cover to secure fibres that may match the thief's clothing. Documents they have handled will be removed for chemical treatment to test for further finger-marks.

Armed with a rudimentary description of stolen property the detective visits each house in the row on the pretext of obtaining information from residents. He is careful not to mention his suspicion about the method used to break into the violated premises. Everyone is helpful, but unable to remember anything of use. The occupant of one house, a shifty-eyed youngster, stimulates mild interest because of his general demeanour: it is a reaction brought about by years of experience and many confrontations with those who have something to hide. The youth is questioned closely about his movements and the detective's persistence incites an over-confident invitation to examine the house. He finds nothing connected with the burglary or any other crime and a casual look at the loft cover is unrewarding.

Although a check of criminal records confirms the cocky youth has been in trouble with the law for minor thefts on several previous occasions, the detective is powerless to take matters further without more substantial grounds to corroborate his suspicions. The liberty of the subject is enshrined in our constitution, and although the law concedes it is everyone's duty to assist police officers in their enquiries, it also raises protective barriers against precipitate or oppressive conduct. Before detaining anyone a police officer must have reasonable grounds to suspect that the person he seeks to apprehend is guilty of an

arrestable offence. Conjecture is not enough – reasonable suspicion must have a concrete factual basis – and one that could be evaluated as such by a third party. The detective has some way to go before he reaches that position.

Further enquiries in the neighbourhood reap no immediate success and he is obliged to consider further options. The SOCO has discovered a finger-mark on a glass dish that was moved during the burglary and one of the shoeprint casts looks, to the naked eye, capable of comparison with a suspect's footwear. Elimination fingerprints will be taken of everyone with legitimate access to the house and examined against the impression found on the dish. The suspect mark will be searched against the national criminal fingerprint index, now stored on computer and available to all forces. This procedure proves unproductive, and while it is possible to keep the mark on the database for comparison with those criminals subsequently arrested, this is an expensive option and only likely to be approved in cases of really serious crime. Once again the detective is back to square one.

Even in an age of advanced science and technology it is still often the traditional and routine methods of detectives that bear fruit. On courteous questioning, a nearby shopkeeper provides information: the previous day a young girl known as a friend of the suspect changed ten pounds' worth of twenty-pence pieces for drink and cigarettes; a phial containing an identical amount is missing from the victim's house. But frustration and delay ensue when the girl's explanation that she also collects identical denominations of coinage is corroborated by her mother.

The initiative seems to be slipping away from the detective as his enquiries, one by one, meet brick walls; but he has one last route along which he may travel. No photographs exist of the many items of furniture removed from the house, so he enlists an artist to create impressions from verbal descriptions given by the victim's relatives. Armed with these he sets about visiting antique shops and second-hand dealers in the town. He is soon rewarded: a dealer recalls a young man bringing in a dining-room chair, saying it was from a set of four and asking for a price. Fortunately he was seen to drive away a gold-coloured Renault, although the registration mark was not obtained.

Events then accelerate rapidly as the pieces of the puzzle slot into place. The description of the potential vendor and vehicle are fed into the local collator's records. This does not produce a match to the neighbour, but instead indicates distinct similarities to a man suspected of disposing of stolen property for local thieves; he has never before been convicted of crime but the original intelligence came from a reliable source and a surveillance operation had already been mounted by the local task force. The man and vehicle had been identified, but during the

limited duration of the observations he had not been seen taking part in criminal activity. The latest information provides the detective with the reasonable grounds for suspicion that he has been waiting for. He cautiously approaches the suspect's vehicle, parked in the street outside his home, and as he walks past sees a chair lying on the rear seat, partially concealed by a blanket. He summons assistance and is joined by his detective sergeant. When he is fetched from his house, the suspect has no option but to uncover the object; it is obviously part of the stolen property.

Matters then take a course dictated by legal requirements for the protection of persons suspected of committing crime. The detective must tell the suspect why he is arresting him and is required to caution him in specific terms about his right to remain silent. In the circumstances which have now been revealed the detectives are empowered to search the suspect's home without acquiring a warrant, before taking him to a police station. In a shed in the rear garden they discover most of the victim's property complete with price tags. The articles are intended for disposal at a car-boot sale the following day.

Caught red-handed, the inexperienced criminal is not prepared to take sole responsibility for the crime. He implicates the arrogant young neighbour who planned the venture, gained access to the attached premises through the roof space, checked whether any items of value were available, ransacked drawers and cupboards for small pieces of jewellery and unlocked the rear door so that his accomplice could enter to help remove larger items. The girlfriend had kept watch while the property was loaded into a hired van; she was rewarded for her efforts with the twenty-pence pieces.

The detectives, having solved the crime, are now obliged to arrest the others involved and secure statements to support the charges.

5 Statutory Powers

The most important attributes of a successful detective are natural inquisitiveness and an ability to question all manner of people, either to elicit information or uncover facts that have been deliberately concealed, unwittingly overlooked or temporarily forgotten. He must also rely upon an understanding of human nature, worldly-wise experience and the use of logic. Investigators also depend upon their intuition and will always hope for, but often be denied, a modicum of luck.

These essential elements enable an individual to develop a rational approach to every case, and as his career progresses become increasingly adept at deploying the various resources at his disposal. At the same time he will also assimilate the complex legal and administrative procedures he is required to observe. Every detective must aim to work to a strict set of priorities and exercise the necessary strength of character to observe obligatory rules, avoid short cuts and act at all times in the interests of justice.

The reciprocal obligation of a society steeped in an ethos of justice for all is to provide its police with adequate powers to enable them to function efficiently, while maintaining a balance between the rights of individuals and the common good. Until recent times investigators had to adhere to directives set out in judicial precedent, or instructions issued by executive powers. Political pressure, triggered by public disquiet about police misdeeds or inefficiency in several high-profile criminal cases between the 1950s and 1970s, brought about new legislation. These laws codified mandatory procedures for the treatment of suspects in police custody, and have had the dual effect of raising the levels of accountability and improving standardization.

The recommendations of a royal commission on criminal procedure, which published a report in 1981, were largely incorporated in the Police and Criminal Evidence Act, 1984, and

introduced written codes of practice setting out police powers throughout the investigative process.

These changes have brought about a quiet revolution in policing methods. What many detectives initially regarded as unnecessary restrictions on their handling of cases compelled urgent reviews of investigative tactics. The emphasis has now shifted from interrogation with the aim of obtaining confessions to the more positive collection of hard evidence before suspects are arrested. In the process detectives have been obliged to immerse themselves in a variety of new disciplines; some, involving psychology or cunning surveillance techniques, have led to accusations of unfairness or even of legal inadmissibility. More effort is now put into crime pattern analysis, assessments of criminal activity and the collection of criminal intelligence. The initial identification of criminals depends more than ever before on technical back-up to traditional surveillance methods, and their connections to specific crimes relies increasingly upon forensic evidence.

Police and Criminal Evidence Act, 1984

The Act and the codes of practice issuing from it set out formal guidelines for the police and provide stronger safeguards for the public in general, and suspects in particular, against malpractice. They cover five areas of activity: powers to stop and search individuals and vehicles; searching premises and seizure of property; detention, treatment and questioning of suspects; identification methods permissible during investigations and the tape-recording of interviews. The extent to which supervisors are accountable is identified throughout the codes; the consequences of disobeying any of them can mean disciplinary action for the defaulter and the exclusion of evidence obtained as a result of the transgression.

Powers to Stop and Search

Random, or routine, searching of members of the public without apparent cause or explanation has always been a contentious issue, often leading to accusations of improper or over-zealous behaviour. The practice caused friction between the police and minority groups, and in inner-city areas led to claims of racial discrimination. It is, however, a legitimate tactic, if used in the right circumstances with the aim of aiding crime detection,

recovering stolen property or preventing violence. Every search must be individually justified and conducted within defined parameters.

Specific authorities to stop and search have always been contained in legislation enacted for particular purposes, for example firearms control, misuse of drugs, theft and poaching. The new codes provide an additional, though limited, general power that allows a police officer to approach a person and delay him for long enough to ascertain if he has been involved in a crime without having to make a formal arrest. He may do so only in a place to which the public have access, whether by right, payment or direct or implied invitation. The general highway is the obvious example of right, and venues such as sporting events, places of entertainment and supermarkets are embraced by the definition. An officer must have reasonable grounds to suspect that the individual he wishes to search is in possession of stolen property, an offensive weapon or any article intended to facilitate a crime of burglary, theft or criminal deception. (Particular powers to stop and search are available to deal with reasonably anticipated occurrences of localized violence – Section 60, Criminal Justice and Public Order Act, 1994.)

The meaning of the phrase 'reasonable suspicion' is one of the most complex issues that a police officer is obliged to consider. A hunch is never sufficient cause to subject someone to a personal search – 'reasonable suspicion' must be based on a matter of fact related to particular circumstances and capable of confirmation as such by independent opinion. It therefore follows that an individual's past criminal history, undesirable associates, unusual appearance or behaviour cannot in themselves give reason to interrupt a citizen's freedom of passage.

In practice most police officers quickly become adept at approaching members of the public in a reasonable manner, thereby securing their co-operation in efforts to detect crime. Powers of persuasion are nearly always enough to get the suspect to produce items he is carrying voluntarily, without the officer having to rely on formalities. Formal rules are intended both to prevent random searches and to provide a reasonable framework when it is necessary to search the recalcitrant.

An officer who makes the decision to stop and search is required to follow guidelines, designed to ensure accountability for the action and minimize inconvenience to the suspect. He must identify himself, the police station to which he is attached

and, if in civilian clothes, produce his warrant card. The reason for the search must be fully explained, and he is required to provide a written record of the procedure if requested to do so. It is not always practicable to supply the written record at the time, but a copy will be supplied on request at any time within twelve months of the search taking place. Search records include the identity and ethnic origins of the subject, or a full physical description if identity is withheld; details of any vehicle examined; the objective of the search and its result; together with the time, date and place of the incident. Any personal injury or damage to property is also recorded.

Comprehensive codes of conduct exist for the actual conduct of a search; this fact is ignored in the cavalier portrayal of such procedures in much of contemporary fiction, and is therefore worth examining. The codes are essentially designed to minimize embarrassment or delay. Reasonable force may only be used as a last resort, when it is obvious that the subject is unwilling to co-operate. The period of detention may not extend beyond what is reasonable to complete and record the search; the search itself must be confined to those areas of the person or vehicle to which suspicion of illegitimate possession relates, for example pocket, bag, or beneath a driver's seat. If a more intimate search is necessary it may be conducted only out of the public view, and any request to remove clothing may only be made by an officer of the subject's sex.

It must be emphasized that the power to detain for the purposes of search is not a power of arrest. If a police officer holds a suspect who will neither identify himself nor permit himself to be searched, further action must be separately justified, and any decision will depend on whether suspicion is sufficiently 'reasonable' to justify a formal arrest.

Searching Premises

It has always been recognized that law enforcers require legal means to enter private premises if they are to avoid being sued for trespass or abuse of authority. Originally these emerged through the common law and were refined by numerous statutes. Now only one common law power exists: a constable's duty to enter premises to deal with a breach of the peace; this is intended for circumstances of great urgency when there is imminent danger to person or property. The remainder have been repealed and substituted by comprehensive measures in the Police and Criminal Evidence Act. In an attempt to balance

the interests of the citizen with the needs of crime investigators, parliamentary draughtsmen have drawn several distinctions between degrees of authority to search. In the process they have created a maze of conditions and controls that even practised lawyers treat with caution. The situation is made even more complicated for the police, who have to interpret the law in the heat of the moment. Even when executing searches in volatile situations they must give full consideration to complex bureaucratic instructions.

The law distinguishes between searches carried out with the consent of the person who has control over premises; those where consent is not forthcoming but particular circumstances render independent authorization unnecessary; and third, searches that may be conducted only under the authority of a magistrate's warrant. Even in those cases where consent is freely given, an officer may enter and search only if permission is confirmed in writing, the reason for the action is fully explained and the occupier is informed of his right to refuse.

Premises affected by multi-occupational or tenancy agreements, such as hotels, lodging houses or factory locker-rooms, may not be searched on the basis of a landlord or manager's agreement unless the tenant is absent *and* the matter is of an urgent nature.

Entry and Search Without Consent or Warrant

The Police and Criminal Evidence Act authorizes a constable to enter and search premises without consent or a search warrant only in the following circumstances:

1. to execute an arrest warrant;
2. to arrest a person for an arrestable offence;
3. to arrest for certain specific offences under the Public Order Act, 1936, and the Criminal Law Act, 1972;
4. to pursue anyone who is unlawfully at large;
5. to save life;
6. to prevent serious injury;
7. to prevent substantial damage to property.

The constable must reasonably believe the person he wishes to arrest is actually on the premises at the time he enters. He must be in uniform to arrest anyone for the designated offences under the Criminal Law Act and any search must be limited to the extent necessary to achieve its purpose.

The Act also empowers the police to search any premises controlled or occupied by an arrested person without need of a warrant. The search may take place immediately after arrest on the arresting officer's own initiative if it is necessary to secure evidence before he takes his prisoner to a police station. However, if a search is necessary after the prisoner has been taken into custody, it may only be carried out under the written authority of a police inspector. The circumstances of searches carried out under either of these authorities must be fully documented, and the record made available to any interested party in subsequent court proceedings.

Search Warrants

A magistrate is empowered to issue a warrant to search premises if he is satisfied that the following conditions apply:

1. a serious arrestable offence has been committed;
2. the premises contain relevant evidence that would substantially progress the investigation of the crime;
3. no material is involved that is subject to the absolute right of confidentiality between lawyer and client;
4. it is not intended that the search will reveal 'excluded' or 'special privilege' material (samples & records relating to a person's health or welfare and journalistic, confidential or secret information that require the search authority of a judge of the High Court)
5. it is not practicable to obtain permission to search from a person entitled to grant right of entry *or*;
6. it is anticipated that consent will not be given to enter and search unless a warrant is issued *or*;
7. the purpose of the search may be hindered unless the police are allowed immediate and unannounced entry.

Grant and Execution of Warrants

Police officers who apply for, and execute, warrants to search are obliged to comply with set conditions, otherwise their actions will be deemed unlawful and evidence thereby obtained likely to be rendered inadmissible.

Application The application for a search warrant requires the written approval of a police inspector, and in cases involving excluded and special procedure material, a superintendent. An application is made personally, under oath, supported by a

written statement identifying the premises to be searched and a description of the articles or persons it is anticipated will be found there. Although it is not necessary to compromise the identity of a confidential informant, the applicant must be prepared to provide substantial reasons for believing the accuracy of his assertion and be in a position to answer truthfully any questions which may be put to him. Obviously, the occupant of the premises to be searched is not told about the application and has no right to attend or be represented.

The warrant, if granted, identifies the specific premises and describes the items or persons it is anticipated will be found. It must show to whom it is issued, on what date and the authorizing legislation.

Execution A search warrant is valid for one month, may only be used on a single occasion, and not necessarily by the officer who applied for it. Unless delay may impede an investigation or there is risk of evidence being destroyed or hidden, a warrant should be executed only at a reasonable hour. It is desirable, although not always practicable, for searches to be conducted in the presence of the occupier or owner, who should be given an opportunity to produce the listed items before any search takes place. All officers taking part in a search need to be identified to the occupier and the purpose of the exercise fully explained before it is carried out. A copy of the warrant is either served personally at the time, or in the event of the premises being unoccupied, a copy is left in a prominent position.

Reasonable force may be used if the occupier cannot be found or his co-operation is unlikely, but, in whatever circumstances the search takes place, it must be limited to the purpose stated in the warrant: once this has been satisfied no further speculative 'fishing expeditions' can be justified. Premises must be left secure and, if damage has been caused, the occupier told how to apply for reparation.

Any constable may execute a search warrant issued by a magistrate, but an officer of at least inspector rank is required to supervise the conduct of a search for excluded or special procedure material. This is to ensure minimum disruption to business activities and gives a responsible person an opportunity to produce the listed items before any inconvenience is caused.

Seizure of Property

When a constable lawfully enters private premises, he is entitled

to seize anything that he reasonably believes has been the subject of crime, and might be destroyed or disappear if he fails to take possession of it. He may also seize any item of evidence discovered during his search that he thinks is connected with a separate criminal investigation.

Where searches involve examination of computerized records, the Act imposes a duty upon a suspect to produce copies in legible form at the request of the officer executing the warrant. Copies of the material produced should be made available to the owner, unless the investigation or judicial process would be compromised by doing so.

Retention of Property

Property seized by an investigator may be retained until lawful ownership is established or all connected judicial processes have been completed. If hardship or inconvenience can be anticipated by the owner from a lengthy period of retention, the articles may be photocopied or photographed, and the originals returned on the understanding that they are re-produced during court proceedings.

During any period of retention, the owner or his representative may be granted supervised access to his property, or be supplied with photographs or copies, *unless* the officer in charge of the investigation certifies that access would jeopardize the inquiry or subsequent proceedings.

The principle behind the comprehensive guidelines for the retention of property is that lawful owners should not be deprived of their possessions for longer than necessary to facilitate the proper administration of justice. In all acceptable cases secondary evidence such as photographs and copies should be substituted for the actual exhibit.

Administration

Every sub-divisional police station is required to maintain a search register, which is subject to inspection by Her Majesty's Inspectors of Constabulary. The record includes comprehensive details of each search, together with reasons for seizure of property, use of force and damage or injury caused. The warrant is also endorsed with similar information before return to the clerk of the court of issue.

Statutory instructions about the searching of private property place great emphasis upon police accountability. The invasion of

personal privacy is not to be undertaken lightly and therefore all such actions must be fully documented for future examination.

Arrest

An arrest is defined as the restraint of a person's liberty, in order that he may be dealt with according to the law. While some arrests are made under the authority of court warrants, the majority are carried out by police officers who rely upon powers granted by common and statute law. The law relating to powers of arrest is extremely complicated, and although it places certain duties upon ordinary citizens, it remains difficult for the lay-person to understand. The Police and Criminal Evidence Act attempts to rationalize the situation, but is not wholly successful.

Anyone is empowered by law to carry out an arrest in certain instances of anti-social behaviour. Police officers are given more flexibility, giving them the opportunity to assess a situation and act upon reasonable suspicion. The common law permits anyone to arrest an offender without a warrant who: commits a breach of the peace in his presence *or* who is thought likely to renew a breach already committed *or* will go on to commit a breach unless he is apprehended.

A breach of the peace is any action threatened or carried out which:

1. causes harm to someone, or his property, while he is present;
2. is anticipated will cause such harm;
3. causes real fear of such harm being done by assault or serious disturbance.

An extension of these powers is granted to those holding the office of constable. They may arrest anyone who assaults, resists or wilfully obstructs them in the course of their lawful duties. Common-law powers may be exercised anywhere and have a distinct advantage in maintaining order in domestic situations.

Principal statutory powers of arrest are incorporated in the Police and Criminal Evidence Act. They include the rights of both members of the public and the police to arrest suspected offenders for 'arrestable offences'. Of significant importance to law enforcement is a new, conditional power that allows police officers to arrest those suspected of minor transgressions of the law.

Any person may arrest without warrant:

1. anyone in the act of committing an arrestable offence;
2. anyone whom he has reasonable grounds for suspecting to be committing such an offence.

If an arrestable offence has already been committed, anyone may arrest:

1. anyone who is guilty of that offence;
2. anyone whom he has reasonable grounds for suspecting to be guilty of it:

A constable who has reasonable grounds for suspecting that an arrestable offence has been committed may arrest the person he reasonably suspects to be guilty of the offence. Additionally a constable may arrest without warrant:

1. anyone about to commit an arrestable offence;
2. anyone he has reasonable grounds for suspecting to be about to commit an arrestable offence;
3. in respect of the commission of any offence if any of the following conditions are satisfied:
 a. the service of a summons is not possible, because:
 i. the name of the offender is unknown and cannot be readily ascertained;
 ii. there are doubts about the authenticity of personal details provided;
 iii. to prevent injury, damage or loss to person or property;
 iv. prevent an act against public decency;
 v. prevent unlawful obstruction of the highway;
 vi. protect a child or other vulnerable person from the offender.

The term 'arrestable offence' is closely defined, but in general embraces more serious crimes for which a court is empowered to impose a prison sentence of at least five years. A number of lesser offences are specifically included in other legislation that allow arrests to be made regardless of punishment. These include indecent assault on a female and being in possession of equipment to be used in theft.

Arrests by ordinary citizens are rare when compared to the overall number of offenders detained by the police. This is hardly surprising when the complex conditions are taken into account. The law attempts to distinguish between those

occasions when the commission of crime takes place in the full view of the general public and requires immediate action, and the more obscure situation when powers have to be bestowed upon those trained to collect evidence, evaluate its worth and act properly upon the consequences. The general power of arrest for minor offences recognizes the difficulties experienced by the police in bringing to justice those who fail to identify themselves for the purposes of normal court processes, and the necessity to temporarily remove from general circulation those who are at risk or are likely to cause harm to anyone else.

The act of arrest is complete once a suspect has been prevented from going about his normal business – no physical element is necessary – but it is an absolute requirement that he should be immediately informed of the reason for his detention, *unless* he makes this impracticable because of violent behaviour or an attempt to escape. In those circumstances the reasons must be given when the situation has been brought under control. Reasonable force may be used to detain a suspect. In normal circumstances no restraint is necessary, but some arrest situations are extremely violent.

Police officers are encouraged to arrest only when no alternative course of action exists, but the detective, who continually deals with more serious issues, usually arrests as a matter of course. Practice makes him confident about his powers, and equally comfortable with the intricate codes of practice that control his actions throughout subsequent processes.

Detention, Treatment and Questioning of Detained Persons

All prisoners must be held at designated police stations in which custodial facilities conform to Home Office specifications. A nominated 'custody sergeant' is responsible for the formalities of detention, and a definitive record is maintained of every decision and action taken concerning each detainee. A copy of the record must be supplied, on request, to the prisoner or his legal representative.

When a detainee is brought to a police station, the first responsibility of the custody sergeant is to satisfy himself that there is sufficient evidence to level an immediate charge, or that good reasons exist to prolong detention for more evidence to be obtained by questioning or active investigation. The reasons for holding a prisoner in custody must be fully explained. Juveniles under the age of seventeen and anyone unable to understand

because of permanent disability or language difficulties are required to have the protection of a parent, social worker, independent responsible adult or interpreter throughout administrative and questioning procedures.

The custody sergeant must record all property in the prisoner's possession and remove that which may cause harm or be required as evidence. No searches of intimate body orifices may take place without the written authority of a police superintendent.

A prisoner may be held *incommunicado* only if authorized by a superintendent who is satisfied it is necessary to avoid obstruction to the judicial process. The considerations that have to be evaluated before this decision is made are intentionally restrictive; this makes it an exception for a person to be denied the opportunity to have someone of his choice informed of his whereabouts. Additional rights include personal telephone calls, writing materials and visits by friends and relatives.

Only in exceptional circumstances will access be denied, at any time, to confidential legal advice and the presence of a solicitor, or a properly qualified legal executive, throughout questioning. There are occasions when legal representatives may be refused access or removed from interview rooms, if they seek to obstruct the proper pursuit of enquiries. Such a denial can have serious consequences to an investigation and can only be exercised within strict parameters by a superintendent.

Legal advice may be *delayed* if the superintendent has good reason to believe that it would interfere with or damage evidence, cause harm to someone, alert others not yet arrested or obstruct the recovery of items connected to the alleged crime. Any delay may not exceed thirty-six hours, after which time the right to legal advice is absolute. (That period is extended to forty-eight hours for prisoners detained under Prevention of Terrorism legislation.) A suspect who requests legal support may not be interviewed before receiving it unless a superintendent certifies that questioning is required as a matter of urgency to avoid an immediate risk of serious damage or injury.

The general well-being of prisoners is the direct responsibility of the custody officer. His remit includes the provision of adequate food, clothing, bedding, accommodation standards, daily exercise and medical welfare. Special provision is made for juveniles, the mentally ill, people requiring interpreters and those admitted to custody under the influence of alcohol.

Comprehensive instructions concerning medical treatment

cater particularly for those suffering acute disorders. More responsibility devolves upon the custody officer for the administration of medicine and isolation of those suffering from infectious disease. Any complaint about treatment, contravention of procedures or allegations of assault must be referred to a police inspector.

Extended Detention

The primary objective of regulations concerning detention in police custody is to ensure that suspects are not incarcerated for longer than is absolutely necessary, for the proper execution of an investigation. To this end time limits are imposed that require careful examination of the circumstances of each case before they may be extended.

The question of whether to prolong a suspect's detention is reviewed by a police inspector no later than six hours after arrest. If more time is justified the period may be extended, in two stages, for a further eighteen hours. When that time has elapsed the situation is reviewed by a superintendent, who may sanction continuing the detention for another twelve hours. Thereafter, if more time is required, the matter must be considered by a magistrate. The prisoner or his solicitor have an opportunity, at each stage of the reviewing process, to make representations against the reasons given for justifying an extension.

Magistrates' warrants for further detention are authorized for successive periods of thirty-six and twenty-four hours, making possible a total custodial period of ninety-six hours. If the police are not in a position to prefer a charge at the end of that time, the suspect must be released unconditionally or bailed to attend a police station at a future date, when it is anticipated all enquiries will have been completed.

Applications for warrants of further detention are only made in exceptional circumstances, when the senior investigator anticipates the immediate release of a suspect would endanger victims or witnesses, create obstruction to the investigation or lead to the destruction of evidence.

In practical terms there is a strong argument for avoiding such applications. The proceedings are held in the suspect's presence and require written information to be presented to him and his legal representative prior to the hearing. This notice contains details of the alleged offence, the evidence available at the time of arrest, a synopsis of enquiries the police have and intend to

make, and reasons why continued detention is justified.

The application is made on oath in the presence of the detainee and the applicant is invariably closely cross-examined on its merits by the defence solicitor. The whole strategy of an on-going investigation can thereby be prematurely compromised, and an opportunity presented to a suspect to frustrate future enquiries.

A warrant to extend detention is granted only if the court is satisfied that it is necessary to obtain or preserve evidence by questioning or other means, in relation to the specific offence for which the suspect is in custody, and that the investigation is being speedily and diligently conducted. There is no requirement for the court to grant the total number of hours permitted, and it may therefore decide to limit the extension for a lesser period of time.

The officer in charge of a case is largely divorced from the administrative arrangements concerning the detention of suspects. This allows him to continue his enquiries as quickly as possible. He is, however, obliged to conform to other conditions linked to investigative procedures during a period of detention.

At the time of arrest a suspect must be cautioned in the following terms: 'You do not have to say anything. But it may harm your defence if you do not mention, when questioned, something which you later rely on in court. Anything you do say may be given in evidence.' When a suspect refuses to answer questions after receiving the cautionary warning, a court will be entitled to draw inferences from his failure to offer an explanation for his presence at, or evidence connecting him to, a crime. He must be left in no doubt about the explanation required, or the consequences of refusal, at the time he is interviewed.

Questioning may continue only until the interviewer believes he has sufficient evidence for a prosecution to succeed. Once that position is reached, no further questions may be asked before the suspect is formally charged with the offence. Only in exceptional circumstances can a person be asked further questions about the offence for which he stands charged. These include occasions when loss or harm may be prevented; to clarify ambiguity in previous answers; or seek explanation of facts relating to the investigation which have subsequently been discovered (for example, a prisoner, charged with murder, could be properly asked questions which would lead to the recovery of a weapon. He could also be asked to identify it, and its source, once it had been recovered.) It is a matter of common sense that

an accused person should also have the opportunity to comment on evidence secured from new witnesses at a late stage of an inquiry, and the results of expert or scientific examinations, which may only become available months after the preferment of charges.

A primary purpose of an interview with a suspect is to give the investigator an opportunity to seek a reaction or explanation to established facts, rather than concentrate on obtaining a confession. Interviews conducted while someone is in police custody have always been contentious, and very often a disproportionate amount of court time was spent testing their veracity. That situation has now been largely eradicated by the presence of third parties during interviews and the general adoption of tape recordings. Experiments are taking place with closed-circuit television to advance the process a stage further.

The abiding axiom for any conversation with a suspect after he has been officially cautioned is that everything said must be faithfully recorded, signed or acknowledged as a true record. There are occasions, usually prior to arrival at a police station, when questions have to be asked and it is impossible to make an immediate record. In these circumstances a summary of the conversation is made at the first available opportunity, shown to and signed by the prisoner. If the latter refuses to sign such a record, it does not destroy its evidential value, but may obviously lead to its accuracy being disputed at a later stage.

Formal interviews take place in designated rooms under the control of the custody sergeant and, if the suspect has so requested, in the presence of his legal representative. Continuous questioning may only last for periods of approximately two hours, interspersed with breaks for refreshment; normal meal times have to be observed and an eight-hour period of rest is normally required during the night. Additional protection is necessary for juveniles, the mentally handicapped, those with mental, visual or aural handicaps and foreigners who do not understand English fluently. A parent or social worker will be present when a juvenile is interviewed and an independent adult or interpreter will support the remaining special cases.

Before an interview starts, the suspect is told the identity of everyone present and reminded that he is not obliged to answer any questions. If a contemporaneous written record is made, it is read and signed by all parties at the end of each session. In the case of a tape-recorded interview the cassette is removed from the machine, sealed and signed; a fresh one is inserted when the questioning begins again.

Written admission statements are less common with the advent of tape recordings, but if an interviewee wishes to make one, he should always be invited to write it himself. If he declines it may be written by a police officer in the suspect's own words and without prompting, other than to query irrelevance or ambiguity. Before beginning a written statement the maker is obliged to acknowledge a printed caption that everything written is freely surrendered; he should furthermore understand the consequences to his defence of omitting something that he later relies upon during a court hearing. An obligatory declaration at the end of the statement also confirms that it has been freely given and that the maker has been given an opportunity to read it and change any part of the content.

If the suspect cannot read or write, or for some other reason refuses to complete the caption, the senior police officer present is responsible for reading the statement aloud and inviting a signature. If this is refused, the officer summarizes exactly what has occurred at the end of the document. Such a situation may appear far-fetched, but in fact it occurs frequently. A recalcitrant prisoner may refuse to acknowledge a statement if he suddenly realizes that he has unnecessarily committed himself. A hardened criminal will sometimes refuse legal advice or tape-recording facilities in order to be able to allege malpractice by the police. If he can cast doubt on the way a statement was obtained or the content of a written record of interview, it may be possible for him to influence a jury's decision. Senior detectives are well aware of the various devices used by those who are their most regular clients; they know the best insurance is to adhere to rules that have been designed for their protection, as well as that of the suspect.

When an investigator is satisfied that he has, either from questioning or available evidence, strong enough grounds to institute proceedings he is obliged to inform the custody sergeant. An evidential assessment is then made and it is the custodian who decides what charges will be preferred.

In practice this means that investigations carried out by constables and sergeants are independently examined. In more serious inquiries the custodian will accept the decision of a more experienced and senior officer, although, in law, the ultimate responsibility still rests with him. In the event of any dispute an independent senior officer will be called upon to arbitrate.

A charge is set out in simple terms on a notice that is handed to the accused. It includes the name of the officer responsible for its preferment and the usual reminder of the right to silence,

together with the added warning about withholding anything that may later be advanced in court as part of the defence case. Any reply is written on both the notice and custody record.

When charging procedures have been completed the custody sergeant has one final decision to make, concerning the disposal of the prisoner. There are only two options open to him: to hold the accused in custody to appear before magistrates or admit to police bail. These considerations are limited within narrowly defined parameters that are heavily weighted in favour of bail.

An accused person may only be kept in police custody after charges have been levelled if his identity has not been confirmed, there are fears for his personal safety, he is unlikely to answer to bail, represents a danger to persons or property or may interfere with further investigations into the alleged crime. The reasons for denying bail have to be explained to the accused and recorded on the custody sheet.

When a juvenile is charged with an offence and it is decided for one of the above reasons that he should be detained arrangements must be made for the local authority to take him into care until he appears at court. If, for any proper reason, they are unable to accept him, the juvenile must remain in police custody to await a court's decision about bail or further detention. In these cases the custodian is obliged to produce a certificate setting out the reasons for holding the alleged offender.

Magistrates who hear remand cases have the power to grant bail, to which they may attach conditions: third person sureties; forfeiture of passport; regular reporting to police stations and imposition of curfews. Someone who has been refused bail by the police is far more likely to be granted it by a court, because the grounds on which magistrates may refuse are much more limited. The applicant will be denied bail only if it is believed that he may not appear for trial, is likely to commit further offences while on bail, presents a danger to witnesses or, it is feared, will obstruct the course of justice.

Another avenue exists for prisoners refused bail by magistrates; a judge of the High Court will hear a further application in the privacy of his chambers at any time while a person is in custody awaiting trial.

Conclusion

The rationale behind the rules and regulations governing custody is that no one should be arrested without good cause, detained by the police for longer than necessary and, only in

essential cases, held in prison to await trial. These principles contribute to the presumption that an accused is innocent until proven guilty by a court of law. The police are therefore directed to release a detainee at any time his continued detention cannot be justified. However, such a release can be made conditional if the investigator has further enquiries to make that may implicate the suspect. The latter may therefore be required to agree bail conditions and appear at a named police station at a specified time to face further questioning or preferment of a charge. This provision gives considerable breathing space for enquiries to be pursued without the pressures imposed by statutory time limits.

Statutory custody procedures made a strong impact on the conduct of operations. Primarily they have made investigators more aware of their responsibility to collect sufficient evidence before arresting a suspect. There are, of course, occasions when arrests have to be made immediately: an offender is caught in the act; it is necessary to take the heat out of violent situations; a suspect may abscond or continue damaging property. But at whatever stage an arrest is made, law-makers consider the police should be allowed adequate time to complete enquiries and collect enough evidence to finalize a charge. The problem comes where serious and complex crimes bubble up to the surface in, for example, extreme violence. Here an immediate arrest is called for, yet inquiries into the background of these offences can take weeks to complete and the stipulated maximum of ninety-six hours' detention often seems unreasonable to the detectives involved. After all, they have a duty to protect the innocent and vulnerable from violent criminals; so, in order to prevent their premature release, the four-day period is usually characterized by frenetic activity aimed at securing sufficient evidence to substantiate a charge.

Identification Methods

English law is cautious about accepting testimony that seeks physically to identify a suspect, whether given by one or more witnesses, particularly when it is unsupported by independent corroboration. A jury must be warned to exercise caution before accepting identification evidence, and a defendant is entitled to be acquitted unless its members are sure of its reliability. The circumstances in which a witness claims to be able to recognize an offender are always closely scrutinized by a court. It needs to examine several issues: the length of time the suspect was in

view; whether the witness knew or had seen him before, and if so for how long or with what frequency; the proximity and visibility at the time of sighting; comparison between descriptions provided by witnesses during questioning with the actual appearance of the accused; the lapse of time between the original occurrence and subsequent identification; and the particular reasons for the witness's ability to recall physical features.

Other methods used to identify perpetrators of crime are generally more reliable. Several depend upon comparing traces taken from crime scenes and control samples obtained from suspects, such as fingerprints, blood, hair, fibres, handwriting, documents and tyre tracks. The high probative value of these techniques ensures that they are more readily acceptable to the courts.

A physical identification often originates from information supplied by witnesses or victims suffering considerable stress; an average person will usually be unable to provide a worthwhile description without skilled questioning and guidance. Their efforts may provide an investigator with the opportunity to suggest one or more likely suspects from his personal knowledge of local criminals, or facilitate a check of police records over a wider area. More often than not a written description will be transposed into a visual representation by an artist or mechanical device. Photofit imagery and computerized 'E-Fits' are examples of the systems available. Police records contain extensive photographic collections of convicted criminals and these are regularly shown to witnesses under controlled conditions. Another method involves witnesses viewing suspects in the flesh. This may be carried out in a busy street, crowded public place or in the more formal circumstances of an identification parade. As a last resort it may become necessary to confront a witness directly with the suspect. Whatever method is used, strict adherence to set procedures is necessary for a positive result to be accepted by a court: the seemingly simple exercise for establishing whether someone touched by crime can recognize its perpetrator is, in truth, an intricate police operation.

Photographs and Other Images

A witness who names a potential suspect after viewing an artist's impression or mechanical composite compiled from another person's recollections should be asked to attend an

identification parade, unless the suspect is otherwise eliminated from the police investigation. The same applies to identification by photograph, and in either case no further witnesses may be shown the samples. Physical identification is always the next stage. If a positive result is obtained and charges follow, the accused person and his solicitor must be told of any previous use of photographs or artwork.

There is a subtle difference between asking a witness to view a photographic collection, in the hope that they recognize someone, and the more formal showing of a small number of pictures, one of them being of an already suggested suspect. A general trawl may contain any number of photographs that need only be of the same type of person that a witness has previously described. In the other case the suspect must be included in an album of at least twelve other representations of people who conform to the same general appearance as the suspect.

Anyone involved in an investigation may supervise the showing of photographs, once the authority of a sergeant has been obtained. It is important to observe the basic rules of fairness, in that there should be no collusion between witnesses, no encouragement or suggestion from the exhibitor and it should be made clear that the criminal sought may not necessarily be included in the sample.

All photographs and images shown must be made available for production in court, whether or not a successful identification is made.

Public Identification Exercises

A detective may be unsuccessful in tracing a suspect by use of photographs or impressions. His witness may be unable to furnish adequate descriptions, but information may come to hand that suggests the person responsible for a crime frequents a certain locality or associates with a specific group of people. He may therefore arrange for an officer who is not involved in his inquiry to accompany a witness to a given place, to attempt to pick out a suspect from a crowd.

An investigator may also show members of the public or police officers films of criminal occurrences involving many people in the hope of tracing offenders. This method is most often used in cases of serious public disorder, but with the spread of surveillance cameras in public streets and commercial premises it is a growing practice. A distinction is drawn when

such material is shown to potential witnesses for the purpose of producing positive evidence of identification – in which case the film must be viewed individually to avoid allegations of collusion.

Formal Physical Identification Methods

Once a suspect has been traced, by whatever means, an investigator is entitled to ask him to participate in physical identification procedures. This will involve him being viewed by witnesses in order to establish whether or not he is the person involved in the alleged crime; it is a request that he may decline. Conversely a suspect who disputes his involvement may demand that he is placed on an identification parade and the investigator is obliged to agree, unless there are cogent practical reasons for not doing so. In either case, once it has been agreed to hold a parade, the matter is taken out of the control of the investigator; both he, and any other person working with him, is prohibited from involvement. Instead a uniform branch inspector is deputed as the identification officer (IO) and he has sole charge of the proceedings.

The IO is guided by mandatory rules contained in a dossier that, when completed, forms the basis of the evidence he will give in court if the suspect is charged. The first thing he needs is the written consent of the participant. If this is not forthcoming he is obliged to issue a warning that refusal may be mentioned during any subsequent court proceedings. The immediate consequences may be a further request to participate in one or other of the permissible methods of identification. In order to form a parade, it is necessary to recruit a pool of volunteers from members of the public who have similar physical characteristics and ethnic background to the suspect. He will eventually stand alongside eight of them, but reserves must be on hand to cater for any reasonable objection advanced by a suspect, or his lawyer to any parade member chosen by the police. Objection to participants is a tactic regularly employed by some criminals and the IO must judge when to call a halt before insisting on continuing or cancelling the parade altogether. It is a dilemma he will also face if the suspect is disruptive or deliberately obstructive.

All will be straightforward if the suspect is co-operative. He will be supported, if he wishes, by his solicitor or a friend, as he listens carefully to the IO's reasons for holding the parade, an explanation of what will happen and his rights and privileges

throughout the process. He receives a specific warning about the consequences of changing his appearance before standing in the parade – it would be mentioned at any subsequent trial. The suspect and his solicitor are also provided with written details of any description the witness has supplied to the police and any previous attempts to identify an offender by photograph or other imagery.

Identification parades consume a great deal of time and space. The recruitment of innocent participants is never easy, and very often witnesses take a lot of persuading to become involved in confrontation. The ordeal is now somewhat alleviated by the use of mirrored screens, through which a line-up can be viewed without the witness being seen.

Several rooms are required, in close proximity to the parade room. All witnesses must be accommodated separately, without being given any opportunity to collude with each other, before or after they see the parade. Neither should there be any chance for the suspect or other participants to be seen prior to the line-up, or come into contact with witnesses. A large room is required where participants and reserves can wait until called upon. The parade room must be large enough to allow space between a line of nine individuals and have doors at either end for entry and egress. In modern complexes it must also house a substantial glass screen running the length of the room, and have sufficient space for photographers and film cameramen, who now routinely record many parades.

Each parade member's position is prominently numbered. The suspect is allowed to occupy the one of his choice during the formation of the line and, if he so wishes, change it before another witness is introduced.

Witnesses are escorted to the room by a police officer who is prohibited from any discussion. The IO ensures that everything he says is within the suspect's presence and hearing or, if a screen is used, in the presence of his friend or solicitor. (In the unlikely event that no supporter is present, everything he says or does must be recorded by video.) He reminds the witness of the purpose of the parade, and before inviting him to walk along the line twice, tells him that the person he is trying to recognize need not necessarily be present and he must state explicitly if he is unable to do so.

It may be that a suspect was originally seen in profile, sitting, kneeling, heard in conversation or uttering a single word. It is therefore permissible to ask all the participants in the parade to adopt the relevant posture or speak a previously agreed form of

words. If any objection about any part of the process is raised by the friend or solicitor the witness is removed to a place of isolation while it is resolved.

When the viewing is over the IO asks if the person the witness seeks to identify is present, and if so to articulate the numbered position. For the benefit of the suspect and his supporter he is then also asked if he has seen any published material relating to the crime before having viewed the parade. At the end of the parade the IO annotates his dossier with any comments made about its conduct by the suspect.

Most witnesses who attend parades find it an intimidating and harrowing experience; some are reluctant openly to accuse someone of a crime, no matter how certain they may be. It is by no means unusual for an apprehensive person to confide in a police officer at some later time that they positively recognized a member of the parade, or that someone closely resembling an offender was present. If this occurs before the participants have dispersed, the IO will attempt to persuade the witness to re-enter the room and confirm his assertion. If he refuses, or the disclosure is made some time later, the issue is communicated to the suspect or his lawyer. Such evidence can be introduced as part of the prosecution case and properly tested by the court, although its probative value is obviously weakened.

Group Identification

Attempts to secure identification evidence by intermingling a suspect with an informal group of people is an alternative method, used on occasions when the right to refuse to stand on a formal parade is exercised, or it is impracticable to arrange one. Similarly, the suspect may again reject this approach.

Group identification normally takes place in public, unless the suspect poses a threat to others or is likely to escape custody. Busy situations are favoured: bus queues, shopping malls, crowded escalators or an exodus from a factory gate. The IO is obviously unable to exercise any control over similarity between the suspect and members of a crowd, but he tries to select a location where people of a similar type can be anticipated. The object is to avoid any subsequent suggestion that, to use a well-known phrase, the subject stood out in the crowd. It is possible to allay this fear by filming the scene, either as the operation is in progress, or immediately afterwards and by having it assessed by the suspect's lawyer or friend. Only one witness at a time may be taken to the area where the operation

takes place, and viewing the stationary or passing crowd is subject to the same conditions of impartiality and representation as a formal parade.

In those instances when police premises must of necessity be used, the suspect is required to interact with a group of at least eight other physically similar people; the witness may again choose to protect his anonymity by standing behind a screen.

Video Recording

Someone who declines an opportunity to be recognized in the flesh can opt to be filmed. Witnesses are then shown that record along with a compilation of eight other numbered sequences showing similar subjects in the same situation or location. All the arrangements for making and showing the film are the responsibility of the IO and his staff. The suspect may see it before it is shown to witnesses, raise reasonable objections to its content, and a representative can attend the subsequent viewing, although, for obvious reasons, the suspect may not. He may, however, witness the film's destruction if no positive identification is made.

Covert Operations

A suspect who refuses to co-operate with any suggested method of identification is told of the investigator's right to try and secure such evidence covertly. Because each covert operation is unique it is difficult to exercise control over environment or participants. The suspect will be unaware of it occurring; nor can he be entitled to representation. For these reasons the administration of the entire process must be scrupulously impartial and fully documented if evidence obtained is to be acceptable to a court.

Confrontation

As a last resort an investigator can instruct the IO to arrange a direct confrontation between suspect and witness. This method is only used when other means of identification have been refused, satisfactory evidence cannot be secured in another way, or the unusual nature of the suspect's physical characteristics make it impossible to present him to witnesses alongside other similar people.

It is a simple procedure, carried out in an open room or with

the protection of a viewing screen. The suspect has no right to object but may have the support of a representative. The question is asked, 'Is this the person?', and the witness's reaction recorded. Evidence obtained in this way, no matter how positive the assertion of a witness, is the most unsatisfactory from the viewpoint of the courts and will almost certainly be severely tested during any subsequent trial.

Fingerprints

The unique ridges of human skin on hands, and occasionally feet, provide investigators with a remarkable medium for positive identification. For this reason the police are empowered to obtain finger and palm impressions from anyone connected to a host of specified offences. These are then classified by experts and filed in local, regional and national indices for comparison with marks found at scenes of crime. They are the surest means of establishing the identity of arrested re-offenders and dead or missing persons.

Positive proof of identity is accepted by the English legal system if sixteen points of a fingerprint impression exactly match a mark held within a reference collection. Sometimes, if two partial marks are recovered and can be shown to have been deposited contemporaneously, fewer points from each may be added together to reach the required standard.

Legal mechanisms exist that allow finger and palm impressions to be obtained to facilitate comparison. Anyone may be asked to have their impressions taken, providing the reason for requiring them is fully explained. If the request is made at a police station a signed consent form is required, but wherever they are taken the donor is assured that they will be destroyed unless he is convicted of a recordable offence. The destruction may be witnessed by the donor if he expresses a wish to do so.

(The home secretary is responsible for itemizing recordable offences for which fingerprint impressions may be obtained without the donor's consent. In general terms the list includes all those offences that carry the possibility of a prison sentence, although some of the more serious traffic and public order offences are also included.)

Fingerprints may be automatically obtained without consent from anyone, once they have been charged or reported for a relevant offence, or after having been convicted by a court. They may also be taken if a police superintendent certifies that they

will assist in confirming or denying an arrested person's involvement in crime.

Police officers are given legal authority to use as much force as is reasonably necessary to obtain the impressions. This is, however, virtually meaningless. Obtaining clearly defined finger marks is a delicate operation, requiring the co-operation of a compliant subject. Securing them from a reluctant person is almost an impossibility. Much, therefore, relies on an officer's powers of persuasion.

Many people are convicted of recordable offences who have never been in custody, but are instead summoned to appear at court. In these circumstances the police may, within one month of conviction, require attendance at a specified time for the purpose of obtaining fingerprints. Failure to attend carries the liability of arrest.

These various powers have enabled the police, over many years, to build up a considerable collection of finger and palm impressions from convicted criminals. Each mark is separately classified into group features and a computerized national data bank is readily searchable.

Body Samples

Several elements of the human anatomy provide material that may, after scientific examination, assist in identification. For legal purposes they are divided into *intimate* and *non-intimate*, each with conditional methods of seizure.

Genetic research, with its ability to isolate deoxyribonucleic acid (DNA) from human cells, has proved the most exciting development in recent times. The identification evidence it provides is on a par with fingerprints. The nucleus of most living cells contains DNA, a genetic code unique to all individuals apart from identical twins. It is extracted from the cells to provide a visual representation akin to bar-codes. These charts, developed from a suspect's control sample and those found on victims or at crime scenes, can be compared to establish matching features. Media through which the process can be carried out include blood, cells from the mouth lining, semen, human tissue and hair follicles. So important are these developments to criminal investigation that a national DNA register of those convicted of recordable offences has been established.

An *intimate* sample is defined as blood, tissue fluid, urine, saliva, pubic hair and swabs from all body orifices apart from the

mouth. These, together with dental impressions, may only be taken with the agreement of the donor *and* if a police superintendent believes that to do so would reasonably assist in establishing guilt or innocence. With the exception of urine, all intimate samples must be obtained by a registered medical practitioner (and dental impressions by a registered dentist). Force may not be used to obtain intimate samples if consent is refused, but the law allows dissent to be regarded as affirmative evidence in criminal proceedings. Consequently, anyone who refuses to co-operate must be warned in specific terms that he may harm his defence by doing so without good cause.

Non-intimate samples, or body impressions, may be taken with the suspect's written consent *or* if authorized by a superintendent who considers them necessary to confirm or negate involvement in a recordable offence. Non-intimate samples include nail scrapings, hair from areas other than the lower abdomen, swabs from any external part of the body and the mouth, footprints and body impressions.

With the advent of a national register, it is important that all donors of samples are informed that speculative comparisons will be made with material already in police possession. All body samples must be taken in conditions of privacy, and unless a doctor or nurse is present, a person of the same sex as the donor must be in the room.

Case Study: Identification

The recovery of a swollen, decomposing female corpse, trapped beneath overhanging branches in receding floodwater, clothed only in a piece of sacking and liberal amounts of silt, may seem an unpromising start to the process of identification. But a dead body in any condition is capable of revealing many secrets to the careful investigator.

Naturally the first step should be to establish how the body came to be in the water – is it the result of a swimming accident, suicide or murder? A pile of clothing and a towel conveniently placed on an upstream bank would indicate the former, although that is highly unlikely in the middle of winter. Anyone intent on suicide does not normally undress before throwing themselves into water; so that solution is also improbable. In any event the subjects of both these possibilities are normally reported missing, which makes the business of elimination relatively easy. So the investigator in this case must be suspicious from the time he first views the body.

External examination on the mortuary slab begins with a complete photographic record. The photographs capture a pattern of silt deposits

on the head and torso that may assist other experts to establish how long the body lay beneath the surface and its posture while the river fell. The sack, secured by a cord tied tightly around the waist, is then examined. Care is taken not to disturb the knot when the cord is cut – it is sometimes possible to tell if it was tied by the wearer, or whether whoever tied it was left- or right-handed. From marks in the underlying skin of the body, it appears unlikely that the woman secured the sack herself. The material is embedded in the swollen flesh and, when measured, the cord is only nineteen inches long. No one, however demented, is likely to inflict such discomfort on themselves before plunging to their death – it provides the first positive indication that no innocent explanation for her demise will be recorded.

Two small wounds on the scalp are carefully examined but provide little constructive information: the condition of the body makes it impossible to establish if they were caused before death. Skin discoloration due to putrefaction obscures bruising, and immersion in water obviously washes away blood that may have seeped from a flesh wound during life. The marks may have been caused by an obstruction in the water. The interior of the corpse is likewise affected by a lengthy period of immersion and it is often difficult to determine whether water has reached the lungs by inhalation during drowning or from saturation by soaking and seepage. Water, however, does not so readily damage bone structures and in this case there is a vital clue that can hardly be attributed to accidental causation: delicate bones in the neck are fractured at a point regularly associated with manual strangulation. It is now almost certain that the detectives are dealing with murder: every effort must now be made to identify the cadaver. More than 80 per cent of murder victims have some previous association with their killer, and early apprehension of a suspect will avoid the danger of evidence being destroyed. To assist in the process it is essential that every fragment of useful information is obtained from the lengthy autopsy.

Distorted facial features rule out any attempt to compile photographic or artistic images suitable for general circulation, but some skilled artists are capable of creating accurate representations. In cases of severe disfigurement the bone formations of the face and skull can be used to reconstruct facial features. A combination of these efforts can often produce lifelike images capable of being recognized.

The pathologist and his forensic colleagues pay particular attention to abnormalities; the woman has an abdominal operation scar attributable to an earlier appendix operation; an old crush injury had disfigured her thumb; and her ears have been pierced. When she died, the woman was still capable of ovulating and was therefore of child-bearing age; skeletal structures give some indication of build and an overall height can be ascertained. Hair colour can be fairly accurately described and samples

are taken for further analysis. Eye colour is not so reliable after a period of immersion, but skin pigmentation suggests a Mediterranean origin.

Initial examination of the internal organs shows a healthy, probably non-smoking, existence prior to death, but samples of the vital organs are removed for later histological examination in the laboratory. Stomach residue indicates consumption of a substantial meal within hours of death and will be analysed to confirm the content. Blood, ordinarily taken from an artery, is obtained for grouping purposes; here it is found in an uncontaminated section of deep thigh muscle that the pervading river water has not yet penetrated. The same tissue will be used to obtain a DNA profile.

The inevitable question about the time of death is complicated by another factor: the investigator is also anxious to ascertain how long the body has been in the water. Most killers are only too anxious to dispose of a victim as quickly as possible but any significant discrepancy in the answers may mean the victim was transported some distance from the death scene. Much depends on water temperatures, the extent of decomposition and the condition of the outer skin. The weather has been cold, thereby delaying the effects of putrefaction, but skin is starting to peel from various parts of the cadaver. After these factors are taken into account the pathologist estimates that the body has been in water for no longer than two weeks.

When the pathologist has completed his task, other experts take over. A radiographer will already have taken X-rays of the corpse to find fractures or other abnormalities, before an odontologist removes the jaws and dental plate. Then a fingerprint expert obtains whatever impressions are still available from the distorted skin on each digit, and the palms and soles of the feet. The condition of the skin leads him to doubt that his efforts in the post-mortem room will provide sufficient detail, so he has the pathologist remove the top joint from each finger and place them in preserving fluid. He may be able to obtain better results in his laboratory.

During the ensuing days, while the various specialists build a complete physical record of the woman and try to establish a cause of death, detectives begin enquiries which may give a lead to her identity. Missing persons' records are checked and widespread searches of the banks of the river and its tributaries are carried out for discarded clothing or other evidence of violence. All these avenues prove to be dead-ends.

Waiting for the experts to reach conclusions is a frustrating time. When they are all eventually ready, the senior investigator must decide what direction the inquiry should take. He soon commits one possibility to the pending tray. The fingerprint examiner has been able to obtain impressions from which he would be able to make a positive

identification, but the national indices have been checked and the woman has no previous record.

Forensic reports are more encouraging. The sack-like garment has been identified as a light canvas bag, almost certainly the type used to stow a large tent or caravan awning. Because the maker's tag has been removed and the material is mass-produced, an elimination exercise to establish the manufacturer and distributor is out of the question. Some information of significance, however, has been found: microscopic examination has shown that the tear in the base was caused by friction between a solid object inside the bag and external surfaces. A human body is thought insufficiently tough to cause the damage; the only possible conclusion is that the bag was weighted with a solid object before being cast into the river.

Scientists employed by the National Rivers Authority, having examined silt patterns on the cadaver, deduce that it was in a vertical position during a period of receding flood while muddy deposits settled. They can also conclude that once the bag ripped, the body was released from the bottom, drifting only a short way downstream before becoming trapped on the surface; otherwise the mud would have washed away in the strong current. By charting the height of the flood waters throughout the time the river was in spate and comparing directional flows and currents, they are able to pinpoint the most likely place of immersion as a river bridge about half a mile upstream. The bridge, carrying a busy A road in an isolated rural location, might well be a convenient spot to dispose of incriminating evidence. Although this information narrows down one area of search, it gives the investigator little optimism that he is dealing with a local crime – the body may have been transported from anywhere in the kingdom.

Scientists in other departments have not been slow to provide information: a rare blood group is confirmed; the deceased consumed a meal of kidneys, mushrooms, rice, rhubarb and red cheese; the woman's hair had been dyed at regular nine-week intervals throughout the eleven months prior to death. These findings open up lines of enquiry at medical practices, hospitals, hotels, restaurants and hairdressers within an area defined by the investigator after assessing the manpower resources at his disposal. Before he can move further afield he will require more information to point him towards a particular locality.

Medical experts supply the most promising details to help advance the inquiry. X-ray plates had not revealed any old fractures, but something far more significant: linear bones are marked with distinct lines, caused by temporarily impaired growth during severe childhood illness. The position of the marks, known as 'Harris lines', is unique to the individual sufferer. Careful measurement and comparison of two sample plates from the same person can lead to positive identification.

The pattern of childhood illness is confirmed by radiological survey of the teeth. These are marked with horizontal chronological hypoplastic lines, which confirm at least two serious illnesses retarding tooth development between the ages of one and two years. The dental examination is also able to narrow down the female's age to between thirty-six and forty-eight as well as providing an exact chart of previous dental work. The dental plate is stamped with the letter 'C'. Many dental technicians engrave their plates with initials for various purposes; they may denote the first letter of the recipient's name, her dentist's, the technician's or his laboratory. It will be necessary to find her dentist and any existing X-ray plates taken during past treatment to make use of these discoveries.

This extensive activity has armed the investigator with a medical and dental profile of his subject, together with some general suppositions about her lifestyle. He will add them to all the other data so far gleaned and build as complete a picture as possible to help him formulate other lines of enquiry. He now knows the woman has been killed and a determined attempt made to conceal her remains. He also appreciates that all the information he has so far collected will be useless unless he can set it alongside details of someone who has either been reported missing, or whose whereabouts give relatives and friends cause for concern.

Although he will be anxious to follow any possible line of enquiry, the investigator must always be conscious of the need to make best use of the limited resources at his disposal.

Having compiled a detailed description based on all the information now at hand, the investigator can now search the PNC missing persons index and circulate photographs and particulars of the cadaver to all forces in the United Kingdom. The Police Gazette *and regional publications will also help publicize the inquiry. Within days it may be anticipated that the investigator will have details of several thousand missing females of the relevant age stored in his incident room computer. His task is then to reduce this number to manageable proportions by comparing individual records with each identifying feature of the murder victim. In order to expedite the elimination process he will often follow a hunch based upon experience and a careful evaluation of the evidence. In reaching his decisions he will weigh up what may appear to be peripheral issues – the woman led a healthy and comfortable lifestyle; she followed a regular regime of hair care until nine weeks before death; the cosmetic dental work had been competently managed and expensive. He will therefore eliminate from his lists those women who do not conform to his appraisal of the victim's social profile.*

Height, build, age, hair coloration and deformities will all be taken into account in compiling a list of 'possibles' that his inquiry teams will

attempt to trace. The weeding exercise is not without risk, but to shy away from it would mean covering every eventuality and bogging down the inquiry in trivia.

There is no reliable central record against which the impressive medical and dental profiles can be compared; a situation that may change if proposals to establish a national database of medical records go ahead. The woman's individual practitioners must be discovered if this information is to be of use. It is a hit-and-miss affair, relying on memory, or an exhaustive search of practice records – one that is rarely undertaken by hard-pressed staff.

Very often it is more productive to concentrate on seemingly less important data. A hairdresser may match an artist's impression with a client who conformed to a pattern of hair care; restaurant or hotel staff might recall someone who ordered a meal containing the same combination of ingredients as was consumed by the woman within hours of her death.

All these factors are taken into account when establishing priorities, but after many thousands of man hours have been expended everything turns to dust. The investigator has to face the fact that despite his best efforts, and without the intervention of a little luck, the cadaver will remain unidentified and a murderer will go free. There is always a chance that a killer will strike again, and it is little consolation to know that most homicides are committed by family members or acquaintances in the heat of the moment and rarely repeated. In fact it is that particular statistic which spurs him towards one final effort before the decision is taken to scale down the inquiry by those responsible for allocating his resources.

The inquiry's complex database is re-examined in fine detail for last-minute inspiration. Only one possibility remains. Someone, somewhere, must know this woman and would no doubt recognize her if presented with a more authentic impression than the wooden-featured death mask previously circulated. In asking a portrait artist to animate the outline the investigator risks the possibility of inaccuracy, but at this stage it is a chance worth taking. There is, however, a further obstacle: achieving widespread media coverage for what is now a stale story. Using a combination of persuasion, guile and a little charm he obtains the necessary co-operation.

After publication of the new impression several days pass before the stroke of good fortune the patient detective has waited for suddenly happens. It has taken a long time for a young man to come to terms with his worst fears. His mother, Italian by birth, suddenly left home three months earlier. Then he saw a facial image flash across the television screen as he casually watched the regional television news. His parents' marriage had been a volatile affair for as long as he could remember and

it was therefore not much of a surprise when the father announced that his wife had returned to her native land. The young man knew all her clothing and possessions had gone with her. What did cause him some unease was his father's increasing irritability and the absence of any communication from his mother, particularly on a recent birthday. He agonized for some days over the similarities he discerned in that fleeting image, but eventually summoned the courage to drive forty miles to the police station hosting the missing-person inquiry.

'That picture on the telly the other night of the lady in the river – it might be my mum.' That may well have been the end of the story; in fact there were many more difficulties to overcome. Both a criminal trial and a coroner's inquest demand high levels of proof before presuming a person's identity. Visual identification of a rotting corpse is invariably impossible, particularly if there is no personal clothing, possessions or jewellery. In this case, however, it is thought that the wealth of medical evidence will surely establish if it is the missing woman. Unfortunately, by incredible coincidence, the Grim Reaper has taken a terrible toll: her dentist and his technician are dead and their records destroyed; the surgeon who operated on her has met the same fate and extensive X-ray plates taken during exploratory tests were incinerated a few weeks before the young man came forward.

The son confirms that his mother had something wrong with her thumb and wore false teeth, although he cannot remember whether it was a top or bottom denture. He also recalls her going into hospital for some type of operation. His father is uncooperative and seems to remember little about his wife of twenty years; he sticks to the story he told their son. He is, however, trapped by one minor detail. He tells the investigator that after his wife left home she telephoned and asked him to forward all her belongings by rail to a left-luggage office in central London. It takes only a short time for British Rail to search their records and establish that no such transaction occurred. It also requires very little effort to trace the woman's hairdresser, who confirms the scientific evidence of systematic dyeing and is able to produce an appointments register.

All this is highly suspicious, but mainly circumstantial, and more needs to be done. A thorough search of the family home gradually unearths vital evidence that will, at last, draw matters to a swift conclusion. A caravan awning and poles lie loose on the garage floor; their container is missing. There is a sizeable gap in the stonework of the garden rockery. Scientists get a reaction to human blood on a wall in the stairwell. Then comes the most significant find: despite efforts to expunge the house of all signs of female occupancy, a small pile of Italian fashion magazines in a corner of a wardrobe has been overlooked. Treated with an enhancing fluid the pages produce several partial finger impressions that match those taken from the cadaver.

Confronted with this absolute certainty the husband faces up to the inevitable and admits killing his wife. The rest of the story is routine. Years of conflict end in a frenzy of violence, unintended slaughter and blind panic to dispose of a corpse. Immersion in water is among the commonest methods of disposal, and in this instance, if the elements of decomposition had progressed a little further the unique characteristics of the fingerprints may have been destroyed completely and positive identification would have been impossible.

Case Study: Aggravated Burglary

A peaceful domestic evening is rudely interrupted by the sound of breaking glass. A widow and her teenage daughter rush from the lounge, where they had been watching television, and find a house brick, surrounded by shards of glass, in the centre of the breakfast room. Casting terrified glances at curtains billowing in front of the shattered window, they run to a neighbour's house. Showing little more resolve than the frightened women, he decides that discretion is the better part of valour and dials 999.

A patrolling policeman soon arrives and makes a cursory examination of the house and garden. He finds no signs of an attempt to open the broken window or footprints in the soil beneath. The commotion has disturbed other neighbours, none of whom can throw any light on the matter. A prank by some local yobbo is regarded as the most likely explanation, and after unsuccessfully trying to reassure the shaken occupants, the officer goes on his way. A brief entry in an occurrence report when he completes his tour of duty will be the only record made of an incident that will be quickly forgotten.

Next day a relative replaces the windowpane and the mother and daughter are obliged to live with their fear, in the hope that time will ease, if not erase, the anxiety caused by a seemingly mindless act.

Almost a week later the young girl is suddenly woken from a deep sleep as a gloved hand covers her nose and mouth – at the same time she is aware of cold metal pressed against her neck. Before she is overcome by paralysing fear, her natural reaction is to pull away sharply and scream at the top of her voice. Everything then happens so quickly that it will later prove impossible for her to give a coherent account of events. The mother, senses dimmed by sleep, is propelled from her bed by maternal instinct. When she reaches the small landing, dimly illuminated from nearby street-lamps, she finds that she is blocking the escape route of a figure dressed head to toe in dark clothing. Her screams echo those of her daughter, and before she can move out of the way, feels a sharp pain in her chest as the figure lunges forward, descends the stairs in a couple of bounds and crashes through the glass panelled front door.

The mother's first concern is for her daughter, whom she finds sobbing hysterically and nursing a gash in her arm. Overcoming her own pain and fear, she helps the youngster into the main bedroom, barricades the door with a dressing-table and screams for help through the open window. It is only then that she becomes aware of blood soaking through her bedjacket.

The same luckless neighbour, already disturbed by crashing glass, listens to a garbled story and again calls the police. The first officer on the scene quickly satisfies himself that the intruder has left the premises before extricating the victims from the bedroom and seeing them safely into an ambulance. The gravity of the situation is immediately apparent to him, having seen the wounds and the amount of blood spread throughout the first floor of the house. He has no need to summon assistance because the 'shout' that first sent him to the emergency was heard by all patrols in the area, and they soon arrive in numbers.

Immediate enquiries are supervised by the night duty inspector. A search by foot-patrols and dog handlers for discarded weapons, masks or clothing is quickly organized. An officer is posted at the front door to prevent unauthorized entry – equipped with a clipboard and pen, she will record the identity and movements of everyone who visits the house.

The divisional detective chief inspector (DCI) is no stranger to disturbed nights: criminals have little regard for normal working hours and many serious crimes are committed at very unsociable times. There is some delay until he arrives on the scene to be briefed by the senior uniformed officer. Searches have discovered nothing significant and the immediate task is to secure sufficient resources for what may become a protracted investigation. Having given a subordinate a list of his requirements, the DCI dons an anti-contamination suit, overshoes and polythene gloves before entering the house. A search of intelligence files in the local computer has already retrieved details of the previous alarming incident and, as the senior detective carefully edges his way alongside skirting-boards to avoid disturbing evidential traces in the centre of rooms and hallways, he notices curtains flapping in the breeze across the breakfast-room window. The freshly installed pane of glass has been neatly removed by stripping the still soft putty from the frame and placed against the outside wall. The point of entry is obviously linked to the earlier event. His examination of the first floor is cursory; it is better left to the expertise of scenes-of-crimes officers (SOCOs) and a scientist he will summon from the forensic science laboratory. Copious blood splashes are in evidence, but he is careful not to draw hasty conclusions, as he knows from experience that a little blood goes a long way and visual effect is not always a reliable indication of the seriousness of an injury. At this stage he is more preoccupied with the unusual method used to enter the house – although he is as yet

uncertain of the motive. It reveals a determination which is not often the hallmark of a house-burglar bent only on theft. What little he already knows of the attack gives him an uneasy feeling that the intent was physical, if not sexual.

Before committing a large number of officers to a full-scale inquiry he needs to satisfy himself that there is no obvious solution: a jealous lover or some other domestic situation. None of the neighbours is aware of any such problem, so the DCI visits the hospital in the hope that he may be allowed a brief conversation with the victims. He is restricted to a few words because, although the injuries are not life-threatening, the women are in a state of severe shock. Though the conversation is fruitless, his instincts tell him that these are decent people who have no idea why they have been singled out for such attention. There is no alternative but to organize a major investigation. A call-out roster is activated; detectives and SOCOs are instructed to rendezvous at an incident room in the divisional police headquarters. A decision to implement a computerized major-incident suite will be delayed for a few hours until the DCI gets a 'feel' for the inquiry – he still hopes for a speedy resolution. A fully manned Home Office Large Major Enquiry System (HOLMES) is one of the most labour- and resource-intensive undertakings in police operations and the commitment is not lightly entered into. Everything done in the initial stages of the investigation will be recorded on paper in the event that back-record conversion later becomes necessary.

Scientific officers are well versed in their task and require little briefing. Their supervisor will ensure that the house is systematically searched for evidential samples that may help to identity the assailant. The first job will be to lay specially designed duck-boards and sheeting on the floors to avoid contamination while a full photographic and video record is made of the interior. When that is finished the scientific and fingerprint officers can get to work. It is a painstaking process that, in heavily contaminated scenes, can take days – but it is largely a matter of routine.

It is the main thrust of the field operation that requires originality and intuition. The senior detective is informed that there has not been a similar incident on his patch in recent times and a search of the regional undetected crime index produces a similar result. He next interrogates the modus operandi *and criminal names indices using wider parameters: method of entry; attacks on women alone at home; violence perpetrated by masked assailants; recent releases from prison of men convicted of violent sexual acts; and so on. At the end of all these enquiries he has a mass of detail to sift through, but little hard intelligence from which to advance his cause.*

Information from local sources is the immediate requirement. He enlists the assistance of the local media to appeal for help and circulates

the details of the crime throughout the regional police network. But usually the best chance of success is a direct approach to people living in the area of the attack. The value of the basic investigative ploy of 'door-knocking', or house-by-house enquiries, is never underestimated by the skilled detective. A supervisor is allocated a number of officers who will solicit information using prepared questionnaires. Another team will stop passers-by at strategic points near the scene of crime. These tactics invariably garner snippets of intelligence that advance the most serious and involved investigations. Later in the day a vehicle road check will be considered, probably a couple of hours either side of the time the original crime occurred. (A road check for the purpose of establishing whether a vehicle is carrying someone who may be a witness to an arrestable offence may only be authorized by a police superintendent, subject to certain restrictions and documentary obligations set out in Section 4, Police and Criminal Evidence Act, 1984.)

Having deployed his investigators, the senior detective can only bide his time and await developments. He is not idle. He will want a report on the victims' condition, and if they are fit enough, will arrange to interview them. Progress on the examination of the house must also be supervised and the scientific team continually updated with anything the victims may be able to say about the assaults. The logistics of a long-running inquiry must also be considered and itemized requirements for such an eventuality submitted to senior management. The matter of scale is constantly in his mind, and a decision to escalate the investigation, with all its ramifications, can only be hours away.

But by mid morning there are signs that the tried-and-tested methods may bear fruit. A mature uniformed constable, engaged on house-by-house enquiries, contacts the control room. He is unhappy with the reaction he has received from a resident in a block of flats, about 400 yards from the victims' house. It is nothing more than intuition: a shifty, dishevelled appearance; reluctance to provide direct answers to the list of questions; and a furtive attempt to obstruct the view from the communal corridor into the flat. The only specific thing that supports the intuitive reaction is an angry, recently inflicted scratch on the evasive man's face; it is not commented on by the policeman, who has no wish to give any indication of his suspicions.

The name given by the young man is checked against PNC and local records – nothing is known about him. Nevertheless his questioner insists that his instincts are correct and the DCI decides to use his personal powers of persuasion to try to gain entry to the flat and speak to the suspect. When he arrives the bird has flown – or at least no one is answering the door. The level of suspicion is insufficient to allow him to break down the door or apply for a search warrant, so he begins a

secondary enquiry to find out something about the young man and trace his present whereabouts.

It is a trait of human nature that close neighbours usually protect each other provided they exist in a state of relative harmony. Conversely, they are only too happy to turn against anyone who disrupts their lives. The suspect is just such an exception and willing tongues are eager to condemn. They describe a loner with a penchant for loud music and a nocturnal lifestyle who only recently moved into the rented accommodation. The owner of the premises provides documentary evidence of the tenancy, which shows previous connections with a northern town.

A constable is posted outside the suspect's flat, while others scour the town for him. It does not take long to find him pumping iron in a local gym, and when approached he tries to flee. Quickly overpowered, he is unable to provide a satisfactory explanation for trying to escape or the scratch mark on his face. More unexplained marks are found on his forearms. The constables decide they have reasonable grounds for suspecting he is guilty of causing grievous bodily harm and arrest him. The arrest empowers an inspector to authorize a search of the flat; initial examination confirms the investigator's suspicions. Sado-masochistic and pornographic literature litter the rooms together with handwritten ramblings of a mind tormented by explicitly violent sexual fantasies. An exhibits officer carefully packages and logs the offending material while a team of SOCOs search for further evidence. The officer examining the bathroom notices that paintwork around securing screws in a hardboard panel at the foot of the bath shows signs of disturbance. When removed it reveals a hiding space for a balaclava helmet, a pair of gloves and camouflage clothing. The lavatory cistern conceals a waterproof box, containing a commando knife and industrial pliers.

Other SOCOs have been dispatched to the hospital. The victims are now well enough to allow collection of control samples of their hair, and scrapings from beneath fingernails. Blood samples are also required and their nightclothes will be separately packaged. To avoid cross-contamination of evidential samples different SOCOs deal with each victim and neither will be involved in collecting evidence from the crime scenes or suspects.

The rapid developments give rise to a mood of quiet optimism among the detective team, but the senior officer's experience tells him that he must never count his chickens before they hatch. The quest for a definitive answer will continue unabated and, as is often the case when a prisoner is in custody before all the evidence is available, immediate challenges lie ahead. A pair of detectives, instructed to interview the suspect in the presence of his solicitor, meet a wall of silence – he insists on exercising his right to say nothing. The only voices recorded on the

tape belong to the two officers, seeking explanations for the facts so far discovered. He also refuses to provide his fingerprints or a blood sample; nor will he submit to a medical examination. Since confirming his identity, detectives have discovered that, until a few weeks before his arrest, he was a resident patient at a psychiatric hospital. However, he refuses to sanction the police to examine his health records, and medical ethics prohibits any unauthorized breach of confidentiality. It is known that the suspect discharged himself from hospital against advice, and that he is considered a threat to himself and others unless he takes regular medication. He will, therefore, be examined by a police surgeon; any prescribed medication is thereafter the responsibility of a custody sergeant.

The evidence so far obtained raises strong suspicions, but is as yet circumstantial. From the moment of arrest the investigator has a mere thirty-six hours to find hard evidence connecting the suspect to either victim or their house. Otherwise he faces the possibility of having to apply to a magistrate for a period of extended detention. In view of the prisoner's medical history and his intransigent attitude, there is good reason to predict that he may be a threat to more members of the public, if he regains his freedom immediately. Those responsible for allocating budgets normally decide in favour of a detective striving to solve this all too familiar problem with sufficient additional resources.

Another facet of major crime investigation is fatigue, particularly when after completing a normal day's work, detectives are recalled to duty in the early hours and are then required to soldier on through the following day. When an arrest is made and the pressure is on to discover sufficient evidence to bring charges, the senior investigator must make sure that his subordinates have sufficient rest. This also applies to himself – weariness dulls the brain, causes mistakes and encourages short cuts. But in these critical circumstances, he is obliged to plan his tactics before considering sleep.

More officers will be brought into the inquiry to speed up the house-by-house process; others will be briefed to find any associates or haunts of the prisoner and his history will be combed for relevant clues. Application for a vehicle road check is authorized and further press releases issued to keep the quest for information in the public arena.

A forensic link between premises or parties involved in the crime is the most likely and surest path to success. The investigator, his scene manager and a forensic scientist discuss the available evidence and identify samples likely to confirm most quickly the substantial grounds for suspicion. Most of the possibilities will take too long to analyse, but blood presents the best opportunity. It is decided that the best course is to screen all the prisoner's clothing in the hope that it will bear traces that can be matched with samples obtained from the victims. With this

decision made, the detective-in-charge can take a well-earned rest and await developments.

It takes several hours to muster off-duty laboratory staff and prepare equipment. The screening process is laborious, and it is not until the early hours of the next morning that the first positive results are produced. Human blood smears have been found on a glove and trouser leg, one of them suitable for grouping purposes. There is more delay while scientists work to give a definitive classification to the sample, and the investigator uses the time to marshal his facts; for, if it becomes necessary to extend the prisoner's detention beyond twenty-four hours, he must present his case to a reviewing superintendent. If such an executive inquiry is needed, it must be delivered in the form of a comprehensive summary in order to counter representations from the accused or his legal representative.

As it turns out, the review will not be necessary. The blood is of the same rare group as one of the victims, and provides the vital corroboration to justify pressing charges.

Relieved of time pressures, the investigation can now take a more measured course. The DCI will once again concentrate on his general duties as divisional crime manager and delegate responsibility for follow-up inquiries to a detective sergeant and a small team of constables.

Eventually a DNA profile of the blood sample produces estimated odds of 25 million to one against the blood on the accused's trousers originating from anyone other than the injured female. Further evidence is produced. Chemical composition of putty samples obtained from the breakfast-room window-frame match traces recovered from the prisoner's gloves, and minute shards of glass embedded in the balaclava are identical to the refractive index of that in the shattered front door. More cross-matching evidence could quite possibly be obtained, but financial considerations impose a policy of selectivity on all investigations once enough evidence is obtained to establish guilt. The lengthy process of screening clothing to find hair and fibre traces will therefore be abandoned in view of all other substantive evidence that the inquiry has uncovered. The prosecution of the offender will rely upon the circumstances of the assault, the recovery of incriminating articles from places of concealment and positive scientific linkage between the victim and accused.

6 Rape

It is an offence for a man to rape a woman.
(Sexual Offences Act, 1956, Section 1(1)).

A man commits rape if:-a) he had unlawful sexual intercourse with a woman who, at the time of the intercourse, does not consent to it; and
b) at that time he knows that she does not consent to the intercourse, or he is reckless as to whether she consents to it.
(Sexual Offences (Amendment) Act, 1976, Section 1(1)).

Allegations of sexual offences always warrant serious examination. A young detective soon appreciates the value of comprehensive information about such offenders held in all police intelligence systems. The irresistible impulse of some young men to expose themselves to women often leads to more serious behaviour. What begins as a passive act can easily progress to physical assault and penetration.

Sexual perversion recognizes few boundaries and is one of the most depressing features of an investigator's work. Apart from coping with the stress of dealing with traumatized victims, he must become hardened to the realities of defilement, sodomy and bestiality.

The era of sexual liberation has not curtailed deviant behaviour; in fact it seems, in the eyes of many, to have widened the scope for vulnerable people of both sexes to be exploited. Women are, however, more aware of their right to determine how they conduct intimate, personal relationships and expect fair and sympathetic treatment from the police, the legal profession and the judiciary – all male-dominated institutions. These pressures have brought about change in the way that sexual offences are handled by investigators and the courts; the result is a more sympathetic system that protects the interests of

the victim, while ensuring that allegations, which can be easy to make but difficult to refute, are properly tested.

Instructions published by the Home Office set out the criteria for treatment of rape victims. The emphasis is on tact and understanding, even when it is suspected that an allegation has little substance. A woman who alleges rape should be medically inspected before being questioned about her ordeal. The examination may provide important information on which a subsequent interview can be based, or reveal evidence to confirm the allegation. Forensic samples should be recovered as soon as possible, to avoid contamination or dissipation. Immediate examination also accords with most victims' wish to cleanse themselves and change their clothing. Only in cases of extreme urgency, when a victim can name her assailant and a quick arrest is feasible, may it be prudent to test the authenticity of an allegation before any examinations are made.

Medical examinations are always conducted by specialist police surgeons, and it is the victim's right to insist upon a female doctor, if she so wishes. Her preferences for the venue should also be respected, but the need for treatment after a violent attack may dictate that it can only be conducted at a hospital. In that event, the extent of the examination is under the control of the doctor administering treatment.

Most constabularies have specially designed rape/trauma suites, either in police buildings or local hospitals, where victims are afforded privacy. Suites are staffed by experienced female officers who have received special training in counselling, stress management and interview techniques.

Detailed questioning is of the utmost importance if a victim is unaware of her assailant's identity. Describing not only the actual event but the circumstances leading up to it is often as distressing as the offence itself. The questioner will have to gain the victim's confidence and try to soothe the mixed emotions of fear, guilt, shame or anxiety before exploring the facts of the case. Many women are also apprehensive about the consequences of reporting rape namely, giving evidence in public in front of her alleged assailant. For these reasons, only mature women are selected as counsellors, and they are expected to provide support at least until the matter is finalized by a court. A male officer in charge of a rape inquiry will often need to speak to the victim, and sometimes, rarely, a female objects to being interviewed by someone of the same sex. In neither circumstance is a male officer allowed to conduct an interview unless he is accompanied by an officer of the opposite sex.

Providing there is no risk of putting an inquiry in jeopardy, victims may receive the support of a friend or relative during the period of questioning. In the case of juveniles it is mandatory that they be accompanied by a parent or some other appropriate adult independent of the police.

The law itself provides assurances to those who may be reluctant to report or pursue allegations of rape and the experienced interviewer will always explain them before attempting to elicit intimate facts. Defence lawyers are not allowed to cross-examine complainants about previous sexual experiences unless given leave to do so by the trial judge. This fear is predominant in the minds of many victims, and police interviewers should show the same reluctance to explore such matters, unless it is essential for the conduct of an investigation. For example, it may be crucial from a scientific perspective to know if a woman had sex with a partner shortly before being raped by someone else.

Assurance may also be given against the dread of unwarranted publicity. It is prohibited by law to publish the name, address or photograph of a rape victim throughout the period of her natural lifetime, unless she provides written consent. In practice, this dispensation is never sought by the investigator although, on rare occasions, a woman will, for her own reasons, wish to reveal her identity. The only anonymity given to an accused rapist is in those cases where publication would be likely to lead to the identification of his victim; this is particularly relevant to those offences committed within families or among close associates.

The treatment of rape victims must strike a delicate balance between a need both to respect the feelings of a traumatized woman and to probe for the smallest detail that may assist an investigation or dismiss any suggestion of malicious complaint. It is an area of police work fraught with difficulty, mainly because of individual complainants' conception of what constitutes rape, or misconceptions about the legal definition of consent. Rape is complete if penetration of the female is achieved, no matter how slight; damage to the hymen is not necessary for the offence to have been fully committed. Consent must be given its ordinary meaning of an agreement and must not be induced by force, fear or fraud.

A detective must treat each case on its own merits and seek to achieve fair treatment for both accuser and accused. While many rape victims feel aggrieved if their allegations do not bring about a guilty verdict, the law insists upon a degree of

independent corroboration. All intimate details of an accusation must therefore be rigorously explored – motives that are frequently misunderstood or resented.

Case Study: Rape

As dusk falls on an early autum evening, a farmer's wife watching television in her isolated house hears tentative tapping on the front door at the distant end of a long hallway. She expects her husband home for supper at any time, but knows that he will always breeze in through the kitchen. Other visitors would be unusual at this time and, in any event, the knock is indistinct. Initial thoughts that it may be one of the yard cats playing in the porch require confirmation when the noise returns after a few seconds. Glancing through the sitting-room window, she is startled by the sight of bare legs protruding from the porch entrance on to a gravel path. More than a little alarmed, she secures the rear of the house before peering through the front-door letter-box. Lying beneath the door is a young teenaged girl, bereft of clothing but liberally coated in blood.

The youngster is barely conscious and her puffy features indicate a severe beating. She can stutter only a few disjointed words that suggest she has been raped in a car. The word 'motorway' is used, and as the shocked listener attempts to comfort her she can clearly hear the hum of traffic passing along the six-lane highway half a mile across the fields.

When the local policeman arrives the girl has already been rushed away by ambulance and he is obliged to piece together a story from the witness, who is herself in a condition of considerable shock. He gleans that the victim's name is Sharon and she hails from an industrial city some seventy miles away. The manner in which she was found and a description of incised wounds on her torso leave him in little doubt that he has been summoned to a crime far beyond his experience or capabilities. It is a matter for the CID. While waiting for assistance he protects any significant areas from further contamination and relays all the information he has to his control room. Immediate missing-persons checks on the Police National Computer (PNC) reveal several Sharons, but none of recent origin or from the city in question.

The duty detective meets several problems when he arrives. He has no idea where the attack took place or, for that matter, the circumstances leading up to it. It is now dark and the only hope he has of finding a crime scene is to use the services of a tracker dog. Scenes-of-Crimes Officers (SOCOs) who arrive are also frustrated by the lack of light and can only secure relevant areas for later examination.

A female detective is sent to the hospital with instructions to relay further information to a senior investigating officer, who is now making

his way to the farm. The local police surgeon is asked to liaise with his hospital colleagues to ensure that, subject to the clinical needs of the victim, no forensic evidence is destroyed which may eventually identify the assailant. A SOCO will need to supervise the taking of sample evidence, as not all general practitioners, hospital consultants or junior doctors are aware of the precise requirements concerning packaging, storage and continuity of exhibits.

The tracker dog detects the scent of a trail leading away from the farm and leads its handler a short distance along the access lane and across two fields towards the motorway. Along the route are some faint indentations in grass. Eventually the track ends in a gateway alongside another quiet road. Shattered windscreen glass and a bloodied blouse are clear indicators that this is the place they are looking for, and a brief radio message to control soon produces the specialists who attend every scene of a major crime. Darkness renders extensive examination futile, so the area is roped off and the gateway covered by a polythene tent. No traffic will be allowed to use the lane until it has been properly searched in daylight, but all houses in the vicinity are visited in a quest for witnesses as uniformed officers stand guard over the gateway and at each end of the lane.

At the hospital the victim's condition rapidly improves. Her initial incoherence was due more to shock and exposure than severe injury. In the warmth of a casualty unit, reassured by the presence of medical staff and a sympathetic detective policewoman, she is soon able to give more details about her ordeal. She is awaiting a university placement and in the last few days of the summer break decided to hitch-hike to visit her married sister in the south. It was a youthful whim, a spur-of-the-moment venture, marked only by a note for her widowed father on the kitchen table. Her sister did not even know she was coming. No wonder she has not yet been reported missing.

The girl was picked up at a motorway intersection near her home by a pleasant-looking young man driving an old silver-coloured car. She knows little about cars and cannot describe the marque, only its general features. The sole thing she specifically remembers is a circular adhesive disc on the windscreen in front of the passenger seat bearing the logo of a leading insurance company.

At the time it seemed an incredible stroke of good fortune when the driver said his intended destination was the very town she was heading for. There was nothing untoward about him throughout the hour-and-a-half they were together; and then he suggested leaving the motorway to find a cup of tea. It would be cheaper than a service station, he said. She began to feel distinctly uneasy when he drove into a narrow lane, and positively alarmed when he drew up in a gateway. As she tried to leave the car, the man grabbed her and suddenly changed from a

pleasant conversationalist to a mute fiend who pinned her to the seat, his forearm crushing her throat as he ripped away at clothing. Resistance was greeted by pummelling blows to the head. At one point she lost consciousness, only to be revived by a searing pain on her left breast as her assailant bit deep into the flesh. She was also aware that he had entered her. Stimulated by pain, as well as fear, she lashed out with her feet, missed her target, and instead shattered the windscreen. The sudden instinctive reaction momentarily distracted the rapist and she was able to flee, realizing that she was naked; her clothes and hold-all remained in the vehicle.

Cowering in a ditch half filled with water, the terrified girl listened for sounds of pursuit like a petrified rabbit. The only sound she heard was the engine of a car, hurriedly driven away. The adrenalin that had given her strength to escape quickly ebbed away and she soon lapsed into the semi-comatose state induced by trauma and onset of hypothermia. It took a long time to drag herself across the fields towards a distant illuminated window and the sanctuary of the farmhouse.

It has taken some time to elicit by gentle questioning the essential parts of the story and an initial description of the assailant. In addition to treatment the victim has had to endure another medical examination for forensic purposes: blood has been given for grouping and DNA analysis; vaginal examination has confirmed injuries consistent with forced penetration and swabs have been taken for traces of semen; secretions of saliva from the breast and scrapings from beneath finger- and toenails may all play an important part in confirming the identity of the rapist. The surface of the skin is closely examined for hairs or fibres, which may also be discovered in residue combed from head and pubic hair. Many more questions need to be asked, but the information so far obtained must suffice; the overall medical care of the victim is more important.

Photographs, which will be taken later, serve to illustrate the extent of injuries to a jury, but are generally of limited evidential value. An exception is the shot of a bite mark on the breast, which needs to be analysed by a forensic odontologist. Comparison between these teeth impressions and a control sample of a suspect's bite marks in dental clay can serve as a means of positive identification.

The senior investigating officer (SIO) has to be satisfied, for the time being, with the information at hand. Until the victim can provide more assistance he must rely upon a meagre description of the aggressor, who gave away nothing in conversation to suggest his name or where he came from. It seems a far better bet at this stage to try and locate a vehicle with a broken windscreen, discover all available evidence from the scene of the crime and locate potential witnesses.

SOCO teams are deployed at daybreak at the farmhouse and field

*gateway. Uniformed officers, some with dogs, search fields, hedgerows
and ditches between the two locations, while others spread out along the
lane used by the offending vehicle. Everyone who uses the lane is
quizzed for information and house-by-house teams visit every dwelling
over an extensive area.*

*Senior detectives generally believe in the efficacy of advertising and
are adept at exploiting the media to seek public co-operation. A more
powerful method of circulation, if used wisely and selectively, may
provide more rapid responses. The internal police communications
system is a sophisticated network allowing constabularies to speak to
each other on a closed circuit and provides a facility for simultaneous
transmissions to all forces when necessary. The extent of circulation is a
matter of judgement and requires authorization by senior supervisors to
prevent overloading the system. The most serious criminal offences will
only be circulated nationally if a positive reaction can be anticipated. In
many cases it is only necessary to solicit the assistance of forces adjacent
to the area where the offence occurred, or those within the same region.
The advantage of modern police communications is that, within minutes
of transmission, a message can be relayed by VHF and UHF radio
frequencies to all operational police officers. The chain of criminal
intelligence stems from interaction between police and public at ground
level; positive results from circulating hard facts about current crime
will therefore depend upon the commitment and initiative of those
trained observers to whom it is directed. While general public interest
can be stimulated by the emotive essentials of a crime, a senior
investigator must compile a comprehensive bulletin for internal
circulation if he hopes to attract the attention of officers burdened with
their own problems. He will therefore bide his time until he can provide
enough detail to stimulate interest.*

*Patience is rewarded when a passing motorist recollects a silver
Datsun in the gateway during the previous evening. Furthermore,
items of female clothing and a hold-all are recovered in fields about two
miles away, alongside a road heading towards a nearby conurbation.*

*More information is now also available from the victim; she is rested
and more emotionally stable. She sat beside her assailant for a long time
and can provide a good description. Probing questions help to trigger
her memory and she is able to elaborate on her original story.*

*By mid afternoon the SIO is able to call his staff together for a
debriefing session. Each phase of the investigation is discussed at length
and information flows back and forth between supervisors and those out
on the ground. The incident room manager is able to provide the results
of suspect and* modus operandi *checks; the sequence of events is now
more easily plotted and within an hour each member of the team has a
clear idea of the overall situation. The SIO's next step is to determine his*

future strategy and assess resource requirements. He must identify specific lines of enquiry and prioritize those most likely, in his professional judgement, to bear fruit. His bid for additional manpower, vehicles and equipment will only be considered by executives when he has completed his action plan. They can then accurately estimate his future needs and balance them against those of contemporaneous operations taking place elsewhere in the force area.

A high priority is the setting-up of a fully computerized system to record and evaluate incoming data. While the girl's ordeal clearly amounts to a serious criminal offence, her injuries are fortunately not classified as serious. As far as can be ascertained, the assault is not one of a series committed over a wide area involving several constabularies. Given the quality and value of information and evidence reaching the SIO, he is confident that with additional assistance from a small number of operational detectives and minimal support staff, he will be able to pursue the investigation without the full panoply of a major criminal inquiry. Like most senior detectives he is more comfortable controlling the efforts of a small number of hand-picked staff than relying on a large number of seconded officers whose strengths and weaknesses are unknown.

No one person can evaluate the mass of detail that pours in during the early days of a substantial investigation. The SIO must rely on administrative staff to perform this function, bringing to his attention those matters pertinent to the advancement of the inquiry. Of equal importance is the recording of all documents and exhibits, so that they may be readily available at any stage of subsequent proceedings for scrutiny by prosecution and defence lawyers.

With his domestic arrangements in place the SIO turns his attention to immediate tactics aimed at detecting the crime. He now has a good description of the offender, but no critical identifying feature that will readily eliminate him from the hundreds of sex offenders listed in national records. His best bet is to rely on local intelligence and the nous of the hundreds, if not thousands, of police officers to whom he can appeal through internal circulation. The rapist's vehicle may offer the best chance of discovery. The colour is certain and the marque firmly established by the witness who saw it in the gateway and who has since been shown photographs of a range of models by specialist vehicle examiners. Marrying the descriptions of suspect and vehicle in a comprehensive broadcast message to surrounding forces will, it is hoped, bring results. If the vehicle can be recovered it should produce a forensic connection with the victim; even if it had been stolen prior to the crime and later abandoned, it should throw up clues that will help in identifying a suspect.

At 10 p.m. next evening a night-duty detective in a nearby city briefs

himself from a pile of documents about current crime, before starting his tour of duty. He is mature and level-headed; his experience and knowledge of local criminals are unsurpassed. Scanning the occurrence log and crime circulations, he notes the message about the rape – which alerts him to another incident that has happened on his own patch since he was last on duty. In the early hours of the previous day the fire brigade had attended a fiercely burning motor car on an area of waste land adjacent to a notorious inner-city housing estate. The vehicle was reduced to a shell and the police officer who attended could only speculate in his written report: 'may be a Datsun – may have been used in crime – vehicle examiner to verify identification'. A quick check with the control room confirmed that no one had yet got around to doing so.

Flicking back the pages to the rape message, the detective thinks he may be jumping to conclusions, but the years had often proved that intuition is one of the greatest weapons in the investigator's armoury. Behind the waste ground, where the vehicle was still awaiting collection by the local authority, was a block of flats, one of them occupied by the older brother of a persistent sex offender recently released from prison. Over the years the officer had good reason to follow their activities – they were a constant thorn in the side – and he had often had dealings with both of them. There are distinct similarities between the younger brother and the description provided by the victim: blond, long, lank hair hanging over the forehead; sharp features; watery blue eyes; slim build, apparently very tall from the position he adopted in the driving seat; Midlands accent; and a high pitched voice. It was worth a telephone call.

The SIO is ready to call it a day when a telephonist in an adjoining office cups her hand over the receiver and indicates she may have something of interest. It is the most positive step in the inquiry so far, but because of the tenuous connection it is necessary to proceed along a tactically planned course and avoid precipitous, unwarranted action. Some hours of groundwork will be needed before positive action can be taken against a named suspect.

It is an easy matter to identify the vehicle: in the absence of number plates, the engine and chassis numbers, indented in metal, provide the key. When these numbers are fed into PNC and DVLC computers they match a silver Datsun Sunny saloon stolen during the previous week. Its use in the abduction and rape is confirmed when the owner is interviewed and describes the tax disc holder bearing the insurance company logo mentioned by the victim. There is, however, little chance that the vehicle, given its present condition, will provide a forensic connection between victim and suspect.

The elder brother opens his front door early next morning to a posse of detectives and, believing them to be interested in his own nefarious

activities, immediately adopts a defensive and uncooperative attitude. They do not go straight to the purpose of their visit, but disarm him with obscure questions and observations before asking when he last saw his brother. By this time they have entered the flat and the occupant willingly seizes the opportunity to deflect attention away from himself. His brother knocked him up shortly after midnight and asked to stay. There is little love lost between the two and the request was refused. Apart from being given food, a change of clothing and a hot bath, no other hospitality was offered. He had not seen his brother for months – since he was last sent to prison – and has no idea where he intended to go when he left the flat. He put his dirty clothing into a carrier bag and took it with him. The elder brother's attitude changes again when the detectives tell him they intend to carry out a full SOCO examination of his premises and require his presence at the police station to be questioned in detail about the previous night's events. The brother refuses to co-operate further and the officers are obliged to obtain a search warrant to examine the flat in greater detail.

It is now of the utmost importance that the suspect is arrested as quickly as possible to avoid destruction of any remaining evidence. Most hardened criminals are creatures of habit and find it difficult to vary their way of life; it does not, therefore, take long for local police officers to find him in one of his favourite haunts, but the only clothes he has are the ones he is wearing.

The young man is a drifter who, when not in prison, lives on state benefits and has never held a steady job; any supplementary income he requires is always obtained by thieving. His unhappy history of sexual perversions began when he was young; he seemed unable to resist the urge to expose himself to lone females on the estate where he lived. This antisocial behaviour occasionally got him in trouble with the police, when victims bothered to report his misdemeanours. Eventually a familiar pattern emerged as he progressed to offences of indecent assault and unlawful sexual intercourse. As his list of convictions lengthened and the police intelligence file grew, local detectives confidently predicted that one day he would commit a violent act to satisfy his lust, unless he could be persuaded to receive treatment. There is very little the police or courts can do to prevent these all too frequent chains of events. A further effect of continual offending and detection is that the criminal becomes more accustomed to dealing with the police – aware of his rights and increasingly cunning in his methods. The saving grace is that most recidivists are rarely that bright; although they may become aware of forensic evidence, routinely fail to answer questions and emphatically deny all allegations, they often bring about their own downfall by making fundamental mistakes when committing crimes or attempting to cover their tracks. The skill of the investigator lies in uncovering these

discrepancies and using the services of all agencies at his disposal to
assist him in proving his case.

When arrested the suspect is true to form and refuses to answer any
questions. He has obviously discarded his previous clothing and
intensive searches fail to uncover them. A request to provide samples of
saliva, blood and pubic hair is immediately refused and the SIO realizes
it would be pointless to obtain a superintendent's authority to examine
the prisoner for non-intimate samples in view of the bath he had
previously taken. The question of head hair can be delayed for the time
being, to avoid unnecessary confrontation. But evidential traces may
have been transferred on to his change of clothing, so replacement
garments are provided and the seized items individually packaged and
sent to the laboratory.

Sharon is convinced that she would recognize her assailant again and
the suspect is told of the intention to place him on an identification
parade. This proposal is also immediately rejected, as is the alternative of
a group identification. He is well aware of his vulnerable situation and
determined to frustrate the investigator at every turn. He therefore
leaves the SIO no option but to arrange a confrontation between the
victim and suspect, a procedure for which consent is not required.

A uniformed inspector, one not involved in the inquiry, is appointed
identification officer. The administrative arrangements are basically the
same as those for a formal parade. A screen dividing the room allows the
witness to see the suspect through one-way mirrored glass. VDU
equipment records the whole process and the suspect is supported by his
solicitor. They are provided with the description Sharon compiled of her
assailant and a copy of the artist's impression released to the media.
When the girl enters the room she is advised that the man she is about to
see may, or may not, be the person responsible for her ordeal and if she
cannot be positive she should say so. The issue is rapidly resolved when
she is asked the question 'Is this the person?' Without hesitation she
nods her head and is then asked to confirm her assertion verbally.

In answer to another question she affirms that she has not seen any
published material connected with the crime.

The SIO, who together with all his team, have been kept well away
from the identification room, later sees the suspect in the custody suite
and informs him that he will be charged with abduction and rape. His
cautionary words that nothing need be said in answer to the allegation
are met with stony silence.

That cannot be the end of the matter; more evidence will be required
before it can be certain that a court will even listen to the case. The
SIO's immediate problem will be to convince the Crown Prosecution
Service that identification alone is sufficient reason to hold the man in
custody while other enquiries are made. If he is unable to do so, the

suspect will be discharged on police bail, with the attendant risks of interference with witnesses or evidence.

The identification, no matter how positive, will require an element of corroboration before there can be any chance of a conviction. Given the cunning and uncooperative nature of the accused, this may well be an uphill task: but pressures placed upon the team to find the assailant have now eased and time can be spent on analysis and reflection in order to identify fresh lines of enquiry.

Direct and provable evidence links the burnt-out car to the crime; the need now is to establish a connection between the car or victim and the accused. His adamant refusal to supply control samples of body fluids substantially rules out forensic tests to provide a cross-match by way of DNA profiling or comparison of the tooth marks on the victim's breast.

There is, however, one slender chance for success. The roots of human hair can provide the material necessary for genetic fingerprinting. Head hair is a non-intimate body sample, which may be obtained from a prisoner by the use of reasonable force if a police superintendent certifies that a sample will confirm or disprove the accused's involvement in a serious crime. In the hope that swabs taken from skin around the victim's bitten breast will contain sufficient saliva to provide a DNA profile of the assailant, the SIO seeks authority to obtain samples of the suspect's hair from which a comparative profile may be possible. Several weeks pass before tests are completed; the result is inconclusive.

During the intervening period much laborious work is carried out on all the material collected from locations connected to the crime, victim or suspect. While he may have thought that he had successfully destroyed any forensic connection with his victim by taking a bath and disposing of his clothing, the assailant made a fundamental mistake in failing to obtain fresh shoes and socks. From simple oversights like this many investigations succeed.

Glass is a substance that features in many crimes and is therefore one of the most common submissions to forensic laboratories. Shattered glass is readily transferred to anyone in the vicinity, adheres to clothing, or becomes enmeshed in hair. Differing refractive properties of separately manufactured batches gives the scientist an opportunity to compare minute traces with control samples. Indeed, this proves to be the clincher in the case against the rapist; glass is found embedded in the soles of his shoes, the fabric of his socks and in debris recovered from the carpet in the room where he changed clothing. The refractive index of the particles is identical to the windscreen glass of the Datsun car and will be of significant probative value in the case. The discovery supplies the essential element of corroboration to the victim's identification evidence, which, together with the more insignificant circumstantial evidence, will ensure the matter goes before a jury. The court will also be allowed

to take the accused's refusal to provide intimate body samples into account as supporting the remainder of relevant evidence against him.

7 Arson

A person, who without lawful excuse, destroys or
damages any property belonging to another: intend-
ing to destroy or damage any such property; *or* being
reckless as to whether such property would be
destroyed or damaged; shall be guilty of an offence.
Criminal Damage Act, 1971, Section 1(1).

A person who, without lawful excuse, destroys or
damages any property, whether belonging to himself
or another: intending to destroy or damage any
property *or*, being reckless as to whether any
property would be destroyed or damaged; *and*
intending by the destruction or damage to endanger
the life of another *or* being reckless as to whether the
life of another would be thereby endangered; shall be
guilty of an offence.
Criminal Damage Act, 1971, Section 1(2).

An offence committed under this section by
destroying or damaging property by fire shall be
charged as arson.
Criminal Damage Act, 1971, Section 1(3).

The destructive capabilities of fire frequently prove attractive to
those seeking to conceal other criminal acts or intentions; it is a
medium regularly used by killers, fraudsters, burglars and
thieves. Other fires are lit to settle scores or from wanton
vandalism. Although one of the most difficult areas of criminal
investigation, the ruinous effects of fire are often over-estimated
by the arsonist: methodical examination of damaged scenes
along with thorough enquiries into the background will often
produce substantial evidence to support criminal charges.

Fire investigation demands a joint approach between fire
brigades, who have the initial responsibility for determining
cause, and detectives, who carry out any subsequent criminal
inquiry. It is another area that often relies heavily on the

expertise of forensic scientists. Unless a high level of co-operation exists between the three agencies there is every likelihood that significant evidence will be damaged, destroyed or overlooked.

The primary duty of firemen is to extinguish a fire as quickly as possible, in order to save life or minimize damage. In doing so they may have to force an entry to premises, and without exception will distribute substantial amounts of water through high-powered jets. To satisfy themselves that a blaze has been completely extinguished and avoid a recurrence, they will have indiscriminately to remove or disturb debris that may contain vital clues. Preservation of evidence is often, quite understandably, a low priority in achieving their objectives.

Initially the brigade is responsible for determining how a fire started, but in those instances where arson is suspected or the cause is not readily recognizable, it is established practice to seek specialist assistance. Brigade fire investigators will automatically alert police and the forensic services in either of the above cases. Thereafter the brigade experts, police scenes-of-crimes officers (SOCOs) and scientists attempt to find evidence to establish cause, while operational detectives investigate the overall circumstances to identify culprits.

Fire investigation varies enormously in scale and complexity: it may be restricted to a single room where a dead body lies among minimal debris, or involve a large industrial building, covering several acres, that has been completely gutted and reduced to a mass of twisted girders and piles of incinerated material. In the former example it may be possible for a police SOCO to examine and recover all the evidence, while the latter might occupy a team of experts for several weeks.

The detective's first task in investigating arson is to gather information from those who took part in the fire-fighting operation. From this debriefing he may obtain vital evidence about a likely cause. All emergency telephone calls are recorded as a matter of routine, and if the person raising the alarm fails to identify himself the tape can hold out the prospect of phonetic identification. The actual content and tone of the conversation can also indicate whether the fire has been spontaneously discovered or is a matter of little surprise to the caller. It is important to correlate precise timings: the reception of an emergency call, the arrival of the brigade and the extinguishing of a fire – all can be subjected to scientific analysis or experiment to find flaws in a suspect's story or establish an accurate sequence of events.

Fire crews can assist with many of the fundamental issues: Was it necessary to force entry to the premises? Were any substantial items of furniture or equipment moved from their original positions? Where was the apparent seat of fire? What was the sequence of operations necessary to control the blaze? Was there anything unusual about the pattern of burning that would point towards a particular means of ignition? More importantly, the detective will want information about the demeanour of witnesses or bystanders throughout the incident and the immediate reactions of owners or tenants.

Many suspicious indicators attending malicious fires typically confirm criminality, the obvious being forced entry unattributable to the fire service. Others include unexplained damage to interior structures, such as forced inner doors, drawers and cabinets. Thieves invariably leave drawers and cabinets open when they have completed a search, and examination of the position of metallic locks, handles, screws or fixings can confirm interference, which, in turn, will indicate trespass. Evidence of debt, business mismanagement or conflict between joint interests in the property will suggest potential motive and fuel suspicion.

Discovering exactly where a fire started is usually germane to establishing how it was caused. Damage confined to a small area presents few problems, but a conflagration that has reduced a multi-storey structure to ashes may make this impossible. In order to succeed in such cases investigation will often rely upon evidence relating to motive rather than causation.

The fire service does not have the resources to identify accelerants scientifically, determine the combustibility of materials involved in fire or recover trace elements from suspects. Therefore, once sufficient evidence has been discovered to cast doubts on the cause, a police SOCO must be involved in the excavation of the site and collection of samples. A scientific investigator will also often be brought in to look for a range of indicators confirming suspicions. There may be more than one means of ignition, two or more seats of fire, interference with electrical circuits, gas supplies or fire-prevention equipment and unusual patterns of damage created by the progress of flames and smoke. Non-scientific grounds for suspicion may involve an unhelpful reception from the occupier of the premises, evidence of another crime or information from insurers or banks regarding undue loading or debt.

Small details that may not occur to the arsonist when planning the crime can provide important clues. Glass from

windows, broken before an outbreak of fire, will be free of smoke staining, while that which remains in the frame or was broken by firefighters to gain access will usually be marked on at least one side. Microscopic examination of glass taken from the point of entry can prove from which side the window was broken. Traces of blood and fingerprints may be recovered, and shoe impressions are often deposited on discarded papers or floor surfaces. The scientist will also be anxious to secure the remains of accelerant containers, incendiary devices and traces of the means of ignition: crumpled pieces of partially incinerated paper are simple, yet forceful indicators, as are certain patterns of scattered scorch marks on floors and walls where liquid accelerants have been splashed about to encourage the spread of fire.

In some cases it may be necessary to conduct a reconstruction to confirm theories arrived at by scene examination. This will be arranged under controlled conditions that imitate the original environment as closely as possible. Plans of the building and its contents, as well as technical calculations of factors affecting ventilation and atmospheric conditions, are necessary prerequisites to successful reconstructions, and video evidence of the results will time-record the progress of flame and smoke so that they may be compared with the effects of the original incident.

Evaluation of evidence recovered from a scene and careful interpretation of those results will often determine the firesetter's motive. Arsonists can be roughly divided between those who are unable to resist the temptation to create a conflagration and those who use fire as a medium to further or conceal a related criminal act. Pyromaniacs, mental defectives or psychotic offenders who haphazardly set fires without definable motive are the most difficult group to apprehend. They do, however, display typical characteristics that may lead to their downfall: an irresistible urge to repeatedly offend, often within a small geographical area and invariably using the same method and materials; a desire to be on hand to witness the effects of their efforts or actually take part in the fire-fighting. Sometimes participation will be connected with a wish to draw attention to themselves, either as victim or heroic rescuer, and there are many recorded examples where fires within this category have been caused to satisfy abnormal sexual predilections. Authorized fire-fighters cannot be excluded from this category, although these culprits are usually confined to volunteer or retained firemen who wish to draw attention to their enthusiasm or profit financially from being called out to extinguish a fire.

The personalities and motives of the other group of arsonists

are as diverse as the methods they employ to commit the crime. Fire is most commonly used in connection with insurance fraud, the scope of which may range between the destruction of buildings and property worth millions of pounds, to domestic articles and privately owned vehicles. 'Torching' property can be committed either by the owner or someone hired for the purpose and many facets of these offences give rise to suspicion in an investigator's mind: a staged burglary; inflated insurance cover; a history of business difficulties; destruction of company records; impending scrutiny by auditors, accountants, VAT or Inland Revenue inspectors. The attitude and actions of the likely beneficiary can also be revealing: undue calmness in the face of disaster; overt obstruction towards an investigation; or, conversely, an anxiety to be over-helpful with information that appears unusually detailed and precise.

By far the most treacherous misuse of fire is the settling of grievances, as they so often lead to loss of life or terrible injury. They may come about because of grudges borne between individuals, business enemies, embittered employees or political activists. The latter group sometimes refines its activities by using high explosives, an area of crime especially catered for by the Explosives Substances Act of 1883.

Wanton vandalism is an increasingly common form of antisocial behaviour and regularly manifests itself in cases of destructive fires. The senseless and often spontaneous conduct of vandals creates many difficulties for the investigator, but the fact that incendiarism is often connected with other incidents of damage caused by groups of footloose adolescents frequently presents the most reliable avenue of enquiry.

Fire has always held a certain fascination in the minds of small children and the investigator must never exclude the possibility of their involvement, particularly when examining the circumstances of a domestic fire. While some will be caused by experimentation or simple accident, a few will be caused deliberately, a fact often deduced by naive methods of fire lighting or a gross overuse of accelerants.

The most difficult inquiries involve fires intended to disguise or conceal other crimes, particularly those involving fatalities. Fortunately the human body is resilient, capable of retaining traces of evidence after sustained exposure to burning. While normal facial methods of identification may prove impossible, teeth and bone structures are invariably preserved, enabling dental and radiological examination. Personal jewellery and fragments of preserved clothing, protected from fire by pressure

between a body and hard surfaces can also provide critical evidence when cadavers are incinerated beyond all other forms of recognition.

Differentiating between accidental and intentional death can be problematic, and the solution usually depends on the degree of damage to both the body and the surrounding area. Important clues are provided by position and posture, signs of unusual disturbance or damage, and forensic traces of blood, hair or tissue on adjacent surfaces. Unless death was deliberately caused by fire the motives of a murderer in creating a conflagration are normally the destruction of evidence and obliteration of the crime. In these cases, the scientist and pathologist are the most likely to corroborate a detective's preliminary suspicions. The human body is so durable that, after most fires, enough of its structure will remain to provide definite information.

Traces of ligature, protected by folds of skin, fractures of delicate neck structures in cases of strangulation, broken bones and shattered skulls – all will be revealed during an autopsy. Sooty deposits in lungs and airways caused by smoke inhalation are positive indications that death occurred after the outbreak of fire, as is the discovery of high levels of carbon monoxide in the bloodstream. If neither of these elements is present it is an equally persuasive omen that the victim died prior to a blaze. Toxicological analysis of blood and internal organs can reveal evidence of drugs or poisoning and visual examination of burns may help to establish a chronological sequence of injury that may assist in predicting the progress of a fire within a vehicle or building.

Finally there is the added complication of determining suicide. Most cases of self-immolation are carried out within public view, as the perpetrator typically intends to attract attention to the act. But some cases occur in private and, as a result, present complications in confirming suicide, as opposed to accidental or malicious cause. The suicide often uses excessive amounts of accelerant, causing rapid and extensive injuries that make identification and establishing a motive more difficult. Comprehensive burning and charring can obliterate flesh wounds, and sudden ignition of volatile accelerant vapours quickly absorbs all available oxygen and prevents air being drawn into the lungs, thereby reducing the chances of finding smoke residue or carbon monoxide. These factors can mislead and confuse a diagnosis. Only a comprehensive examination of the scene and cadaver will make it possible to

reach any firm opinion – and not always then.

The sheer scale of major industrial fires can preclude the discovery of material evidence that would point to a deliberate or accidental cause. A large warehouse covering a two-acre site, stacked with millions of commercial products and reduced to rubble in a short space of time, can prove a daunting challenge. Although safety measures are observed for those who need to examine the remains, delay is inevitable while the debris cools. In this interim period the investigator can occupy himself only by collecting data and interviewing potential witnesses.

Detailed plans of a large building, based on architectural drawings, are necessary to formulate a structured approach to scene examination if the location of the fire seat is not readily apparent. Useful data will be obtained by compiling location charts that plot the normal working routines and movement within the building and comparing them with any abnormal behaviour at the time of the fire. In complicated situations the investigator will recruit an industrial ergonomics expert to link commercial activity to particular events, such as the discovery of the blaze and the identity of whoever raised the initial alarm. An exercise of this nature can also provide valuable information about the conduct of individuals or groups during the progress of an incident, and in some cases pinpoint those who were in close proximity to an area of interest.

Eye-witnesses and fire-fighters may assist in locating the fire seat, or it may become all too apparent from the signs of intense heat and abnormal damage in one particular area. A meticulous examination of the site, which involves removing each layer of debris, will often supply vital clues concerning the cause, but in those cases where the fire's intensity has completely destroyed all physical evidence, the investigator will have to rely on other means. He will examine business records, the character background of both employer and workforce, the maintenance history of the building and fire prevention measures. If, at the end of these enquiries, he is no further forward, a change of tactics may be called for. Employees who face the loss of their livelihood are not best disposed towards any of their number who stupidly or maliciously place them in that situation. Very often the vindictive victim of circumstances is a rich source for an investigator to exploit. It may be that a no-smoking ban has been ignored, or rules governing physical possession of flammable material in prohibited areas. Sometimes, simply circumvention of recognized working methods has become accepted practice, occasionally with the connivance of

management. If this type of information can be elicited through confidential appeals the investigator may obtain sufficient evidence to satisfy himself about the cause.

Industrial sabotage, bogus or inflated insurance claims and commercial fraud are not the only contemporary criminal trends involving fire. Unfortunately, some people seem irresistibly attracted to destroying the very institutions that support communities. For example, there is no more worrying trend than the continual violation of school premises. A crowd of distressed children, parents and teachers viewing the remains of a burnt-out school is a sadly familiar sight. Years of effort and commitment can be destroyed within minutes, and the cause is rarely accidental – all too often it is the work of witless vandals or someone angry with the establishment. The construction materials used in modern school buildings, the nature of their contents and the fact that they are often built in isolated locations make them an easy target for the arsonist.

Unless a school is completely gutted it is likely to disclose many features of the perpetrator's level of sophistication and will help to determine motive. There are usually signs of forced entry: shattered windows, broken doors and, in extreme cases, holes punched through flat roofs or prefabricated walls. It is rare for anyone having legitimate access to a building to be able to simulate a forced entry in such a way that it will fool the expert scene examiner. Fragments of glass lying on grass beneath a window are a sure give-away that it has been broken from within, as are jemmy marks on a door's inner side. School caretakers are sometimes tempted to rebel against their status, treatment, salary or conditions of employment. Invariably they bring suspicion upon themselves by creating fire in the centre of the complex without attempting to divert attention by manufacturing a bogus burglary or simulating malicious damage – so often a feature of school arson. In these cases the investigator looks for the clinical execution of revenge.

Random damage to fixtures and fittings, graffiti, scattering of books and papers around classroom floors, and the destruction of pupils' wall displays are all hallmarks of the vandal. Numerous seats of fire are not only conclusive evidence of intent, but their composition can also tell much about the mentality or maturity of the arsonist. Crumpled piles of paper, some of which have failed to ignite, and a number of spent matches might signify the work of a juvenile experimenter, while pyres of flammable articles collected from various parts of the school, ignited with the use of accelerants, will normally

point towards an older, more determined offender. In addition to routine searches for fingerprints and forensic traces, a SOCO examination must include any material that has not been destroyed and with which the offender may have been in contact. Books and wads of paper are difficult to destroy completely by fire and can be a source of incriminating evidence. More particularly, papers strewn on floors may have been trampled on and bear footwear impressions. These can also be found on ledges and workbenches near a point of entry or on receptive floor surfaces. An exercise to eliminate the footwear of pupils or other suspects by comparing unique manufacture and wear characteristics with those of a scene mark has often successfully identified an arsonist.

An investigator can always find a grain of reassurance in the fact that most malicious school fires are either the work of someone connected to the building – no matter how tenuously – or someone living in the immediate vicinity. He does not often therefore have to extend his inquiry very far beyond the centre of operations. In many cases anger about the destruction of a communal focal point stimulates a positive reaction and information obtained by extensive questioning of staff, pupils and local residents can often be useful, particularly when damage is so severe that forensic examination is unproductive.

Case Study: Arson (1)

Just before midnight the alarm is raised about a fire that is consuming a semi-detached house on a run-down estate on the edge of a small provincial city. The brigade arrives to find a crowd of spectators helplessly watching flames leaping through windows on both levels. Their immediate concern is to establish if anyone is inside, although it looks highly likely that the fire has gone too far to give any hope of rescue. The next priority must be to prevent flames spreading to adjoining properties. Police officers are already at the scene and one is talking to an elderly man; others are making sure that threatened properties are vacated.

A female police officer briefs the senior fireman as his crew rapidly prepare their equipment to tackle the blaze. The old man to whom she has been speaking lives in the house – no one else is inside. His wife left home earlier in the day after a row and he has no idea where she is. On walking up the road on his way back from the pub, he saw his house ablaze. A fire engine arrived as he was collecting his senses. Although reeking of alcohol, he appears remarkably calm and coherent for someone witnessing his home going up in smoke – the young officer is uneasy and calls for the duty detective.

Firemen do not have to break into the property; the rear door is unlocked and the keys are still in the inside keyhole. There is little left of the ground floor apart from the kitchen, which has been partly protected by a closed and substantial door. As they subdue the flames with high-pressure hoses and work their way into the building it becomes obvious that the conflagration has been most intense in the living-room, before being sucked up the stairwell and wreaking havoc on the first floor. The spread of fire is quickly curtailed, and soon after completely extinguished, but it takes some time to damp down the remains to prevent reignition. By the time this has been achieved, many thousands of gallons of water have been pumped into the house and damaged fabric and furnishings thrown into the rear garden. All that remains is an empty shell, smoke-blackened walls and an acrid stench, unique to the conflicting elements of fire and water.

There is something distinctly odd about the householder. His three married children live in other parts of the city, but he declines the offer to have them informed of his predicament, or be taken to spend the night with one of them. He usually locks the house, but says he must have forgotten to do so when he went out. The only explanation he can offer for the fire starting is embers falling from the grate on to the hearth of the living-room. He quite willingly accepts an invitation to be taken to the police station for questioning. At this stage he is treated as a witness — there are as yet no firm grounds for suspicion — and the emphasis will be on obtaining his co-operation in locating his missing wife.

The detective at the scene easily checks the old man's credentials with PNC — he does not have a criminal record. A search of local files reveals only details of a number of occasions when police have been called to the house to mediate in domestic disputes. Neighbours, who are beginning to drift away now the excitement is over, are quick to confirm the almost daily spats between the couple, and although they have sometimes ended in violence no one can recollect the wife leaving home before. The detective follows his nose and visits the children; it soon becomes apparent why the father did not wish to involve them. They all despise him for the way he abused and neglected every member of the family, and all express concern for their mother's safety. She has not, as they would have expected, contacted them; nor were they aware that she had left home.

The detective is also concerned. Next he knocks up the licensee of the local pub. The old man is a regular customer; he spends most evenings steadily consuming substantial quantities of beer and is always among the last to leave. The previous evening he did not arrive until about nine o'clock but, more significantly, left well before closing time.

The young detective judges it high time to summon the assistance of a senior officer. A detective inspector satisfies himself that the man is still

giving the same account of his evening's activities and is content to remain at the police station, providing a list of addresses where he thinks his wife may be. He also tells lies – there is, he claims, no truth in any suggestion of domestic strife – but, quite abnormally, if that is to be believed, he wants no contact with his children. It is as if he is almost frightened to confront them. The DI recognizes the warning signals of his overall attitude and, although he will not say so, is certain that some harm has befallen the woman and her disappearance may well be connected with the fire. He visits the house with a team of searchers and looks for the obvious – blood or other signs of violence. In the circumstances he is not surprised when they find nothing; every surface is blackened by smoke, and debris on the ground-level floors lies several inches deep. The only significant feature is an area of wooden flooring in the centre of the living room that has been completely burnt away to expose badly charred joists, whereas the remainder is damaged but intact. The uncultivated garden is a mass of weeds and on the patio, immediately outside the living-room window, lies a huge pile of fire-damaged furniture, removed during the damping-down operation.

The circumstances call for the services of a forensic scientist. There is a need to establish what has happened in the house as quickly as possible, as both fire investigator and policeman are convinced that the fire has been started deliberately. Great care must therefore be taken to ensure that any evidence which may feature in a future investigation be collected and preserved by experts.

The scientist works closely with the detective and a SOCO team. They all know that it is difficult completely to destroy human remains by fire and, if that was the intention, it is highly likely that they will find some evidence of it within the house. In most cases, a criminal who sets out to cover his tracks by committing arson is in too much of a hurry to devise sophisticated methods of incineration. Immediate searches are therefore limited to the obvious, rather than the obscure.

The charred edges of floorboards and underlying joists in the centre of the living-room are a good starting point. It appears the most likely original seat of the blaze, an opinion reached by observing fire and smoke progression across the room before they vented through the stairwell. As it is several feet from the hearth, the original explanation of likely causation is a little hard to swallow. A layer of plaster and timber detritus from ceilings and the room above await excavation on the remaining floorboards, but first, that which has dropped through the hole between the joists is lifted and sifted for clues. The remains will no doubt be charred carpet, wood, paper and cardboard, but as these may be impregnated with an identifiable accelerant, they are carefully packaged in containers designed to prevent vaporization. Two items are easily identified: a hacksaw and a carving-knife blade, twisted and buckled by

intense heat. Before turning his attention elsewhere, the scientist acts upon a hunch. There may be a reason, other than the destruction of the building, for creating a fire in the middle of the room. Using a chemically impregnated tissue, he wipes the underside of the joists and boards surrounding the damaged area and obtains a positive reaction to human blood.

His next step is to examine the ashes still lying in the open grate. After a thorough sifting he recovers a number of small charred objects that arouse his curiosity. He is not an anatomist but thinks they may be small bone structures. What has been unearthed within the space of half-an-hour is enough to convince the investigator that the scene will need dedicated scrutiny; a glance through the window at the pile of soaking debris convinces him equally that it will be a long and filthy job.

Remnants from the seat of fire are quickly dispatched to the laboratory and another detective takes the bony fragments to a Home Office pathologist: he quickly identifies them as human finger and toe bones. Although the search for a body will now supersede every other activity, the process may be curtailed if the husband can be persuaded to co-operate.

The suspect faces the detective inspector across a table in the interview room. He has been told that he is under arrest on suspicion of setting fire to his own home and has been provided with the services of a solicitor. The fact that human remains have been found inside the premises is put to him and he is invited to say what has happened. After many hours of acting out a lie, the suspect is ultimately relieved to acknowledge the inevitable, although he is not yet prepared to come to terms with the true horror of his crime. All he will say is that his wife is buried beneath the patio.

Disturbed paving slabs are quickly discovered beneath the accumulated debris, and as is usual with those who wish to dispose of a corpse as quickly as possible, the grave is only inches deep. Gruesome remains quickly come to light: the dismembered body of the elderly wife, crudely dissected into head, torso and four limbs. Fingers, toes, parts of hands and feet have all been severed.

The killing is a familiar story to hardened detectives and one which the perpetrator is now anxious to admit. Years of verbal and physical battles have culminated in an explosion of violence: death was caused by multiple skull fractures and a brain haemorrhage from hammer blows.

Most people are unaware how resistant corpses are to combustion, making it difficult to annihilate them completely. They are equally ignor- ant about the quantity of blood that flows from a cadaver when it is dismembered. To the simple-minded husband it seemed a reasonable proposition to cut up his wife and dispose of her remains in the grate. When his first attempts to dispose of the smallest pieces failed, and the

larger limbs confounded his attempts to reduce them to smaller sections, he realized the futility of his task. In addition the centre of the room was soon swimming in blood and his clothes were plastered.

By now all rational thoughts had gone and he could not rid himself quickly enough of the macabre result of his evening's work. The immediate solution that came to mind was burial and fire. Unfortunately the blaze only provided temporary concealment by destroying the bloodied clothing and gore strewn about the centre of the living-room. As with most domestic murders, his attempts to evade responsibility were futile and unlikely to divert even the most inexperienced investigator.

Case Study: Arson (2)

During the late afternoon a farm-worker, ploughing a lonely furrow in a remote country field, notices a column of smoke rising above a distant house. Within a few minutes he finds an old but recently renovated cottage well alight, but cannot make contact with any occupant. He has no alternative but to drive to the nearest house half a mile away to raise the alarm.

The stricken cottage is normally occupied by a middle-aged couple and their two adult daughters. Formerly city-dwellers, they had moved to the area four years before and appeared to spend most of their time renovating and extending the property. They were reclusive and avoided contact with local people. Natural rural curiosity was often aroused because no one in the family appeared to be in work and they were only ever seen outside their small-holding, collecting building materials in trailers drawn behind a couple of old vans. The only fairly certain thing about them was a love of horses; a number grazed well-tended paddocks and were regularly ridden through surrounding fields by the daughters.

In the twenty minutes it took the fire brigade to arrive from the nearest town, fire rampaged through the ground floor, whipped up the staircase and demolished the first floor before starting on the roof. The old part of the stone cottage did not readily surrender to the onslaught and heavy wooden beams, joists and inch-thick floorboards, although severely damaged, were still in evidence at first-floor level. The newly built kitchen, utility and bathroom extensions were quickly reduced to rubble.

It takes some time to put out the blaze and ensure the building is structurally safe to allow entry. There has been no sign of any occupant and conditions mean that survival would have been impossible. Though both vehicles are in the yard the disaster has not brought anyone rushing back from nearby fields. The local policeman begins making some enquiries to trace the family, but has little idea where to start.

It is only when firemen enter to satisfy themselves that the cottage is safe for salvage operations to start that the first indications of real tragedy appear. At the foot of the stairs their way is impeded by barbed wire, intricately wrapped between the balusters on either side and obviously intended to impede progress to the first floor. They are also temporarily alarmed by an object lying in the hallway: at first sight they mistake it for the body of a child – closer examination shows it to be that of a large dog.

Hurried consultations follow – the senior fireman knows that he will be joined shortly by a fire-service investigation team, but the suspicious barrier causes him to request his control to inform the local CID.

The first detective constable to arrive is conscious of the need to avoid unnecessary disturbance when the discoveries are explained to him. He climbs to a first-floor window on a borrowed ladder and peers into a smoke-darkened room. What he sees confirms his worst fears: lying on the floor is a blackened, contorted human form, too severely charred to determine age or sex by superficial examination.

Any death which occurs as a result of fire is rigorously investigated by both fire service and police. Not only is this necessary to satisfy the demands of the coroner or criminal investigation, but it also provides the opportunity to recommend safety and preventive measures for the future. The detective constable cannot possibly determine the type of incident he is dealing with; the deliberate placement of the barbed wire makes an accident seem highly unlikely. It could be suicide – but where are the remaining members of the family? It may also be murder. Taking no chances, he withdraws and stops all activity by fire personnel until he can obtain some advice and assistance.

A senior detective, forensic scientist and SOCO team appear infuriatingly slow to get off the mark as they survey the house; they will shortly be joined by a Home Office pathologist who will be equally fastidious. The caution is intentional, to avoid disturbing anything that may provide an answer to the cause of the fire, or a reason for the fatality. More bodies may well lie in the building, but there is no likelihood of anyone surviving the inferno, so they have no need to take an unnecessary risk of contaminating evidence by making a hurried search.

A SOCO team is delegated to approach the property through a rear door and clear a pathway to the centre of the building using extending metal platforms. Their first task is to establish the seat of fire and everything they do will be photographed, video-recorded and plotted on exhibit sheets. A second team make their way through the front of the house to the stairwell. The barbed-wire barricade is examined and photographed before being removed.

Unfortunately the stairs are unsafe, so the team of senior experts are

forced to scramble up a ladder and through a first-floor window to examine the upper floor. They make sure to send a junior officer in first to establish that the floor will support a bevy of substantially built adults. Only the DI ventures far from the window – and he is soon able to confirm that they are dealing with a quadruple fatality. Two bodies lie among the mass of twisted springs of a bed frame, and another is crouched in a foetal position in the doorway of a smaller room. It takes some time to clear a pathway for the pathologist to view the corpses and for scientists to start examining the surrounding area.

Clear patterns of destruction permit a preliminary deduction that the most likely seat of the original fire lies in the recently constructed kitchen area. The evidence lies beneath a pile of debris, created from the collapse of the roof and first-floor bathroom. Careful excavation unearths proof of a deliberate effort to torch the premises – two bottled-gas containers with opened valves are connected, by what remains of a flexible metal hose, to a domestic heater. They lie among what were once items of domestic furniture, identifiable from screws, fixings and handles. A plan of the position of each item clearly shows that furniture had been heaped on top of the heater to create a bonfire. A metal drum in the same area points towards the use of an accelerant, but only laboratory analysis of samples taken from relevant locations will confirm that issue.

The operation has now assumed the proportions of a major inquiry demanding the attention of a detective superintendent. The emphasis must now be on establishing if death was caused by one of the household members or the actions of someone else who has attempted to destroy any evidence of involvement. Multiple suicide is still a possibility; three murders and a suicide more likely. The superintendent will approach the problem with care, as he is aware of previous, well-publicized cases in which detectives' premature judgements have been subsequently overturned when all the evidence came to light.

The obstruction on the stairs will provide the first important clue as to what occurred. Its disentanglement by a scientist, recorded on film, clearly demonstrates that it was wrapped around the supports by someone standing on the stairs, above the obstruction. The reason for its presence can only be a matter of conjecture, but suggests either a desire to prevent escape from the first floor or delay anyone intent on rescue from below. In any event, its construction indicates that whoever set it in place also intended to barricade themselves within the upper floors. This reassures the detective somewhat that the tragic events might not involve an outsider.

Scientific prognosis about the cause of fire is not available when a cursory examination of the bodies takes place. An untrained eye would not deduce much from the position of the four bodies, but years of

experience enables experts to reconstruct a likely sequence of events, and a view of the original scene is the first link in the chain.

The first body lies face down in the centre of a gutted bedroom, well away from the bed with feet nearest the door. A second, smaller figure has collapsed in another doorway and rests partially on the landing. In a larger room the relative sizes of the couple lying among the remains of their bed give the instant impression of a male and female, although they have been so badly ravaged that it is impossible yet to be conclusive. Their comparative positions are interesting – the smaller figure is in natural repose, but the larger is on its back at right angles across the lower torso, with the ashes and metal elements of a single-barrelled firearm at the feet.

There is a further delay while other expert services are marshalled. It is certain that the heavily built figure died from gunshot wounds; a gaping hole in the cranium is clearly visible, but further examination is delayed until the arrival of ballistics experts from a forensic laboratory many miles away.

The practised eye takes little time to identify the weapon as a .22 rifle fitted with magazine and silencer. Further examinations will take place in the sterile conditions of a brightly lit laboratory, but to give himself the best chance of relating his technical findings to a likely order of events, the expert must assess every relevant feature that he can extrapolate from the circumstances. Only when this vital phase is complete will the cadavers be removed for autopsy.

The fact that all four victims have been shot is apparent when the bodies are unwrapped on mortuary slabs. What has to be determined, if at all possible, is the specific identity of each one and the precise manner in which each met their death. Only the smallest figure presents identification problems. However, when a pair of stud earrings and equestrian belt buckle are found in ashes where the body lay, a close relative is able to affirm the identity of the youngest daughter. Teeth from the other bodies provide sufficient detail for positive comparison with dental charts by a forensic odontologist.

The eldest daughter died within her bedroom; the couple on the bed were husband and wife. No other weapon is found and laboratory tests will eventually confirm that all four people were killed by the rifle found at the father's feet. The manner of his death is a classic example of 'self-selection' – a bullet hole in the roof of the mouth, causing severe brain damage and eruption of cranial structures on exit. His wife was shot at close range through the left temple when standing in a far corner of the bedroom – a deduction made possible by calculations based upon her height, the passage of the bullet and its recovery from plaster in an adjacent wall. It can only be presumed that she was later placed on the bed by her husband. The opinion that her injuries were not self-inflicted

is confirmed by the location of the entry wound and the certain knowledge of relatives that she was right-handed. The daughters have also been executed, one by a bullet in the back of the head from point-blank range, causing her to fall forward on to her face. The fate of the other who fell in the doorway is not so readily established. The bullet entered her chest; X-rays and probes define its passage and the injuries it caused, spinal structures diverting the missile through critically damaged vital organs. But her position immediately before death cannot be established with certainty as the projectile is found within the abdomen, and in any event its erratic course would have rendered any calculations based on the eventual location of the emerging bullet virtually useless. The only consolation available to grieving relatives is that everyone in the house died instantaneously, although they can only speculate on the horrible events leading to the tragedy.

Pathological findings and ballistic evidence are, however, only part of an inquiry that is carried out with the same vigour as any murder investigation and extends beyond the confines of the house. Within days a sad picture emerges: comprehensive letters of remorse in the father's handwriting are received by close relatives; instructions regarding the settling of the estate arrive at banks and solicitors' practices. And a recorded message on the local vet's telephone about the disposal of the daughters' ponies suggests that the animals' welfare was the final thought in the father's frenzied mind. A pattern of crippling indebtedness, doubtless linked to mounting depression and despair, comes to light. The eventual coroner's inquest will record verdicts of unlawful killing and suicide and will be based upon all the evidence obtained from the aftermath of an almost totally destructive fire.

Case Study: Arson (3)

The huge Victorian building has survived a chequered history as a workhouse, hospital, servicemen's wartime billet and latterly a derelict ruin, the subject of many acrimonious disputes. When the local authority decided that its cavernous proportions made it completely impractical for any municipal purpose, it was sold to the highest bidder. A preservation order protected its façade and restrictions were imposed on its future use and development.

Over twenty years a succession of owners had acquired the plot for a continually diminishing price, as every planning application was rejected. The cost of maintaining the protected areas had become increasingly prohibitive and the only money made by various owners had come from the refurbishment and sale of staff cottages and the stable block within the grounds. Further conflict was sparked off when promised improvements to the old building did not occur and the new

occupiers of the dwellings saw their investment decline in value and become impossible to sell. Many people had cause, therefore, to wish the derelict eyesore out of the way, once and for all.

Nevertheless the crump of an explosion late one Saturday evening took the neighbourhood by surprise. The few remaining windows in the ruin scattered glass shards throughout the grounds; those in the converted stable block were blown inwards and the noise and shockwaves brought every resident in the area to their doors. They were rewarded with the sight of a fireball shooting through the roof of the old hospital, casting an eerie silhouette against a darkening sky. Now fire swelled through the interior, rapidly developing into an inferno.

An explosion demands a cautious approach by fire-fighters. The possibility of structural collapse, or presence of more unexploded devices, must always be considered. Until entry can be confidently authorized the blaze is tackled from the exterior; all the local brigade can hope to achieve is containment to prevent fire spreading to other buildings. Eventually dozens of water jets become available as assistance arrives from all quarters and hoses stretch hundreds of metres towards every available water source. After several chaotic hours the fire is under control and all the police and fire personnel present cannot but be aware of a lingering, pervasive smell of petrol in the atmosphere as steam rises from the wet, smouldering remains.

Examination of the interior is impossible for another two days – roof collapse has made damping-down procedures a difficult and laborious task. Even without a confirmed cause, the circumstances of the fire are viewed with deep suspicion, and a criminal investigation gets underway immediately the police are aware of the incident. This is aimed at securing witnesses and information that may throw light on a likely reason for arson and, thereafter, the identity of the culprit.

The extent of the structural damage means that entry can be permitted only under the protection of a scaffolding gantry with reinforced roof that is laid along the length of the ground floor. Fire investigators have already confirmed that all main services had been disconnected for some time, and therefore no leakage of gas or electrical fault can have caused the conflagration. They have also established that the main structural damage, caused by the explosion, is confined to one end of the building, while the most significant effect of fire damage is restricted to other areas, the most severe being in a relatively small room near the front entrance. The doors, which had been secured by a padlock, have been completely destroyed – this despite the fact that alternative access was readily available to any would-be intruder through many insecure windows.

Only a thorough examination by SOCOs, working under a forensic scientist, will provide solutions to the many unanswered questions.

They begin by surveying, plotting and photographing the entire scene from their vantage point on the gantry. This initial inspection provides significant information about the passage and patterns created by the inferno, which in turn permit some preliminary hypotheses.

Extensive fire damage in the front hallway indicates the most likely seat of the fire and excavation produces a five-gallon metal oil-drum and broken padlock – the cropped hasp will be photographed under magnification for comparison with any suitable tools recovered from suspects. These two finds alone confirm felonious entry and justify the decision to regard the fire as a criminal enterprise.

As excavation progresses and debris is removed from the ground floor, it comes as no surprise to discover that the heavy wooden flooring has escaped total destruction; the main force of the fire has shot upwards through the tinder dry structure, encouraged by draughts whistling through broken windows. A continuous line of scorch marks is clearly visible on the floor, creating a path throughout the length of the building, and ending in the area most badly affected by structural damage, but where the ravages of fire are least apparent. Examination of the joists beneath the edges of the boards shows vertical scorch marks, where an ignited liquid has dripped between them. Analysis of samples will later confirm that the agent was petrol. Large quantities must have been splashed around at the end of the trail before the arsonist retraced his steps, spreading a liquid fuse across the floor to a point of ignition near the front door. By the time flames had licked their way back to the heaviest concentration most of the petrol had vapourized, creating ideal conditions for an explosion. But because the chemical reaction had absorbed the majority of available oxygen in the atmosphere, any flames in that area had quickly extinguished themselves, forcing the fire to take hold near the point of ignition and progress through the remainder of the building.

The scientists' evaluation of the scene leaves no room for doubt that the intended consequence was complete destruction. Furthermore it provides investigators with several avenues of enquiry. A financially unhealthy development company owns the site. The directors have been constantly frustrated in their development plans and are not visibly devastated by its fate. They have concrete alibis, but after extensive enquiries into their backgrounds and business activities the SIO is left with the unpalatable conclusion that, in all probability, they have recruited the services of a 'hired torch' to do their dirty work. He excludes the only other credible options: a determined method of entry and time-consuming, well-thought-out preparation do not indicate random vandalism; disgruntled householders in the refurbished properties have all been eliminated from suspicion; the scale of the fire is rare for the area, and a trawl of criminal and suspect records has not

highlighted anybody with a history of arson or other reason to commit the crime.

Finding the actual arsonist does not prove difficult. Standard investigative procedures once again prove themselves to be the most reliable methods. Appeals for information are rewarded when a motorist reports narrowly avoiding a collision on the Saturday evening with a car being driven furiously along a country lane, about a quarter of a mile from the scene and within seconds of the explosion. By good fortune the witness is a motor dealer who was not only able to recognize the make and model, but also remembers the suffix letter of the registration mark.

The PNC quickly provides a print-out of owners of identical vehicles within a ten-miles radius of the hospital, and an elimination exercise is mounted. The first step is to exclude the possibility that the vehicle in question had been stolen for the occasion; this is achieved by checking the stolen-vehicle index. A criminal names search is then carried out against the names of all the owners listed by PNC. Forty-seven have criminal records for a variety of offences and are the first to be visited, before detectives move on to question the rest. It is a time-consuming and labour-intensive business, but eventually two detectives arrive at the door of a dilapidated house in a nearby town. The occupier is ill-at-ease and evasive in answer to questions they pose from a printed questionnaire. The detectives recognize the signals; interpretation of body language, facial expressions and mental and physical reactions are part of their stock-in-trade, so they gently probe and pry before posing further direct questions.

The man has no criminal record, is unemployed, divorced, heavily in debt and months behind with maintenance payments for his estranged children. No association with the property company can be traced, but it is established that he has recently settled a couple of outstanding debts in cash. Enquiries in the neighbourhood elicit the information that on the Sunday morning following the fire he had thoroughly washed both the exterior and interior of his car, including the boot. Other detectives, trying to trace the source of the five-gallon drum of petrol, have been told of a similar man filling a container while also purchasing fuel for his car at a local service-station. The transaction was effected by credit card.

Armed with the new information the suspect's house is searched under the authority of a warrant. The unfortunate novice criminal has failed to cover his tracks, and they find a sizeable wad of money hidden beneath a mattress and the receipt for the purchase of petrol in his wallet. Heavy-duty shears are recovered from a garden shed – control samples of metal cut by the blades will later match striation marks on the severed edges of the hasp which secured the hospital doors. Despite

his lack of criminal skills, the suspect remains loyal to those who engaged his services. He makes a clean breast of his involvement in setting alight the old building, but refuses to acknowledge that others were involved. No co-conspirator will ever be brought to book for the arson, but a fraud-squad inquiry, ordered by the SIO, produce evidence of dishonest business transactions by senior members of the property company. For this they will have to face criminal charges, thus proving an oft-quoted maxim of seasoned detectives: 'There are more ways of killing the cat'.

Explosions

A person who, in the United Kingdom or (being a citizen of the United Kingdom and Colonies) in the Republic of Ireland, unlawfully and maliciously causes by any explosive substance an explosion of a nature likely to endanger life or to cause serious injury to property shall, whether any injury to person or property has been actually caused or not, be guilty of an offence.

Explosive Substances Act, 1883, as amended by the Criminal Jurisdiction Act, 1975.

(Other legislation places further prohibitions on the criminal manufacture, possession and control of explosives, or material for use in connection with explosives.)

Case Study: Terrorism

At 3.41 precisely on a chilly February night the telephone disturbs a provincial head of CID. The call heralds a new experience for which he has been trained, but never before encountered. An explosion has occurred at an army camp fifty miles away at the northern extremity of his territory; it is not yet known if there has been any loss of life.

An hour-and-a-half later he stands with an aide about 200 yards away from a scene of utter devastation. A long three-storey barrack block lies in ruins and a small crater can be seen in a road leading to the front of the building. Everyone is being kept well away for fear of a secondary device intended to incapacitate rescuers. Some comfort can be taken from the fact that all the occupants have been accounted for and are safely secured in distant drill-sheds. The detective silently thanks his lucky stars that he is not embarking upon a multiple-murder inquiry, although he does not underestimate the scale of investigation that he must now pursue.

Earlier two patrolling soldiers waylaid a hooded figure scurrying towards the block. When challenged he dropped a hold-all on to the road before exchanging shots with the soldiers and running off towards the rear of the camp. While one guard gave chase, the other ran through the barracks, hollering and banging to wake the sleeping occupants, who, having recently served in Northern Ireland, needed no second invitation to seek sanctuary from a likely bomb. Within minutes of the evacuation two explosions destroyed the central spine of the building and ruptured most of the remaining structure. A third erupted simultaneously from the abandoned hold-all, sending a plume of tarmac and earth high into the night air.

Shortly afterwards the police received an emergency phone call from a distressed resident a couple of miles away. He and his wife had been forced to surrender the keys of their car by a hooded and armed intruder with an Irish accent.

A thousand questions fill the superintendent's mind as he surveys the scene and tries to marshall his thoughts. He realizes that the size of the explosion is beyond the scientific resources at his disposal and he will require specialist assistance from elsewhere. His knowledge of contingency plans held by all police forces for emergency situations at strategic locations means that he must also immediately divert large numbers of investigators from essential duties to undertake the intricate investigation that is already being planned. Having issued instructions for the security of the site and leaving a ground controller in command, he sets in motion a well-rehearsed call-out system for senior staff before retreating to the nearest major-incident suite. He must give himself a couple of hours' thinking time – before all hell lets loose, as senior officers, politicians, and the media start baying for instant answers to impossible questions.

Much is achieved within a few hours. The head of Scotland Yard's Anti-terrorist Branch, whose responsibility is nationwide, arrives by helicopter with the news that the IRA has claimed responsibility for the attack. Although he will leave the operational inquiry to the local detective, he is able to supply a large team of experienced scientists and officers who have examined many similar disasters in the past. Their work will take months to complete, but by the end of the second week they will ascertain that the two internal explosions were caused by strategically placed devices of identifiable chemical composition. Only a cursory on-site examination is possible of material excavated by machinery and squads of soldiers. Selected remains are then transported in 5,000 plastic dustbins to a government research establishment, where they will be drawn on conveyor-belts past practised eyes looking for the smallest evidential traces. Eventually experts will be able to calculate the size and type of the device, the timing mechanism and means of

detonation. Comparison of these features with those used at previous incidents often confirms similarities in construction and assists in identifying the maker. The intelligence gained from these examinations is often stored for several years before it realizes its evidential potential. A linked database between all major-incident rooms dealing with undetected terrorist offences allows for centralized storage of information.

The operational inquiry into the bombing follows the well-established pattern of any criminal investigation, but the complexity of the event requires methodical planning. The collection of evidence is paramount – first to identify a suspect, and then to collate sufficient facts to arraign the offender. The SIO can rarely anticipate early success against sophisticated, well-planned terrorist attacks; target reconnaissance is invariably detailed and efficient, and the execution of a bombing committed at a time and in circumstances likely to frustrate immediate detection. But in this case there is room for optimism: the terrorists bungled by exposing themselves and were forced to adopt tactics that could lead to their early downfall.

The senior officer's period of reflection is valuable. He evaluates the information already at hand and decides upon a tactical plan. The stolen car features prominently in his thinking. No terrorist group would set out on a mission in a remote rural area without ensuring they had a means of escape – so why did one of them need to 'show out', burgle a house and terrorize the occupants in order to secure the keys to a vehicle? Two plausible explanations present themselves: the driver of the getaway car heard the exchange of shots and decamped without his companion; or, having been put to flight, the bomber may have been unable to return to a vehicle parked in the vicinity of the camp, and was instead obliged to flee across country. These possibilities set in train a series of enquiries: a search for an abandoned vehicle; a sweep of the countryside between the camp and burgled house to discover any track that may hold vital clues; a separate SOCO examination of the house for forensic traces; but the key issue is the recovery of the stolen vehicle.

An immediate and extensive trawl of the area for information is also important. All personnel known to have access to the camp will be questioned, and everyone living in the locality visited. Attempts must be made to trace anyone passing through the area who may have seen a reconnaissance operation at some earlier time or anything significant during the night of the attack.

Instructions for implementing these various avenues of enquiry pour out of the SIO's office throughout the first day. He sits in conclave with his senior advisors, who will each be given responsibility for a section of the operation. The incident room manager and the senior detective's deputy, whose mandate is to procure the personnel to set the

investigation in motion, soon begin to appreciate the sheer scale of the undertaking.

But even in this most complex scenario, a routine approach soon bears fruit. Appeals issued by a press liaison officer attract information about a car with three male occupants seen near a section of the perimeter fence shortly before the explosions. Separate sightings of a similar vehicle, crawling at slow speed along lanes surrounding the camp during preceding days, are also forthcoming. The stolen vehicle – obviously abandoned hurriedly – is recovered from a cul-de-sac in a small village six miles away; yet more resources are required to undertake a satellite enquiry at that location. The car, now completely encased in protective material to prevent contamination, is winched on to a recovery vehicle and conveyed to a forensic laboratory. Intensive inquiries continue for a considerable time. The SIO examines all information and evidence reaching the incident room and, when necessary, modifies the investigation. When everything possible has been done a complete review will be carried out by an independent senior officer before a decision is reached that the inquiry has run its course and nothing is likely to be gained from prolonging it.

However, anti-terrorism operations can be a waiting game and the effort put into collecting evidence is never wasted. It may be years before it can be used against a suspect, who perhaps commits one atrocity too many and is either caught in the act, identified by forensic means or through the words of an informer. It is also certain that while detectives continue the task of unearthing admissible evidence to present before a court, their colleagues in the shadowy world of Special Branch will pursue their own inquiries among intelligence sources.

To facilitate these processes the police are given special extended powers to detain and question suspects, and in the exceptional circumstances of Northern Ireland, on the authority of the home secretary, can exclude an individual from residing in or entering the United Kingdom.

8 Homicide

The unlawful killing of a human being is classified by degree in English law, which either reflects the gravity of the crime or mitigates for special and understandable circumstances.

Murder was originally defined in common law as the unlawful killing of a human being by another. This ancient interpretation of the crime has been frequently refined and updated by parliament and the courts to reflect changing attitudes and circumstances. Defences are therefore available when a killer can convince a jury that he was provoked into losing self control or was suffering temporarily an abnormality of mind sufficient to diminish responsibility for the crime. Insanity is also a special defence to a charge of murder and if proved to the satisfaction of a court the offender is committed for hospital treatment rather than punishment.

To secure a murder conviction the Crown must prove that an assailant intended to kill or inflict the serious bodily harm that ended in death – an intention that may be deduced from evidence that the assailant should have foreseen the consequences of his actions.

Manslaughter is an unlawful killing that does not amount to murder and may be either a voluntary or involuntary act. An alternative verdict of voluntary manslaughter is available when it is decided that someone accused of murder is

(i) suffering from diminished responsibility, or
(ii) was sufficiently provoked, or
(iii) a surviving party to a suicide pact with a deceased person.

Involuntary manslaughter verdicts cater for those instances when death is *unintentionally* caused by an otherwise unlawful act, a neglect to perform a legal duty or by exhibiting utter recklessness in connection with an otherwise lawful action: examples are the performance of a criminal abortion; failing to

provide food or care to a child or infirm person; or a negligent use of machinery.

Infanticide is committed by a woman who causes the death of *her* child while under the age of twelve months by a wilful act or omission, when the balance of mind is disturbed through not having fully recovered from the effects of childbirth or the consequences of lactation (Infanticide Act, 1938).

Homicide Investigation

In years gone by, the familiar phrase, 'the Yard has been called in', heralded the arrival in a provincial constabulary of detectives from the Metropolitan police, experienced in the science of murder investigation. The ultimate crime was then an exceptional event in many small forces and detectives could complete careers and not be involved in a murder inquiry. Considerable public acclaim was awarded to the handful of men who travelled to the provinces – some becoming household names and surrounded by a myth of infallibility. In reality all the visiting detective did was channel the energies of the local force along avenues that had proved successful in the busier environment of the metropolis.

The senior officer was invariably accompanied by a junior assistant, who ensured that the results of all enquiries were properly recorded, indexed and easily retrieved. Over the years the 'Met' had evolved an operational plan, known throughout the police service as 'the system', a checklist which ensured that no strands of an enquiry were overlooked, and information was methodically indexed.

The explosion of serious crime and expansion of police forces during the second half of this century has greatly changed the situation. The Metropolitan police have quite enough problems of their own to deal with and secondment of officers to forces outside the capital is now rare. Larger provincial forces now have sufficient resources to deal with any internal investigation and the frequency of these demands has developed individual skills.

'The system' was universally adopted as the best means of administering complex investigations until events in the early 1980s demanded change. The 'Yorkshire Ripper' investigations highlighted deficiencies when it was discovered that the murderer of several prostitutes had evaded arrest even though

he had been recorded as a potential suspect in various sections of a huge and inefficient manual indexing system. It was reluctantly appreciated that many criminal enquiries were now too complex, and public expectations of police efficiency too high, to sustain the unwieldy card index system. The police service needed to embrace the computer age.

The Home Office Large Major Enquiry System (HOLMES) is a computerized package that all constabularies are obliged to adopt. It is a system based on designated roles and set procedures, capable of linking a series of simultaneous investigations taking place in any part of the country.

The detective who plans and controls a major investigation is designated the senior investigating officer (SIO). He is the strategist and tactician with responsibility for every aspect of the inquiry throughout its duration. The SIO works closely with two senior members of the team: his designated deputy and an incident room manager whose respective responsibilities relate to the control of day-to-day operations and the management of information.

Major Incident Rooms (HOLMES)

Incident room procedures are intended to standardize the examination, recording, analysis, retrieval and presentation of all information produced during a criminal enquiry. This can only be achieved by adherence to a rigid system that controls the flow of material. The scale of the operation is directly related to the complexity of an investigation: straightforward incidents may only require the commitment of two or three operators, whereas an intricate and extended enquiry may demand the services of several people to carry out a single function.

An incident room is ideally situated at a designated, equipped location near the scene of crime and centre of operational activity, preferably within the security cordon of police premises. Most forces have purpose-built incident suites that are activated as and when required. In remote locations it is often necessary to compromise and use whatever premises are available, linked by communications systems to the central facility many miles away. A developing feature of criminality, the travelling offender who does not respect constabulary boundaries calls for greater measures of co-ordination between police forces, and HOLMES has built-in procedures to satisfy all requirements. When positive links are established between

separately committed crimes in more than one constabulary area, an assistant chief constable with wide investigative experience is designated to oversee the efforts of the separate SIOs involved. The prerequisite for any successful inter-force operation is compatible computer technology.

Incident Room Functions

The **office manager** is responsible for establishing and staffing the room, together with the supervision of all internal functions. He must maintain close liaison with the SIO and his deputy over matters of policy and results of enquiries. He also routinely maintains a policy document, a device by which an SIO may be held to account for his strategy and tactics throughout the enquiry.

The **administrative officer** exercises control over manpower requirements, duty rosters and budgetary matters. He also relieves the SIO and office manager of much of the minutiae of routine administration.

Every item of information relating to the investigation is channelled through the office of **receiver**, who decides upon its relevance and disposal. It is then logged on computer indexes for future reference, before being prioritized for further action. Urgent material is weeded for the attention of the SIO before entering the logging system so that he may have an early opportunity to redirect his policies. Policy directives, telephone messages, officers' reports, witness statements and exhibits are all included in the type of material passing through this office, and the perspicacity of its staff is all-important. They must be fully conversant with all aspects of the original crime and regularly briefed about developments, so that they can quickly detect significant data and highlight it for further attention.

Witnesses' evidence requires thorough attention from one or more **statement readers** so that the burden on the receiver is reduced. The reader extracts relevant issues from the body of the statement for follow-up enquiries, and marks those details that must be inserted in categorized indexes in the database.

The **action allocator** receives everything that requires operational attention, either emanating from directives issued by the SIO or those identified by the receiver or statement reader. It is his job to allocate a consecutive number to each task and complete a job-sheet or 'action', before delegating it to a specific officer for further investigation. Many of these enquiries will revolve around the elimination of suspects, events or

vehicles. These are known as TIEs (trace, interview and eliminate) – the emphasis on elimination explains the 'pyramid' philosophy adopted in most criminal enquiries: an SIO begins with a host of possible solutions to the problem, and by systematically reducing them hopes to arrive at a definitive answer.

At the outset of an investigation, the SIO must nominate specific computer indexes into which he requires information to be stored. As situations develop these may be augmented, while some may become redundant. Several basic categories are common to most inquiries – nominal, vehicle, street, house-by-house, victim – but particular circumstances of the crime will necessitate unique classifications: weapon/s, descriptive peculiarities, deformities, jewellery, stolen goods, injuries and so on. Computer technology permits division into any number of sub-categories and the skill of the **indexer** lies in cross-referencing information so that it is included in all relevant files. The distinct advantage of an efficient database is the research and retrieval facility: what would have taken days using a manual system can now be achieved in seconds.

Large-scale enquiries demand the services of a full time **researcher**, who constantly reviews the database for further lines of enquiry and performs special projects nominated by senior operational detectives.

In all cases involving the use of the HOLMES system the SIO is obliged to nominate specific personnel to ensure that the use of the database does not transgress data protection legislation.

Senior Investigating Officer

The fundamental approach to homicide investigation is no different to that employed for any other crime; but the emotive nature of the offence usually means that the SIO works in the full glare of publicity – if only at a local level. He exercises control over all operational matters and the practical uses of computer technology, and must also be an effective communicator, publicist and motivator, capable of exercising fine judgements on a range of issues. While his critics will always have the advantage of hindsight, the SIO is required to possess a capacity to anticipate or predict the consequences of his decisions.

Homicides are always tragic events, but the majority are

mundane and often self-detecting affairs. Eighty-five per cent of murders are committed by someone with some form of relationship or association with the deceased, and a large proportion of victims are children, killed by a parent or guardian. But every year a senior investigator can expect his personal expertise to be stretched to the limit by a death that is not so easily resolved, and to which he may be committed for a lengthy period of time, in some cases for the remainder of his career. In some frustrating instances he will be certain he knows who the offender is, but will not be able to secure the necessary evidence to bring the suspect to justice. The proper guarantees of anonymity in these circumstances ensure that his best efforts are regarded as failures in the eyes of the public at large. Because of the vicissitudes of the most complex inquiries, they are only entrusted to the most experienced, skilful and analytical detectives, whose shoulders are broad enough to withstand the pressure of adverse publicity on top of a burdensome investigation.

Before determining the overall policy of a murder investigation, the SIO will always obtain as much information as he can from the cadaver, the scene of crime and antecedent events. Armed with these facts he will then proceed along a tried and tested course to secure additional evidence and refine what he already has. Invariably he will delegate specific areas of the inquiry to his most senior aides. Very few constabularies suffer a sufficiently high number of homicides to justify a fully committed 'murder squad', and in normal circumstances these investigations are staffed by detectives seconded from normal duties, working under the supervision of a handful of specialists, dedicated to major crime investigation.

The trawl for information is largely routine, a policy of tried-and-tested methods, which can be amended to meet particular circumstances: house-by-house visits; static road-checks; reconstructions; examination of the victim's background and associates; elimination of suspects through enquiries or interrogation of police records. During this blanket operation the information it produces is continually assessed to produce a progressively detailed plan of campaign.

Many of the elimination enquiries will be conducted from carefully compiled questionnaires and briefing sheets, which are designed to enable detectives to elucidate further facts from potential witnesses. A feature of all intricate investigations is the frequent briefing sessions, during which information is exchanged and all officers are updated on developments.

During a lengthy inquiry the SIO is generally allocated to an

office adjacent to the incident room, continually reviewing his plans and the results of his subordinates' efforts. It is a process that has been properly compared to completing a jigsaw puzzle: one begins with a single shred of information that one must fit to each new discovery until the picture is complete. No textbook can cater for the diversity of criminal behaviour – there are only guidelines based on experience and common sense, and adaptable according to the requirements of unique circumstances.

Case Study: Homicide (1)

A teenager is reported missing in the early evening of a foggy, dank November day. The girl is from a decent, hard-working family, and the young police officer who answers the call from her distraught parents quickly appreciates that something is seriously amiss: this is not the usual story of an adolescent skipping off on a whim for a few days without telling anyone. Having left home in a happy frame of mind to visit the hairdresser, she was expected back for lunch. Her daily routine was predictable: she would normally spend her days around the house and garden, before helping her mother prepare the evening meal. She rarely went out and did not have a boyfriend.

The family home is in a quiet area on the outskirts of a county town, about two miles from the shopping precinct, and it was the girl's normal practice to take a bus from near her home. The hairdresser, summoned from his home after a check of key-holders' particulars on police files, confirms that the girl kept her noon appointment. A short time after a bus driver is traced who remembers taking her to the precinct. No one can be found who recalls her making the return journey.

Any search is hampered by darkness, a dense, clinging fog and the topography of neglected heathland lying between her home and the town centre; it is an area bisected by a railway line and riddled with paths created by people taking short-cuts between nearby housing estates and the central amenities. At the end of a long evening, spent checking all known associates, the police are unable to offer the frantic parents any crumbs of comfort – only the minimal reassurance a mature female officer can provide to help them through the night.

An extensive search is organized for first light: publicity on the local radio brings forward volunteers to join dozens of police officers in scouring several hundred acres of wasteland. To avoid undisciplined groups running amok, the exercise requires careful planning. A marshalling point is advertised and the area delineated on to large-scale maps and divided into manageable sectors. Groups of searchers, working under police supervision, are briefed about the disappearance and given

written descriptions of the missing girl. They are told that if they find anything possibly connected with her, they are to leave well alone until it can be photographed and recovered by an exhibits officer. A communications vehicle establishes a control point for use by the officer in charge, from which he will be able to issue instructions and receive reports from officers equipped with personal radios on a closed frequency. Particularly difficult terrain is allocated to specialist police sections: mounted officers make better progress through hillsides covered in high ferns; dogs search dense undergrowth and divers plunge into rivers, streams and standing water. A helicopter, fitted with a thermal-imagery device, will fly over the whole area, seeking hot-spots on the ground created by an injured person or cooling corpse.

A separate detective operation is set in motion to retrace the girl's route to the hairdresser's, question shoppers and passers-by and search for any hint of an assignation or other reason that may explain her disappearance.

Uniform officers cause traffic disruption as they question motorists at a road block set up under a superintendent's authority.

By mid morning the combined efforts of searchers, investigators and the local media bear fruit. A former schoolfriend reports seeing the girl walking away from the precinct towards her home at about one-thirty, and a shopper recalls seeing her on a footpath leading towards the heath shortly afterwards. A large number of searchers are immediately diverted to that area and work in a line along either side of the meandering path. At a point where a footbridge crosses the railway line, an observant policeman notices a freshly trampled path through undergrowth on the embankment to the edge of the track. A dog handler is summoned, casts his dog on a long tracking lead down the bank and the scenting animal follows an invisible trail along the rails for some forty yards before running into heavy thorn bushes on the opposite side of the line. Within seconds the dog barks and his handler knows he has a 'find'. The search is over – a female body lies on its back, her coat belt wrapped tightly around the neck.

The grim discovery sets in motion a well-rehearsed contingency plan. The area is sealed off and all rail traffic suspended. Until senior detectives, scientists and a pathologist arrive, the only person who will be allowed access is the police surgeon to certify death and obtain a body temperature to estimate time of death. The best guess is that she died between twelve and twenty-four hours earlier, but a pathologist may be able to refine the calculation by assessing the degree of rigor mortis.

Within a short time the area erupts into intense activity. To avoid contamination of evidence access routes are marked by phosphorescent tape and a fresh path is cut through the undergrowth into the place where the body lies. Everyone requiring access dresses in sterile overalls,

over-shoes, gloves and hoods. The first stage of the examination is to make a complete photographic and video record before anything is disturbed. The SIO will then assess the extent of on-site examination needed, both before and after the removal of the body. He will stand off for some time at a vantage point on the bridge, trying to focus on the most likely sequence of tents that preceded the girl's death.

She had obviously decided to walk home. Her previous history would seem to discount a prearranged assignation; signs of a struggle and scuff marks across railway sleepers indicate that she was dragged reluctantly to the bramble thicket. The view from the footbridge is unobstructed and he gets the impression of a reckless assailant, prepared to tackle a lone female in broad daylight at considerable risk of being seen from the regularly used walkway.

When the Home Office pathologist arrives, the two men take a preliminary look at the body. It is fully clothed, albeit with signs that undergarments have been disturbed. Her shoes lie nearby, having fallen off as she was dragged through the undergrowth. An unopened handbag lies at her side and the hands are raised towards the ligature; the purple congested features, protruding tongue and many haemorrhaging capillary blood vessels around the eyes are obvious indicators of manual strangulation. The body lies in a well hidden, flattened patch of undergrowth reached by a ten-yard, well-trodden path. It is reminiscent of a children's den or lovers' arbour.

These observations set the SIO thinking that whoever is responsible must either have prepared this hiding-place or carried out a careful reconnaissance to find it. Does this contradict his previous assumption about the victim's blameless character and indicate a tryst that has gone tragically wrong? There is little indication of a frenzied sexual assault, but the minimal interference with underclothes could mean that the assailant was disturbed before fulfilling his mission. It is all a matter of speculation, but serves to rehearse the strategic considerations the SIO must take into account when setting the parameters of the investigation.

The pathologist can deduce little from these initial observations; an autopsy will disclose more and the corpse is removed from the scene in a polythene body-bag to preserve evidential traces.

Before leaving, the SIO discusses the extent of scene examination with his scientific managers and the forensic team. When crime is committed in the open air and events have taken place over a wide area, this must be carried out as quickly as possible to avoid any risk of damage by adverse weather conditions. It is possible to protect a small area with temporary tents, but in other situations, speed is of the essence. An initial scan will be made of all undergrowth for obvious residues of hair, fibres, blood or scraps of clothing. Then the vegetation will be stripped to ground level and packaged for laboratory

examination. Numerous soil and mineral samples will be obtained before a line of SOCOs undertakes a fingertip search of the complete area between the footbridge and thicket. The SIO's analysis of a likely scenario extends the quest for forensic traces beyond the bridge to any place where an offender may have lain in wait for a victim before dragging her down the embankment.

The SIO must confront one more task before concentrating on the investigation – one that every police officer dreads. He must inform the parents of their daughter's fate and there is never an easy way of accomplishing this ordeal.

The hours immediately following the discovery of a brutal homicide place enormous pressure on an SIO. He cannot afford to miss any opportunity of securing evidence to identify his prey. Time is an enemy; the longer an assailant remains at large the greater becomes the likelihood that material connecting him to the crime will be destroyed or lost. For these reasons he will be constantly juggling his priorities, while at the same time concentrating on events unfolding around him. Once decisions for operational activity have been made he must stand aside, allow subordinates to carry out the spadework and give himself a breathing space to assess developments.

Section leaders will be given concise instructions to organize house-by-house enquiries in the vicinity, question all users of the footpath and swamp the town centre with officers armed with questionnaires. If information does not flow freely, the SIO will consider finding a volunteer who physically resembles the deceased, to take part in a reconstruction of her final morning. It is a frequently used device, aimed at stimulating memory. Information rarely presents itself; it must be sought out.

Formal identification of the deceased, an unpleasant duty for a near relative, is necessary before the autopsy can begin. Only the girl's face is visible beneath covering shrouds in a discreet room next to the mortuary. A nod of the head is sufficient confirmation. The female officer who has been with the family throughout the ordeal will now provide support for as long as they need her.

The post-mortem examination is conducted in marbled sterility under the glare of intense lighting and the whirring of cameras. The body-bag is preserved for later inspection – it may contain traces that have dropped from clothing during the journey from the scene. Pathologist, SIO and scientist view the clothed body for obvious signs of violence, damage or transfer of evidence from an assailant, such as blood or semen. Each item of clothing is separately packaged and labelled before adhesive tape is used to pick up fibres and hair from areas of exposed skin. Swabs are taken from the vagina, anus, mouth and nose and control samples of pubic and head hair plucked and cut. Scrapings from

beneath nails and samples of blood are sealed in sample phials. During all this activity the gimlet eyes of the pathologist seek out marks, wounds or abrasions that will help him complete the picture of how the girl met her end.

He is not required only to establish the cause of death – he must also interpret any feature that will help identify the murderer or indicate motive and method. In this regard the external examination is as important as his later efforts with the scalpel. There are a few scratch marks on the neck, caused by the victim struggling to claw at the ligature. Disturbed underclothing gives rise to suspicions of a sexual assault, but the absence of injury or bruising in the genital area suggests tentative fumbling rather than purposeful effort. Congestion, a bluish pallor and small red spots on the face are classic indications of strangulation, and the internal examination supports this diagnosis.

The victim was a healthy girl with no indication of natural disease that may have contributed to her death. The only internal damage is a small fracture of one of the horns of the thyroid cartilage, caused by terrific pressure exerted on neck structures. A further telling feature is that the girl remained a virgin. Without narrowing down the field of likely suspects at this stage, this does at least imply that the offender was either young, inexperienced or interrupted during the assault – or was simply a sadist with only death on his mind.

There is usually a brief respite for the SIO once he has issued instructions for the inquiry structure, and while evidence and information is being collected. He uses the time to assess the value and quality of every pertinent fact so far stored in his HOLMES incident room. From these he will seek inspiration to advance the investigation and secure an arrest. If he is fortunate, matters may be quickly resolved, but in complex cases he must expect to be led along many blind alleys before finding the path to success. The skill lies in inducing reluctant witnesses to provide snippets of information, or discovering those who may be completely unaware of the significance of their observations. A reassuring fact of life is that once an initial breakthrough is made, associated facts often begin to tumble into place.

The SIO does not have long to wait for an opportunity to concentrate on a particular line of inquiry. Police in a nearby town are investigating the disappearance of a married man. The absentee has a teenage family and throughout their childhood he and his wife have managed to keep his unsavoury past from them. He had been a compulsive 'flasher' in his earlier years – conduct that brought him before the courts on several occasions. The wife thought he had grown out of the habit, but he had recently been caught again and on the morning of his disappearance – which coincided with the day of the girl's death – had been distraught after receiving a court summons. The next day his wife received a letter

stating his intention to commit suicide.

At such an early stage any connection between the two events can only be tenuous, but it cannot be ignored. The SIO decides to interview the woman personally and before doing so will read and dissect the statement she has made to formulate the many questions he wishes to ask.

The anxious wife is well aware of publicity surrounding the murder; she has put two and two together and realizes the significance of the presence of such a senior detective. Loyalty induces a natural reluctance to impart anything harmful to her husband. The disarming skills of the interrogator are tested to the full as he gently probes for a possible connection between the two events. He must persist, because his experience tells him that she is hiding something. A female detective sits alongside the woman, not only to support her, but also to protect the SIO against allegations of impropriety as he gently and sympathetically insists on the disclosure of intimate details that are never normally necessary when someone is reported missing. She soon speaks of the warmth of the marital relationship, love of a large family, heartbreak caused by her husband's peccadilloes and her willingness to satisfy his every demand to diminish his perverted sexual needs. Reluctantly she speaks of practising fellatio. The significance of her frank admission is quickly assimilated by the investigator – could it explain the absence of signs of enforced penetration?

Further important developments await him when the interview ends: routine procedures have borne fruit. A young couple living on a housing estate near the heath were unaware of the intense police activity until they opened their door to a detective on house-by-house patrol. The previous day while walking towards the footbridge they saw a man hurrying towards them through long wet grass. He wore training shoes and the bottoms of his trousers were soaked. As he passed in front of them he averted his eyes, but not before they noticed a trickle of blood running down his face. He wore similar clothing to the missing husband.

Other police officers questioning people using the footpath have come across a group of schoolgirls going to the shops in their lunch hour. It is a daily habit, and the previous day they had seen nothing suspicious, but remember a dilapidated mini-van had been parked in a nearby lay-by. Their description matches the husband's vehicle.

Hard, scientific evidence must now be found to confirm a connection between the victim and suspect. The obvious people to consult are the scientists. In the absence of orthodox sexual activity, it is possible that the killer indulged his predilection for oral sex. Mouth swabs, ligature and the upper areas of the deceased's clothing are urgently tested for human semen, and debris recovered from beneath her nails is examined for traces of blood.

Within a few hours the answers are available, but they resolve very

little. No semen can be found, and while the nail debris reacts to tests for human blood, the sample is too small to hold any prospect of obtaining a finite grouping or DNA profile. The mundane slog for more witnesses must continue.

The trawl can be assisted considerably if the investigator can sustain the interest of the media. As other news stories compete for space, this becomes increasingly difficult and a senior detective soon learns to ration the material he releases in order to manipulate press coverage. In these circumstances he cannot yet publicize his interest in the husband, because of the possibility of prejudicing subsequent court proceedings and, in any event, he does not yet have firm evidence to connect the two inquiries. But he breaks no rules by appealing for any sightings of an old mini-van of certain description, and within forty-eight hours this brings success.

A local motorist narrowly avoided a collision with the van as it was driven erratically through a bend in a country lane about a mile from the murder scene. The memory of a demented driver's face is implanted in his mind. Further evidence of an agitated demeanour comes from a petrol-pump attendant, who recalls serving him during the fateful morning.

The SIO is now sufficiently interested to divide his investigation between a quest for evidence and a concerted effort to trace his suspect. All his haunts are visited and associates interrogated. A helicopter scours a wide area, looking for the vehicle – if abandoned, the location may give some clue to his present whereabouts. A riverside gateway may indicate suicide; a car park near a railway station could mean that he has left the area. For several days the efforts are completely unproductive, then, as is usually the case, a telephone call from a member of the public brings the matter towards its climax.

A young mother, who has been ill for a few days and consequently taking little interest in current affairs, has been told about the police interest in a mini-van by mothers collecting children at a school gate many miles from the centre of activity. She instantly remembers an identical vehicle swerving to avoid her as she walked her children along a woodland track towards their isolated forester's cottage some ten days earlier. Within half an hour of her call the village policeman finds the van on a woodland ride, hidden from view by a canopy of trees. A flexible hose leads from the exhaust through a barely opened window and the lifeless form of the suspect is draped across the front seats.

The untimely deaths of both players in the drama are separate issues for a coroner's inquest, which may only determine a cause and time of death, without attributing blame. But this will not satisfy a community needing reassurance that the police have satisfactorily solved the girl's murder and proved the identity of a dangerous killer. For this reason an

equally meticulous investigation into the suspect's death is required to establish beyond reasonable doubt that the two occurrences are linked.

An autopsy confirms the cause of death as carbon monoxide poisoning, and the absence of any injury or sign of violence negates the possibility that anyone else was involved. When results of every forensic examination are compared, the remarkably accurate picture that emerges sets a seal on both investigations.

The murder victim's coat shed fibres on to the suicide's socks, shirt, pullover, trousers, anorak and skin on his thighs. Vegetative traces identical to flora stripped from the railway embankment adhere to his outer garments. Red acrylic fibres recovered from ligature, panties, slip, pullover and coat are cross-matched to the lining of the offender's anorak – all providing overwhelming proof of contact between the participants. However, the scientists are capable of further deductions.

The man had heavy mud stains on his trousers and substantial deposits were recovered from his knees and lower thighs. The position of faint soil traces inside of the trouser legs indicate that they had been pulled upwards over the soiled flesh. From these observations and subsequent scientific analysis a sequence of events can be extrapolated.

Soil on the knees of the trousers is of identical mineral composition to that found in the woodland glade – he had knelt down to secure the hose to the exhaust. The deposits on the flesh are from the embankment, as are scrape marks inside the trouser-leg. The position of mud on the point of the knee, extending upwards for three inches on to the front thigh, indicates the posture of the assailant at the time of the killing. By comparing the distribution of clothing fibres it is possible to establish the relative positions of both murderer and victim. The assailant knelt in front of the girl, leaning towards her with trousers round his ankles. Fibre distribution shows that the lower half of his body was in contact with her head and shoulders. This leaves little doubt that he at least attempted to indulge in his favourite sexual pastime, presumably without achieving satisfaction. Heavy, dried semen deposits on underpants and trousers indicate that his climax was delayed, but as the age of these cannot be calculated, the pathologist is left to provide an answer to that particular conundrum. An internal penile swab recovers a sample of semen from the urethra. Normally such deposits are expelled by any passage of urine following ejaculation. It is therefore safe to assume that he secured some form of gratification only a few hours before his demise.

Eventually inquest verdicts of unlawful killing and suicide are formally recorded; the general public is left to draw their own conclusions from the familiar police statement that no other person is being sought in respect of the unfortunate girl's death.

The Office of Coroner

The Crown office of coroner, first established in the twelfth century, enquiries into unexplained deaths lying within the jurisdiction of the appointee. An additional duty involves investigating and arbitrating on matters of 'treasure trove' – items of value that have been secreted away, rather than misplaced, in earth or buildings and where ownership cannot be established. A coroner, who must be legally or medically qualified, holds a prestigious office. Deaths can be reported to him by the general public, police or registrars of death, but are more usually notified by doctors in general and hospital practice. It is a long-established convention, rather than a legal obligation, for doctors to withhold certification for the purposes of a coroner's inquiry when a deceased person:

(i) has not been medically attended during a final illness;

(ii) has not been seen by a doctor within fourteen days of death, or the body has not been viewed subsequently;

(iii) when a cause of death cannot be established;

(iv) where death appears to have been caused by industrial disease or poisoning;

(v) where the cause appears unnatural, a result of violence, neglect, abortion or other suspicious circumstances;

(vi) when death occurs during surgery or before recovering from anaesthetic;

(vii) if death occurs while a person is in lawful custody.

On receipt of the coroner's report, and after enquiries by a coroner's officer – who may be either a police officer or civilian appointee – the matter may be disposed of by directing a doctor to issue a certificate or asking a pathologist to carry out an autopsy. If the post-mortem examination attributes death to a natural cause, the coroner is empowered to issue a certificate allowing disposal of the remains. In other circumstances he may hold an inquest.

An inquest is mandatory when:

(i) someone has met a violent or unnatural end;

(ii) the cause of death cannot be established;

(iii) death has occurred while the deceased has been held
 in lawful custody;
(iv) an inquest is required by Act of Parliament.

An inquest is a properly constituted court of law and may
proceed with or without a jury of no less than seven, and no
more than eleven, members. Its purpose is to determine the
time, place and circumstances of death, but it may not attribute
any criminal or negligent responsibility to any individual. A jury
is obligatory in cases where the deceased has been in police or
prison custody, has died as a result of an injury caused by a
police officer in the course of duty and in certain specific
circumstances relating to industrial, public health or safety
legislation.

A coroner has power to summon witnesses and examine them
on oath, although no one is required to answer any question
which may be self-incriminatory. The normal rules of evidence
are usually followed, but a coroner is not bound by them, and
may therefore admit any evidence, including hearsay, in order
to arrive at a conclusion.

The only verdicts available to an inquest are: unlawful killing,
accident, suicide, natural causes, industrial disease, drug
dependency or, in those instances where the evidence does not
allow a definitive judgement, an 'open verdict'. (If a person is
arrested and charged with homicide, causes death by reckless
driving or commits certain offences stipulated in the Suicide
Act, 1961, a coroner is obliged to adjourn an inquest until
criminal court proceedings are finalized.)

Exhumations

An ecclesiastical court convened in a diocese may authorize the
removal of legitimately buried corpses from one consecrated
burial ground to another. All other disinterments may only
lawfully take place if authorized by a principal secretary of state
or a coroner. A coroner may order exhumation of a body that lies
within his jurisdiction, if he considers that an inquest or other
enquiries into the death are necessary. Fortunately applications
for exhumations are rare and always subjected to the most
rigorous scrutiny, as they almost always arise from information
or allegations that contradict a previously diagnosed cause of
death.

Traditionally exhumation takes place at first light, but the top

soil is usually removed to coffin level during the previous day, after the grave has been definitely identified from cemetery records.

The value of the subsequent autopsy will depend upon the condition of the remains. The rate of decay depends on many diverse factors, ranging from ground temperature at the time of original interment and condition of the corpse when buried to moisture-retention properties of the surrounding earth. In ideal conditions it may be possible to obtain useful information from an autopsy carried out several years after death.

If the reason for exhumation follows an allegation of poisoning it is imperative that soil samples are taken from the area surrounding the coffin.

Case Study: Homicide (2)

The click of the closing back door registers faintly in the subconscious of the sleeping middle-aged woman. Her husband leaving for work at his normal time means that she has another hour in bed. She anticipates seeing him next when she returns from work mid afternoon, when he will almost certainly be lying flat-out on the settee, sleeping off a regular lunchtime drinking session. His departure never disturbs their only child, lying in an adjoining room in the arms of her ne'er-do-well lover, who has done nothing but cause disruption in the family since his arrival a few weeks earlier.

When the wife arrives home from work, she finds her husband in the expected position, but his head is bashed to a gory pulp and the surrounding walls, ceiling and window are spattered with his blood. She does not linger, but flees to a neighbour's house where a police officer soon arrives to find her sobbing hysterically. An ambulance, which arrives at the same time, is unnecessary; the victim is beyond help, and the scene is obviously one of murder.

Only one police officer gingerly enters the room to confirm the obvious, before retreating to summon assistance. A detective and police surgeon arrive together and select a suitable path to the body officially to certify death.

A morbid crowd of onlookers views the build-up of activity as a car screeches to a halt outside the house, and the daughter and boyfriend demand to know what all the fuss is about. Their demeanour does not escape the notice of a young detective, as the girl collapses on to the pavement when the news is broken, only to be ignored by her companion who stands indifferently aside as she makes a rapid recovery. The certainty of a major crime ensures that the well-oiled machinery of a major investigation is set in motion without hesitation. While the

appointed SIO travels to the scene an incident room manager secures the services of Home Office pathologist, forensic scientists, video cameramen and a SOCO team, before starting to summon his own staff. The force is equipped with a centralized facility at its headquarters, which means that clerical and support staff can be quickly diverted to respond to an emergency, without unduly interrupting other police operations.

The SIO will be preoccupied for several hours: obtaining as much data as possible from scene examination; conferring with his medical and scientific colleagues; and attending the post mortem. Only by soaking up knowledge during these first few vital hours is he able to get a feel for the investigation and determine how best to deploy resources. In the meantime he must depend upon his deputy and office manager to oversee routine preliminaries aimed at quick identification of an offender and the proper recording of everything that occurs. Most senior members of the team will have worked together on many similar occasions and will confidently anticipate the SIO's basic strategy. They will set about tracing the movements of the deceased during his last hours, obtain a full history, secure the same information about other members of the household, seal off the scene and question everyone in the immediate area. They will also check police records for any previous suspicious activity in the locality and draw up lists of known criminals with a propensity for violence.

It does not take long to present the SIO with a formidable dossier of intelligence. The victim died as a result of several blows to the head, causing the skull to shatter and the brain to haemorrhage fatally. The force of the blows indicates the use of a heavy metallic object, but the shape of skin lacerations, although unusual, does not suggest any particular weapon. The forensic scientist is able to say that the man was attacked when already lying on the settee and can confirm the pathologist's estimation of the number of blows: droplets of blood that flick off a weapon raised to repeat an attack travel through the air, forcing forward their volume weight. When they meet a firm surface they deposit a series of pear-shaped pathways from which can be estimated not only the number of blows, but also the relative positions of the victim and his assailant. When other examinations are complete it will be possible to refine this data and suggest the most likely entrance and exit routes taken by the intruder.

A contradictory history of the deceased is unravelled: the façade of an inconspicuous, happily married and devoted father is belied by tales of an unscrupulous wheeler-dealer with many enemies and an obsessive animosity towards his beloved daughter's latest boyfriend. Early on in the investigation it seems likely that the answer will lie within the immediate family or someone with reason to bear a grudge. But the SIO

cannot jump to conclusions: he must keep an open mind and rely upon the discovery of real evidence, before he sets his sights in any one direction.

The widow, daughter and boyfriend have good alibis. The unfortunate wife was in the company of workmates all morning and was dropped off outside her home by a colleague only seconds before making her grim discovery. The young couple were together all day: at a dental surgery in the morning, drinking in a town-centre pub until early afternoon and then visiting friends before returning home. Many hours will be spent confirming and timing their movements, and even then the SIO will remain sceptical about their innocence.

The victim was employed as a yard foreman for a scrap-metal company, and the state of his rear garden suggests that work was also a hobby – the ground is littered with piles of metal and partially dismantled vehicles. It is necessary to trace all his customers, concentrating at first on the many he allegedly upset by sharp practices. This task is not made any easier by the itinerant nature of those who regularly trade in industrial and domestic waste.

As usual many diversions hamper the main thrust of the inquiry: a neighbour recalls two scruffy men calling at his home during the previous week seeking the deceased's address; another remembers a red van cruising slowly up and down the road at lunchtime on the fateful day, and there are several more unexplained people and vehicles that have to be accounted for. All must be traced, interviewed and eliminated.

For a man of lowly occupation, the victim possessed the trappings of considerable unexplained wealth: a flashy new car; an extravagantly furnished and equipped home; three substantial building society accounts showing regular large cash deposits – all financed, so the local underworld would have it, by links to narcotics distribution and services rendered as a 'fixer' for the criminal fraternity. The SIO must attempt to disentangle what amounts to a veritable can of worms.

For several days the investigation progresses along traditional lines. Divided into teams, each under the management of a senior supervisor, detectives prod and probe the several sectors into which the inquiry has been divided. They are assisted by many uniformed colleagues who undertake extended house-by-house enquiries, road and pavement checks and visits to pubs, cafés, itinerants' compounds, laundries and dry-cleaners'. They seek information, but also evidence of blood-stained clothing or a suitable weapon. Labour-intensive searches are conducted in gardens and wasteland for the same reasons, and forensic experts continue to examine the house for trace evidence. Several other scientists test clothing taken from the deceased, his immediate family and a number of alibi witnesses for tell-tale signs of incriminating contact.

Throughout this period of fervent activity the SIO distances himself from the tedium of routine enquiries and concentrates on tactics. He will

be debriefed each morning and evening by team leaders and the office manager. At all other times he must be available to assess sudden developments and, if necessary, amend his plans. He continually updates himself on the state of his inquiry by accessing the computer, so that he may call an immediate halt to unproductive lines or switch resources to those which appear more positive. Inevitably administrative delays will occur while computer operators feed innumerable data into the system; when such time-lags occur the SIO must rely on back up from a team of researchers, who work with the incident-room staff to extract material for immediate attention.

He must also be available to 'front' press and television appeals: the media are rarely satisfied with a subordinate if a story is to hold its own among other major news items. The daily routine quickly develops into a pattern of briefing, evaluation, assessment and decision-making, as well as reading endless piles of statements and documentation. The whole process demands high levels of concentration, commitment and stamina.

An investigation can easily become bogged down in a mass of trivial information, which, while giving the offender increased confidence, saps the morale of detectives undertaking routine tasks. The SIO must continually seek initiatives to bring matters to a conclusion and very often rely upon an intuition developed over many years' experience. In this case his instincts tell him that something about the boyfriend is not quite right. His alibi cannot be shaken, but it appears too explicitly supported, a view shared by a trusted colleague who has known the youth since he was a young scallywag. Sticking in the back of the senior officer's mind is the lack of reaction the detective noted when breaking news of the victim's death to the young man. His general suspicion, combined with lack of progress in other directions, forces his hand. He decides to commit a small team to back-track on the alibi story and carry out continuous surveillance on the lad's daily routine. No sophisticated operation is needed because no harm will be done if the team 'show out'. Indeed if the youth realizes he is under scrutiny it may spark off some irrational behaviour. At the same time, the SIO diverts other officers to exploit the rumoured links between the victim and the local criminal fraternity.

Criminals are a furtive breed who avoid the authorities at all costs. Nor do they welcome undue attention and prying into their affairs: it increases the risk of detection and curtails profitable activity. Most are known to local detectives, even if insufficient evidence exists to bring them to book; only a few very clever operators can completely conceal their involvement in crime. The old convention of criminals grassing on colleagues who commit violence has largely disappeared, but an investigator can influence a similar reaction by placing a group of them

under the spotlight. In their anxiety to retreat into the shadows, some of them will invariably turn against the cause of unwelcome attention and, at the very least, point an inquiry in a profitable direction. Anyone who believes there is honour among villains has probably read it in a feeble crime novel.

Attention directed towards the boyfriend brings few dividends, but a surveillance exercise mounted at the scrapyard, an area of business notorious for its criminal associations, soon has the intended effect. Small time 'totters' ' livelihoods are at stake if they are prevented from disposing of ill-gotten scrap, and the yard's owner is similarly affected by a sudden downturn in business. Soon enough whispers reach the SIO's ears that convince him he is thinking along the right lines. One informant identifies another potential source of information – a young man who was seen drinking in the suspect's company in the days leading up to the murder. The detective knows that his subordinates have as yet been unable to identify and trace every pub customer, but now he has a name and description he is able to consult his database and match them to an outstanding TIE 'action' that his officers have been trying to resolve. As they set out to trace the man in question, the slice of luck occurs that, as is often the case, swings the pendulum in favour of the detective. At last he senses his opportunity to crack the impenetrable wall of silence surrounding the alibi. The investigation is ten days old when a phone call reaches the incident room from the adjutant of an army unit serving in Germany. One of his young soldiers has received the local paper from home. News about the murder occupied several pages, including appeals for information. On the last day of the soldier's leave – the day of the murder – he had spent the afternoon fishing in a canal not far from the deceased's house. He saw a car come to a standstill on the brow of a narrow bridge about a hundred yards away and seconds later heard a loud splash. Only the vehicle's upper outline was visible above the parapet, but the colour and shape the soldier saw matched that of the suspect's vehicle.

An officer from the Special Investigations Branch (SIB) of the Royal Military Police (RMP) is quickly sent to debrief the lad and obtain a written statement. Just as rapidly, an underwater search unit is dispatched to the canal and a plastic sack recovered from its bed. It contains a heavy metal bar, wrapped in a woollen jumper.

The bar is readily identifiable as part of a lorry's steering linkage and a visit to the victim's back garden satisfies the SIO that it is from a partially dismantled chassis. The soaking jumper may still retain hairs and foreign fibres capable of comparison with other samples. Identifying its previous owner is obviously crucial, but the detective does not yet wish to show his hand. Although sure that he has recovered the weapon, can connect it to a car and, by inference, to the boyfriend, he prefers to

play a waiting game until he has positive evidence to corroborate the links.

Selecting the time to strike is always a finely balanced decision, only taken when all relevant facts have been marshalled. Prematurely executed arrests create difficulties that may be avoided by exercising a little patience. In this case there is little to be lost by delay – the suspect vehicle has already been forensically examined and the results awaited, so – there is no immediate need to impound it again. The suspect himself is a proven liar and unlikely to confess anything under questioning, and he is doing nothing actively to impede the investigation. It is therefore far better to wait until a solid foundation for arrest has been built, rather than inflict unnecessary pressure on the murder squad to secure evidence within the time limits for detention.

Of course the SIO must take into account other factors when weighing up his decision. It is suspected that a small group of people has been seriously intimidated into supporting the apparently indestructible alibi – they may be more prepared to come clean if the suspect is taken out of circulation. The general public's safety must also be protected by taking violent offenders out of circulation, but there is little foreseeable risk when the matter appears confined to a family group. The decision to allow him a further brief period of freedom is tactfully sound and, in the light of developments, fully justified.

First, the pathologist comes up trumps: the metal bar is precisely the type of weapon he predicted. The bulbous, rounded end makes a compelling match with the scalp wounds. His expert opinion and the photographic record will be used to impress a jury. It will be a matter for defence lawyers to arrange their own examinations and expert evidence if they wish to contradict or throw doubt on his assertions.

Forensic scientists are equally helpful: fibre comparisons between the jumper recovered from the canal and a number found on the shirt worn by the suspect when originally interviewed are positive. More significant still is a small clump of hairs, held together by a fragment of human tissue, that had adhered to the iron bar and been held in place by the jumper – it can be matched to control samples taken from the victim. At this stage it is not yet known whether saturation will prevent the recovery of sufficient DNA sampling to establish a positive profile.

The game of cat-and-mouse brings other unexpected benefits. By a process of elimination detectives establish that the soldier fisherman is one of the unidentified customers in the bar that features in the alibi; there appears to be something more than a casual relationship between him and one of the young men who has so resolutely maintained the suspect's innocence. Suspicions are further aroused when an SIB officer communicates his disquiet about the soldier's demeanour under interview. Facial expression and body language have told him all he

needs to know – the youngster is hiding something. Rather than bring pressure to bear without being in full possession of all the facts the interviewer backs off. Meanwhile army authorities arrange for the witness to be escorted to a UK base. When confronted with a few basic facts by a detective, the youngster soon capitulates and becomes eager to relieve his conscience.

The original tale had been concocted out of a genuine desire to impart information while at the same time distancing himself from a situation into which he had become innocently entangled.

The truth was that he had been inside the car when it stopped on the canal bridge; his mind was a befuddled haze after a heavy lunchtime session. Throughout his leave he had little to occupy his time other than hang around pubs with a couple of unemployed mates, one of whom was a main alibi witness. On several occasions he was on the fringe of conversations when the daughter and her boyfriend spoke freely about turbulent family relationships. Once they spoke of a wish to see the father dead and hinted that the soldier could obtain a weapon from military sources; but the disciplined youth had already assessed them as a pair of wastrels living in fantasy-land and summarily dismissed the episode from his mind.

On the last day of his leave he was drinking alone; his best friend had, uncharacteristically, failed to turn up for a farewell drink, and he was well in his cups when the young couple arrived. They appeared unusually excitable and downed an inordinate amount of alcohol before offering him a lift to say goodbye to his friend. In what must have been a rash, unguarded moment, the suspect stopped on the bridge to dispose of incriminating evidence. He probably over-estimated his passenger's level of inebriation and knew that he would be on his way out of the country well before nightfall.

It was when the soldier read the local paper a week later that the significance of what he had witnessed struck home. Torn between protecting his own position and a desire to help he had naively concocted a story to divert attention away from himself. He had not considered that others might have chosen to inform the police of his involvement with the couple. Failure to appreciate the consequences of hastily concocted lies often leads to the downfall of criminals and those who try to protect them.

The soldier's evidence is the stroke of good fortune the SIO has patiently waited for, although to some extent he engineered the break by judicious exploitation of the media. It is the familiar tale of a momentary lapse of concentration, inexperience or arrogance on the part of the criminal that now presents an opportunity to destroy the alibi piece by piece.

Once the breach has been achieved, the pace of the investigation

gathers momentum. The soldier's complete debriefing takes many hours, and relieved of the burden of silence and mendacity he is only too willing to help. He had dismissed the attempt to procure a firearm and the threats towards the father as fanciful pub talk, but his recollections of what occurred when he arrived at his friend's flat assumed greater significance when he read of the murder. The suspect had greeted his friend with the words, 'The deed's been done' and they immediately went into another room. The soldier sat in the lounge while the daughter and his friend's partner chatted. Within minutes he fell into a drunken slumber. Some time later he was disturbed as the young couple took their leave, and it stuck in his mind that the suspect had changed his clothing. After they left his mate appeared jumpy and couldn't get him out of the house quickly enough. Within a few hours he was on a train to London, completely unaware of the mayhem erupting in the small town.

While the interrogation is taking place, the SIO and incident-room researchers are scanning data sheets to establish connections between the soldier and other as yet unidentified pub customers, work out which alibi witnesses have deliberately omitted to mention his name and plot those occasions when he would have been present in order to relate them to other witness statements. This operation strengthens the supposition that he was an innocent participant on the periphery of events. It can only be presumed that the conspirators, well aware of the danger he posed, chose not to disclose his existence, believing he was safely out of the way.

Conspiratorial alibis are extremely difficult to unravel if the participants do not waver in their resolve to confound the police. This sometimes leaves an investigator in the certain knowledge that he knows who has committed a crime, but frustrated in his attempts to conclude the matter satisfactorily. Invariably conspiracies are resolved by persistence and patience. Once again it is a foolish operator who rushes to arrest those suspected of involvement in a web of intrigue; far better to unravel the plot first and possess most of the answers before posing questions. Such tactics do not always need to be conducted covertly; much pressure can be brought to bear on the equanimity of suspects if they are unnerved by insidious police activity. The recipients of such attention and their legal advisers may huff and puff about harassment, but if the operation can be justified, the complaints usually evaporate.

In these situations it is paramount that crucial witnesses, upon whom the arrest and conviction of violent thugs depend, be adequately protected from threat or intimidation. In the soldier's case it is an easy matter to entrust his security to the military authorities, but other circumstances may require physical protection, electronic surveillance methods or, in some serious cases, rehousing a witness and his family in a distant part of the country and providing a new and officially documented identity.

The boyfriend will never accept responsibility for the killing, but

unfortunately he cannot rely upon others in whom he placed his trust. The soldier's friend and his partner, together with the victim's daughter, are the only malevolent conspirators; the remaining alibi witnesses have essentially told the truth about the couple's movements and associations. Authenticating the soldier's story involves reinterviewing all the previous witnesses. By the time the exercise is completed the main players are thoroughly unsettled. The tactic has worked and the time for action has arrived.

There are now adequate grounds to remove the conspirators from circulation on suspicion of murder. All are closely questioned under caution in the presence of their lawyers and, as expected, the couple remain obdurate and maintain the right to silence. But their allies prove more co-operative. Initially repeating their account, they play directly into the hands of their interrogators – it is always a useful ploy to allow a suspect to lie before confronting him with inescapable facts. The conspirators, having denied the presence of anyone other than the two murder suspects at their home, are suddenly confronted by reality when the soldier's name is mentioned. By subtly introducing minor facts, the questioner shows that he knows far more than his interviewees have yet appreciated.

From that moment on, their only goal is self-preservation. They distance themselves from any suggestion of involvement in the ultimate crime but are ready to accept lesser responsibility for an act of misplaced loyalty. Such admissions will almost always be watered down by mitigating excuses of threats, coercion and fear, but they provide the corroboration the SIO requires and will direct him towards further positive evidence.

With the main players out of the way, detectives are free to capitalize on the situation without the risk of evidence being concealed and/or witnesses threatened. The widow identifies the jumper recovered from the canal – it is identical to one owned by the murder suspect, and she had washed it more than once. The alleged weapon can now be scientifically matched to the partially dismantled chassis. Now that the fear of reprisal has receded, more tongues are loosened. Testimony describes conflict within the family, threats of violence on both sides and what were previously regarded as imaginary plans to harm the victim.

The main alibi witnesses say they failed to realize until too late that they had got themselves involved in murder. The story they swallowed involved teaching the older man a lesson by damaging his property and had nothing to do with physical injury. They had been worried stiff by the stupidity of bringing the soldier to their house, but reasoned his imminent departure would, with luck, shield him from the investigators and his drunken condition might erase the events of the afternoon from his mind. Although everyone had agreed not to mention his name, they

should have anticipated that before long he would be identified by one means or another. Small-time villains rarely possess powers of logic and foresight. The only thing they tend to share is a sense of their personal infallibility.

The fact that the soldier was drunk at the time of his critical observations causes the SIO some disquiet, because the consequences to his memory will be severely tested under cross-examination. He can draw comfort from knowing that even the wiliest lawyer will be unable to contradict the fact that his recollections led directly to the recovery of evidence from the canal. Nonetheless he will still have to withstand an attack concerning his association with the main conspirators. The defence may go so far as to suggest he was the murderer and concocted a story to shift blame from himself. It is an intrinsic part of the SIO's job to anticipate such ambush defences and work between the time of arrest and trial to have evidence available to contradict them.

The machinations of co-defendants charged with serious crimes are frequently full of intrigue as each attempts to minimize their personal culpability, usually at the expense of a co-defendant. A murderer's refusal to admit guilt, however, provides little protection when others turn against him. In this case the victim's daughter is first to appreciate the benefit of shifting the blame on to someone she has so far vigorously defended. The plan was to wreak havoc in her parents' home in retribution for the hostility shown her lover. She claims never to have foreseen the terrible consequences of their madcap scheme. The murder, which occurred while she sat in the car some distance away, had so frightened her that she felt compelled to maintain the alibi for her own safety. Though not altogether convincing, the story, cleverly presented by a defence lawyer, is enough to satisfy a jury that she is no murderess – instead a verdict of guilty to a lesser charge of conspiracy will reduce what would have been a mandatory sentence of life imprisonment to that of a few years. The couple's friends are fortunate to receive suspended prison sentences for their part in the venture; a merciful judge takes into account their guilty pleas, unblemished past and the fact that they are unlikely to offend again. These punishments are imposed at the end of the murderer's trial, during which they all gave damning evidence against him.

Exploiting a criminal's weakness and playing off one suspect against another are the habitual tactics of detectives at any level. The moral code of villainy is far removed from that of normal society, and in order to protect the good from the bad, it is often necessary to root out the truth by deviousness and stealth.

9 The Case for the Crown

Popular perception of the criminal judicial process is generally limited to reports of high-profile courtroom drama. In reality it spans the complete period between a crime being brought to the notice of the police and the day an offender completes the punishment imposed for the transgression. At various stages between those parameters the system provides for several methods of disposal that do not necessitate court appearances.

Police involvement is limited to investigation and collection and presentation of evidence to the prosecution authorities and courts. The only quasi-judicial functions exercised by the police are the decision to charge offenders, admit them to bail or, in minor cases, administer an official caution. Most minor traffic violations are routinely dealt with by fixed fines that do not involve court appearances. Responsibility for the disposal of all other cases rests with the Crown Prosecution Service (CPS).

The majority of criminal offences are dealt with by magistrates' courts who summon most defendants to appear before them by issue of a written notice. Many of these summonses can be dealt with in the accused's absence. Those who appear after arrest and charge have committed more serious crimes that necessitate a temporary loss of liberty on grounds of public safety, or to facilitate an investigation.

Magistrates' courts are presided over by lay justices of the peace (JPs) or a legally qualified stipendiary. (Juveniles under the age of eighteen are, with certain exceptions, dealt with by youth courts.) These tribunals have the power to dispose of minor cases and reach verdicts based upon the presentation of evidence by both prosecution and defence. However, when a defendant does not dispute the facts and tenders a plea of guilty, the court's judgement may be based upon written submissions. Magistrates may commit guilty offenders under their jurisdiction to the Crown Court for sentencing if they consider their limited punitive powers inadequate to reflect the

scale of wrongdoing or previous criminal record. More serious crimes fall broadly into two groups: indictable offences, over which Magistrates' Courts have no jurisdiction and which must therefore be transferred to the Crown Court; and 'either-way' offences that magistrates are empowered to transfer in appropriate cases. In any event, accused persons in 'either-way' cases have the right to elect to be tried by a jury.

Transfers occur either after considering written evidence from the prosecution or when the defence argues that the accused has no case to answer. In these situations witnesses are not called to give evidence, but magistrates may permit oral submissions from either side in complicated cases.

Crown Courts are classified according to the seniority of the presiding judge and the gravity of the allegations they are empowered to hear. High Court judges preside over trials of the most serious offences in the criminal calendar and circuit judges over those of lesser gravity.

Higher courts also hear appeals against the decisions of subordinate tribunals, and the Court of Appeal performs the appellate function of those convicted and sentenced on indictment. The highest court in the land is the House of Lords, comprising the lord chancellor and his predecessors, lords justices of appeal and other peers who hold high judicial office. The House of Lords may only arbitrate on matters referred to it by the Appeal Courts that are certified as being of general public importance.

Case Preparation

It is no part of an investigator's responsibility to determine the guilt or innocence of a person he decides to charge: that is the duty of a court of law, and in the eyes of the police a suspect will remain an 'alleged offender' until that decision is reached. The investigation and preparation of case papers must therefore be completely impartial, and any evidence in favour of the accused should be presented so that it may be communicated to lawyers acting for the defence. Before trial the latter will receive the complete prosecution case, including all peripheral documentation and material gathered during an investigation, even though it may have no bearing on the proceedings.

Compiling a file of evidence is a laborious business that must be completed within statutory time limits, particularly if an alleged offender is remanded in custody awaiting trial. The

principle behind these restraints originates from the maxim that because an accused person is innocent until proven guilty he should not, unless absolutely necessary, lose the right of liberty prematurely. However laudable those sentiments may be, in practice great pressure is often brought to bear on investigators and CPS lawyers. This is particularly so in serious cases, when offenders are often arrested at an early stage of the investigation on minimal evidence in order to prevent further harm to a victim, safeguard witnesses or protect society in general. In those circumstances a file is presented that satisfies a *prima facie* case while the investigation continues to secure all the evidence.

Two attributes are essential for file preparation: an eye for detail and good knowledge of the rules of evidence. However, attention to detail at this stage will be laborious and quite likely worthless if the same meticulous care has not been exercised throughout the investigative period. If old ground has to be covered again, much time will be wasted and may also prove futile. Circumstances change – a photographic record of a scene will be of little material advantage to anyone unless recorded in the first instance, and medical or forensic traces recovered some time after the commission of a crime will, in most circumstances, be given reduced weight.

A thorough knowledge of the rules of evidence is a prerequisite of an efficient investigator. The law relating to evidence is a complex minefield, and no matter how convinced a detective may be about the culpability of his suspect, all his efforts will come to nothing if the material he collects is inadmissible.

The burden of proving beyond reasonable doubt that a crime has been committed by the person who stands before the court rests firmly with the prosecutor, who must support his assertions of guilt with proper evidence. A defendant, or his representative, has no need to prove innocence, although he is entitled to call evidence to dispute any aspect of the Crown's case. If he chooses to do so, the standard of proof is less stringent than that required of the prosecution and need only demonstrate that, in all probability, the alleged facts are untrue.

Evidence is presented to a court in one of three ways: orally – when a witness affirms facts within his knowledge or experience; by production of documents that go to prove elements of an allegation and by presenting tangible objects as exhibits related to the crime. A general rule is that a witness may only speak of matters perceived through his own senses and may not rely on what someone else has told him. Several

exceptions, however, are admitted to this general policy of excluding hearsay evidence. For example, evidence about the demeanour and utterances of a victim of sexual assault within a reasonable time of the offence is deemed permissible; as is a statement made by a murder victim immediately before death about the cause of his injuries.

With the obvious exceptions of a young child and someone whose mental deficiencies render them incapable of understanding the proceedings, everyone is deemed competent to give evidence before a court of law and risk punishment for contempt if they should refuse to do so.

Compellability is another matter. The doctrine of privilege excludes evidence by one spouse against another of any communication between them during marriage. Similarly, no one may be compelled to give self-incriminatory evidence and any dialogue or interaction between lawyer and client is absolutely protected. Material adjudged contrary to the public interest may also be excluded, but the popularly held belief that penitential confession to a priest, or a patient's disclosure to his doctors, are inviolable, is not recognized by the doctrine. A court may require both doctor and priest to answer questions or disclose records relevant to the matters at hand.

Immediately after the preferment of a charge responsibility for the entire prosecution process passes to the CPS, whose power over the future progress of the case is absolute. After reviewing the available evidence, the Crown prosecutor has authority to discontinue proceedings without reference to a court at any time prior to a defendant being committed for trial. Such decisions are based on the realistic possibility of securing a conviction and whether it is in the public interest to continue to trial. However, this transfer of responsibility does not end the SIO's involvement and it is essential that he retains an interest in the case until it is finally disposed with.

The SIO's personal contribution to the evidential weight of a serious case is invariably limited, and he more often than not assumes the mantle of collator and adviser during the pre-trial period. Any testimony that he would normally give to the court in more minor cases about personal observation and record of interviews is replaced by evidence from specialist experts and subordinate officers delegated the task of formally interviewing suspects.

While many criminal prosecutions are conducted from a handful of papers, others rely on documentation the size of a public archive. Although the rules and procedures are exactly

the same in either case, the presentation of complex prosecutions involves total commitment by all participants, all of whom will have supporting staff from an early stage. Many major cases are beyond the total comprehension of any individual in the preparation phase, and a team effort is required to reduce material to relevant issues that may be understood by a typical jury.

Ideally the SIO and his staff work closely with CPS personnel who advise on file preparation and presentation of evidence. It is also a growing practice to brief a barrister early in the pre-trial period with a view to securing the best possible assistance from the outset. Crown prosecutors may only present evidence in magistrates' or youth courts. Privately engaged advocates have right of audience in the Crown Court, and their specialist knowledge is invaluable in the preparation of difficult cases.

A barrister will often be chosen for the expertise he has developed in a specialist area of the law. Others will be selected for their abilities to cross-examine or because of their intimate knowledge about a core issue of a particular case, such as a branch of science, medicine or engineering. In the first instance a 'brief' will always be submitted to a 'junior' counsel, whose title often belies considerable experience. Later the gravity and intricacy of a case may demand the services of Queen's Counsel (also known as a 'silk' or 'leader'), to study, advise and present the issues in court.

The sheer number of cases that pass through contemporary courts means that many months elapse between an offender's arrest and appearance before judge and jury. The intervening period is occupied with conferences and consultation between the investigators and prosecuting team, negotiations with defence lawyers and appearances before a nominated judge for pre-trial reviews concerning the conduct of a case and directions over legal issues. Rules governing the disclosure of all evidence and information to the defence necessarily prolong this period. Proper enquiries naturally need to be made on behalf of the defendant into any aspects of the disclosed material.

The Criminal Trial

When a matter eventually reaches trial, the facts at issue are considered by a jury of twelve ordinary people, empanelled from the register of voters within the court's jurisdiction. The function of the presiding judge is to ensure that the case is

properly conducted, to arbitrate on legal arguments and advise the jury about the law. His summing-up of the evidence presented by both sides is intended to highlight the essential issues of the case to the jury members, who may have been obliged to sit for weeks or months listening to conflicting accounts.

It is a jealously protected constitutional right that a person accused of a serious crime can only be tried by his peers, and it is therefore for the jury, and the jury alone, to decide upon guilt or innocence. Until recent times the jury was obliged to reach a unanimous verdict, but in the realistic recognition of the whims and eccentricities exhibited by any group of twelve people, majority verdicts are now permissible. At least ten jurors must agree on the final outcome, but this decision is only acceptable as a verdict when a judge decrees that the panel has been given sufficient time to consider all the evidence. In exceptional circumstances due to death or illness the number of jurors may be reduced to nine but they must reach a unanimous decision. If ten remain a majority verdict of nine is permitted.

In the event of a hung jury, the options available are either a retrial or abandonment of the proceedings by the Crown. It is most unusual for a case not to be withdrawn completely if a jury fails to reach a unanimous or majority verdict after the evidence has been aired twice.

A lengthy trial is an endurance test to all who are not professionally engaged; to the outsider its machinations and tedium are an unceasing revelation. Continual interruptions occur when the jury is asked to retire while legal arguments are settled. Inevitably these cause delays that inconvenience witnesses and add to the overall costs.

The proceedings begin with the swearing-in of a jury and the taking of pleas to the indictment, which is presented to the accused by the clerk of the court. The case for the Crown is then outlined by the prosecutor, who presents his evidence by calling witnesses to the stand or reading aloud statements previously agreed by the defence. This latter mechanism avoids the need for a witness to be present and saves time.

Oral evidence is given under an oath, the nature of which will depend upon the religious convictions of the witness. The prosecutor must bring to light relevant facts without presenting leading questions, that is, suggesting the answer he wishes to hear. He must then allow the defence advocate to test the accuracy, credibility and honesty of the witness by cross-examination. This is an opportunity for the inquisitor to try and

diminish any detrimental effect the evidence has had on the defendant, and to achieve maximum benefit he is permitted to pose leading questions. Should he succeed in extracting new facts or sufficiently cloud previous answers, the prosecutor is entitled to re-examine his witness about the new material.

When the prosecutor indicates to the court that his presentation is complete, the defence may make a submission in the absence of the jury that the Crown has failed to establish an adequate case for the defendant to answer. If the judge refuses the application it is then a matter for the defence to decide how to promote its denial of the allegations. The accused may give evidence on his own behalf from the witness-box – but is under no obligation to do so. Should he choose to do so, he lays himself open to cross-examination, during which the only subjects that must be avoided are references to other crimes he may have committed in the past or questions about his character. These particular safeguards often lead to perplexed faces among a jury who have agonized for hours to reach a verdict, only to discover, while listening to the sentencing process, that the accused has a long list of previous convictions for exactly the same type of offence he now so strenuously denies.

Immediately before the judge's summing-up, the jury are addressed by both prosecution and defence counsel. It is their last opportunity to advance a précis of the case to influence a decision.

Unless a prisoner is obliged to remain in custody to answer other criminal charges, a verdict of 'not guilty' will mean an immediate discharge from the dock. A presiding judge is obliged to take into account a guilty defendant's previous criminal record, personal history and circumstances and any reports compiled by one of the social agencies before determining the most appropriate sentence. Compilation of the reports may engender considerable delay between a finding of guilt and imposition of sentence. Punishments are dictated by national tariffs and guidelines, although a judge is allowed considerable discretion to make the punishment fit both crime and offender.

The Witness

There are three types of witness: the lay witness, either a victim or an observer, who is able to relate what he knows about the facts at issue; the expert, whose professional qualifications and

experience qualify him to support an opinion reached after an evaluation of data; and the professional witness, usually a police officer or member of some other law-enforcement or regulatory body, who has been trained to observe, record and present evidence correctly.

For the ordinary person, giving evidence is often an unwelcome ordeal and it is therefore part and parcel of the prosecuting team's job to care for the welfare of their witnesses. This does not mean that they may, in any way, attempt to influence anything the witness says under oath – the only reminder permitted is sight of any written statement made prior to the trial. For obvious reasons of fairness, a witness may not be influenced by being allowed to listen to prior evidence; the only exception is the expert, who may hear evidence that has a bearing on his specialist opinion.

Waiting around to give evidence, an unfortunate feature of the court system, is a tense experience for the uninitiated – tension that is often magnified when the witness comes face to face with the formal austerity of courtroom styles, traditions and procedures. While a lay witness may regard a close examination of his story as a personal attack on his integrity, the expert witness realizes that the purpose of the exercise is to test the weight of evidence against the accused, and expose any weaknesses or contradictions that may act in his favour. He will, therefore, generally accept attacks on the validity of his opinions as a part of the ritual.

The professional has a distinct advantage over the ordinary witness in that he has been trained for and becomes acclimatized to giving evidence. A police officer is expected to be an example of the perfect witness, because it is an integral part of his occupation. The manner in which an officer conducts himself in the witness stand can often influence a jury significantly. For this reason alone he is often subjected to rigorous cross-examination and attacks upon his integrity and honesty and the validity of his evidence. The code of conduct for a police witness has never been better expressed than in an old manual of instruction written by a chief constable:

> He should relate in ordinary language the story he can tell of his own knowledge as to what he has seen, heard etc. He should confine himself to facts, avoiding inferences and opinions, or beliefs. He should tell his story in the natural order and sequence of events as they occurred. He should speak from memory, expressing himself clearly and

accurately. He should not produce his notebook as a matter of course and read all his evidence therefrom. If he finds he has to refresh his memory he may be allowed to consult his notes. When asked a question, he should listen carefully, make sure he understands, and give an intelligent and proper answer to the best of his ability. He should only answer the question put to him, and then, in as few words as possible, promptly and frankly. He should never lose his temper under cross-examination, and he should always reply politely and quietly to offensive questions. He should not show partisanship or prejudice, and ought to give his evidence fairly and impartially, giving all the evidence in favour of the accused in addition to the evidence against him. If he does not know something asked he should say so. He is sworn to tell the whole truth and nothing but the truth.

Police Law by C.C.H. Moriarty

Only experience can adequately prepare the police officer for the wiles of an aggressive defence advocate, whose reputation, and therefore his livelihood, depends on an ability to destroy or cast doubt on evidence. He will employ many stratagems to achieve his goal and, whereas an ordinary member of the public will be protected from undue pressure or bullying by judicial intervention, the professional witness is expected to be capable of fending for himself under hostile questioning.

It is a foolhardy officer who does not prepare beforehand and anticipate probable defence tactics. He may rest assured that his opponent, with access to every aspect of the case, will have trawled the entire material for discrepancies and contradictions, in the certain knowledge that he only has to find enough to create a doubt in the jury's mind to be assured of an acquittal.

There are several familiar avenues of exploration that a detective may anticipate: his notes of conversations with the prisoner, particularly those which may have occurred prior to a tape-recorded interview; his conduct of the investigation and his impartiality; the preparation of his case and his relationships with witnesses and informants; and personal references to his character.

A hostile cross-examination can be an uncomfortable and seemingly endless ordeal, but a police officer's ability to resist and emerge with honour intact is one of his most satisfying achievements, and the experience of several skirmishes brings additional benefits. Detectives, particularly at senior level, often

lock horns with the same small number of lawyers who are regularly briefed to defend those charged with the most serious crimes. Not only do their reputations go before them, but familiarity with their tactics and courtroom manner enhances the likelihood of an accurate assessment of defence strategy.

Good advocates, however, are capable of tailoring their style to suit the circumstances of a case or the personality of a witness. Some will patronize to the point of ridicule, show friendliness to induce a false sense of security, or aggression to undermine confidence. Some adopt a theatrical approach: firing out a stream of rapid questions aimed at causing confusion and inaccuracy; demanding direct answers when elaboration is necessary; suggesting that a witness's testimony has been directly contradicted by previously tendered evidence. Dramatic gestures and facial expressions are all part of his armoury: a look of disbelief or exasperation, raised eyebrows or a smirk when he believes he has scored a point, can be just as effective as an additional question. Throughout the time that he has the witness under his control, the advocate will continually try to measure his effect upon the jury. This enables him not only to adjust his approach to questioning, but also influences the manner in which he will approach the issues when he summarizes his case and endeavours to sway them in his favour.

The mature detective takes the trauma of the witness box in his stride, and learns to leave it with the same composure that he showed when he entered; no sigh of relief, no smile of satisfaction, no hostile glance towards his tormentor or the prisoner in the dock and, certainly, no air of resignation or defeat. Above all he must remain dignified when a verdict is announced: displays of triumph in victory or dejection in failure have no place in a court of law. He must always remember that his function is to collect, evaluate and assess the facts: it is for others to decide if they meet the criteria of certainty required by the courts. If he has carried out his duties faithfully and with integrity, it is no reflection on his personal qualities if the best evidence he has been able to find fails to tip the scales of justice against an accused.

Bibliography

Books

Allason, R., *The Branch* (Secker & Warburg, 1983)
Churchill, W.S., *A History of the English-Speaking People* (Cassell & Co. Ltd., 1956)
Cook, R.A. & Ide, R.H., *Principles of Fire Investigation* (Institute of Fire Engineers, 1985)
Critchley, T.A., *A History of the Police in England & Wales*, 3rd edn (Constable & Co. Ltd., 1979)
Gibson, B., *Introduction to the Magistrates Court*, 2nd edition (Waterside Press, 1995)
Kind, S.S., *The Scientific Investigation of Crime* (Forensic Science Services Ltd., 1987)
Knight, Prof. B., *Simpson's Forensic medicine*, 10th edn (Hodder & Stoughton, 1991)
Moriarty, C.C.H., *Moriarty's Police Law*, 24th edn (Butterworths, 1981)
Ryder, C., *The RUC – A Force under Fire* (Methuen, 1989)

Reports of working parties, royal commissions and documents published by HM Stationery Office

The Committee on the Police Service, 1920 (Cmd 874 & 574)
The Royal Commission on Police Powers & Procedure, 1929 (Cmd 3,297)
The Committee on Police Conditions of Service, 1949 (Cmd 7674)
The Royal Commission on the Police (interim report) 1960 (Cmd 1,222)
Police Training in England & Wales, 1961 (Cmd 1450)
The Royal Commission on the Police (final report), 1962 (Cmd 1728)
Police Manpower, Equipment & Efficiency, 1967
Committee of Enquiry on the Police, 1978 (Cmd 7283)
Royal Commission on Criminal Procedure, 1981 (Cmd 8092)
Association of Chief Police Officers – Statement of Common Purpose, 1990
Police & Criminal Evidence Act, 1984 – Codes of Practice (Revised Edition), 1995

Index